D1197473

About this book Throughout history there have been attempts to define the precise nature of feminine 'beauty'. Reversing the direction of such inquiries, Francette Pacteau focuses her attention not on the attribute 'beauty' but on the act of attribution itself. Drawing on psychoanalytic theory, she develops a simple, and original, premise: that the word 'beauty' is best understood as a generic term for a number of different, mainly masculine, *symptoms*. She discusses a wide range of written and visual texts, from Renaissance poetry to Jean-Paul Goude's photographs of Grace Jones, and reveals the complexity of that familiar observation – 'Beauty is in the eye of the beholder'. Not content with the complacent relativism this adage usually entails, the author is relentlessly curious about the workings of the mental apparatus to which the beholder's eye is attached, and the fantasies within which the contingent object of desire is formed.

About the author Francette Pacteau studied languages in France at the Université de Grenoble and then trained in England as a photographer, prior to gaining her doctorate in the History and Theory of Art from the University of Kent at Canterbury in 1991. She currently holds a Getty Postdoctoral Fellowship, and is Research Associate in Art History at the University of California, Santa Cruz.

The Symptom of Beauty

Francette Pacteau

REAKTION BOOKS

Published by Reaktion Books Ltd
1–5 Midford Place, Tottenham Court Road
London W1P 9HH, UK

First published 1994

Cover and text designed by Humphrey Stone
Photoset by Wilmaset, Birkenhead, Wirral
Printed and bound in Great Britain by
BAS Printers, Over Wallop, Hampshire

British Library Cataloguing in Publication Data:

Pacteau, Francette
Symptom of Beauty. – (Essays in Art & Culture)
I. Title II. Series
709

ISBN 0–948462–53–1
ISBN 0–948462–54–x (pbk)

Contents

Acknowledgements

My special thanks to Stephen Bann, Victor Burgin, Elizabeth Cowie and Laura Mulvey; research funded in part by the Getty Grant Program.

PHOTOGRAPHIC ACKNOWLEDGEMENTS

The publishers wish to express their thanks to the following for supplying photographic material and/or permission to reproduce it: The British Film Institute, London: pp. 20, 180, back cover; the British Library, London: p. 96; © Chuck Close, courtesy Pace/McGill Gallery, New York: p. 56; J.–P. Goude: p. 73; the Hulton Deutsch Collection, London: pp. 144, 202; LOOMIS DEAN/ Time/Life/Katz: front cover; Oskar Kokoschka-Dokumentation, Pöchlarn (© DACS, London, 1994): p. 55; Lanvin, Paris: p. 33; the Musée Ianchelevici, La Louvière, Belgium, photo from Artothek (© ADAGP, Paris and DACS, London, 1994): p. 159; the Musée National Fernand Léger, Biot, France, photo from Studio Jacques Mer/MNFL (© DACS, 1994): p. 98; the Musée du Louvre, Paris, photo from the Service Photographique de la Réunion des Musées Nationaux: p. 75; the Musée d'Orsay, Paris, photo from the Service Photographique de la Réunion des Musées Nationaux: p. 160; the Museum of Modern Art/Film Stills Archive, New York: p. 97; S.AA. Mortensen/Nordfoto, photo from the Hulton Deutsch Collection: p. 195; The Cecil Beaton Archive, Sotheby's, London: p. 10; the L. Treillard collection (© TMR/ ADAGP, Paris, 1994): p. 122; © the Estate of Garry Winogrand/ Fraenkel Gallery, San Francisco: p. 179.

Beauty is nothing else but a promise of happiness

STENDHAL

But if she is clipping quickly down the big-city street in heels, swinging her purse, or sitting on a stoop with a cold beer in her hand, dangling her shoe from the toes of her foot, the man, reacting to her posture, to soft skin on stone, the weight of the building stressing the delicate, dangling shoe, is captured. And he'd think it was the woman he wanted, and not some combination of curved stone, and a swinging high-heeled shoe moving in and out of sunlight

TONI MORRISON

Introduction: more than a woman

℘ *It is plain that the object of my quest, the truth,*
lies not in the cup but in myself
MARCEL PROUST[1]

'This was more than a woman, this was a masterpiece!',[2]
exclaimed the sculptor Sarrasine, as he saw for the first time
the exquisite Zambinella on the stage of the Teatro Argentina.
To the eponymous hero of Balzac's novel, Zambinella rep-
resented the convergence, in one person, of all the disparate
perfections which, until then, he had been condemned to seek
in many. She had the round neck of one, the delicate hand of
another, the slender waist of a third, 'the smooth knee of a
child'. When he returns to his studio, 'smitten by passion', he
draws the ravishing creature in every pose that his delirious
mind allows: revealing her body, unveiling her splendid
perfection. But the more he draws and carves the figure of
Zambinella, the further he is taken from the reality of Zambi-
nella. 'La Zambinella', Balzac's reader learns, is less than a
masterpiece; 'she', in fact, is less than a woman. By the end of
the tale, the super-natural beauty which set the tragic story of
Sarrasine in motion has faded in the gap that separates the
performance of the castrato from the statue that the young
sculptor has carved in the image of his beloved. In this story,
the dazzling image of a woman's beauty appears, and is
eclipsed, only in the spaces between representations: 'La
Zambinella'; Sarrasine's carving of Zambinella; a replica of the
carving; a picture of Endymion based on the replica; and the
anecdote that the painting prompts, which is the beginning of
Balzac's tale.

 In another text by Balzac, an ageing painter secretly strug-
gles to complete the image of the most beautiful woman that
might ever be conceived.[3] Wiser than Sarrasine, Frenhofer
does not imagine that perfection can be found in a human
being; the model that guides his brush lives only in the
circumvolutions of his feverish mind. A lovely and living

woman is brought into the tale only to allow the Master to assert the superiority of his own creation over the imperfect work of nature.

We may suppose that neither Balzac's Sarrasine, nor his Frenhofer, would have disagreed with Plato's Hippias, who, when it seemed that the debate with Socrates on the nature of beauty had unsatisfactorily exhausted all possible form-ulations, sought to bring the argument to a triumphant and irrefutable conclusion: 'For rest assured, Socrates, if the truth must be told, a beautiful maiden is a beautiful thing!'[4] Nevertheless, in their quest for an absolute beauty, both Sarrasine and Frenhofer are drawn, ineluctably, to close their studio doors to the presence of living flesh, and to withdraw into their private acts of carving and painting. Like the arguments in the *Hippias Major*, their deliberations come to no definite conclusion. Sarrasine completes the petrified replica of Zambinella, his 'beautiful mistress', only to attempt to destroy it in despair. Frenhofer's 'Belle Noiseuse' reveals only a single foot, albeit a 'delectable' one, emerging from layer after layer of paint, beneath which the rest of her body will remain perpetually interred.

But why begin an essay on the beauty of the woman with a tale about an exquisite castrato – a tale in which, in effect, no woman appears? Why begin with the story of a failed paint-ing, which was intended to depict the most beautiful woman imaginable, but which, finally, shows no woman at all? Precisely because each tale is a *mise-en-scène* of that absence of the 'real' woman that is the necessary support of the attri-bution of beauty. The cancelled sex that 'La Zambinella' conceals beneath a richly embroidered dress, and the indeter-minate sex of the body that Frenhofer smothers beneath encrusted layers of pigment, are allegories of the misrecog-nition and undecidability on which beauty subsists. It is in this confused space of barter between the woman and her rep-resentation that I wish to site my own discussion of beauty. However, I should first make clear that it is not my intention to construct a simple opposition between the 'real' woman and the 'unreal' images made of her – or to attempt a simple ruling between truth and falsity, nature and culture, reality and representation. Distinctions of this sort provided the initial basis for a feminist contestation of 'images of women' – in cinema, in advertising, and so on – in the early days of the

resurgence of the women's movement in the 1970s. At that time, the primary political reaction was against the merchandizing of the female body – represented quite literally by prostitution, but extended by analogy to the use of the female body as a marketing tool. A 'just anger' fuelled the early contestations, but anger alone came to be seen as insufficient to an understanding of the roots of the oppressive state of social relations.

The issue of beauty, as such, played little part in the initial feminist debates about 'images of women'. Nevertheless, it formed the backdrop against which the debates were staged. The anger directed towards advertising, for example, was basically in protest against a world of representations – in particular, the representation of a world in which a woman was young and 'beautiful' or she was nothing. The close-cropped heads, the burned bras, the functional overalls and the eschewal of make-up which characterized the *appearance* of feminism in the 1970s, represented the will to eject 'beauty' (seen as an oppressive male cliché) from the world of women.

The magazine *Spare Rib*, an important index of feminist positions of the time in Great Britain, put pictures of women on its covers – just like mainstream women's magazines such as *Cosmopolitan*. However, the women on the covers of *Spare Rib* were not the unreal confections of male 'glamour' photographers; on the contrary, they were intended to portray *real* women. This presented women photographers of the period with a fundamental question: what does a 'real' woman look like? As a photographer friend of mine remarked, the answer provided by *Spare Rib* was that a real woman was 'middle-aged and very badly lit'. Bringing the marginalized majority of women into representation, although a political imperative, did not itself solve the problem of beauty – unless, that is, one took the position that the problem *could* be resolved by simple fiat.

Such a position was in fact taken, and is held to this day by many women who write about beauty. For example, Tolmach Lakoff and Rachel L. Scherr state: 'Women must reclaim beauty, somehow, as something that is their choice and their judgment – not in the eye of the beholder, but in the mind of the beauty.'[5] Lakoff and Scherr's 'somehow' poignantly betrays the uncertainty of their voluntarism. Be it repressed, disavowed or denied, beauty remains a problem for a woman.

Freud observed that no man escapes castration anxiety; without making any theoretical claim for the analogy, it seems to me that, at least within the so-called developed Western world in which I am situated, no woman escapes 'beauty'. Unavoidably, from her earliest years, beauty will be either attributed or denied to her. If she does not have it, she may hope to gain it; if she possesses it, she will certainly lose it. But what exactly is 'beauty'?

Common sense has it that beauty is simply an 'attribute' of an object, or is an equally unproblematized 'universal'. On the one hand, the wish to pin down the attribution of beauty to a set of features leads to the impasse of tautology; on the other hand, the intuition that beauty has an existence *beyond* the confines of circular definitions opens the way to a metaphysics of universality. And it is in the name of universal values that, historically, women have been both despised and revered. The anguished sense of inconvenience that the contingent bearer of an attribute of universal value should also be a living being, is communicated well in Villiers de l'Isle-Adam's novel of 1889, *L'Eve Future*:

> The only misfortune that has befallen Miss Alicia is thought!
> . . . If she were deprived of all thought, I could understand her. The marble *Venus*, in fact, *has nothing to do with thinking*. The goddess is veiled in stone and silence. From her appearance comes this word: 'I am Beauty, complete and alone. I speak only through the spirit of him who looks at me. In my absolute simplicity all thought defeats itself since it loses its limits. All thoughts sink together in me, con-fused, indistinct, identical, like the ripples on rivers as they enter the sea. For him who reflects me, I am the deeper character he assigns me.'
> This meaning of the statue, which *Venus Victorious* expresses with her contours, Miss Alicia Clary, standing on the stand beside the ocean, might inspire as her model – if she kept her mouth shut and closed her eyes.[6]

A woman may be privileged to be the bearer of Universal Beauty itself, on condition that she shuts her mouth and closes her eyes. Moreover, Lord Ewald's references to the *Venus Victorious* (which we know today as the *Venus de Milo*) imply that by closing *his* eyes he might see Alicia's beauty all the better. In Carl Spitteler's autobiographical novel *Imago*,

'Imago' is the name that the hero of the story gives to his idealized mental representation of his beloved – unfortunately, for him, an obdurately real and unobliging young woman by the name of 'Theuda'. No less than Alicia, Theuda keeps her eyes open, and does not always keep her mouth shut about what she sees. Undeterred, the love-sick young man re-names Theuda, 'Pseuda'. In a letter to a (woman) friend, he explains that he has forgotten the names of all the 'terrestrial women' he has known except for one: 'I have retained only one name: Pseuda, named X, the little one, the infidel who has afflicted Theuda and made Imago ill.'[7] It is true to say then – quite simply – that it is an imago of the woman that the Sarrasines and Frenhofers sculpt, paint and photograph. (What is a 'model', after all, if not a woman who keeps her mouth shut so the artist may see her better with his mind's eye?) It would be true to say this, but it is not quite so simple as that. We would have learned nothing by simply renaming the problem.

This essay is an attempt to talk about the problem of beauty – which is at one and the same time a theoretical problem, and an everyday problem for me as a woman. I do not, however, wish to speak in the terms which have been employed to date. I take it as self-evident that the use of 'beauty' as the sole measure of the worth of a woman is contemptible. I also assume it to be obvious that such a criterion nevertheless continues to be paramount in our postmodern, post-colonial and so-called post-feminist society. I further take it as demonstrated, and understood, that what is considered beautiful in a woman varies between historical periods and between cultures.[8] I therefore intend neither a history nor an ethnography of beauty, much less a historically retrospective and cross-cultural account of what, from this particular culture at this moment in time, I myself see as constituting beauty in a woman.[9] I am not so concerned with the objects of the attribution 'beautiful', as I am with the act of attribution itself. I subscribe to the old saying, albeit now worn smooth of meaning through endless use: 'Beauty is in the eye of the beholder'. But I shall not be content with the complacent relativism implied by this adage. I am interested in the psychical apparatus to which the beholder's eye is attached; that is to say, I am interested less in the contingent object of desire than the fantasy which frames it.

To speak of fantasy signals that psychoanalytic theory provides the methodological framework for my investigation. My point of departure is my intuitive conviction that 'beauty' is not a singular thing, but is rather the generic term for an unspecifiable number of disparate experiences. Since formulations of feminine beauty by men appear to be largely unselfconscious, I take the step of supposing that they might indeed be *unconsciously* motivated – as is suggested by the very endurance of the fantasy of beauty in the face of one hundred years of feminist common sense. In other words, the variety of formulations of what is recognized as beauty in a woman would correspond to a variety of (mainly) masculine *symptoms*. (The term symptom here has to be understood in the fully psychoanalytic sense of the word, as indicative of a repressed past.)

A glance at the psychoanalytic literature on beauty, however, produces only that which appears already familiar. In *Three Essays on the Theory of Sexuality*, for example, Freud writes: 'There is to my mind no doubt that the concept of "beautiful" has its roots in sexual excitation and that its original meaning was "sexually stimulating". This is related to the fact that we never regard the genitals themselves, which produce the strongest sexual excitation, as really beautiful.'[10] Later in his work, this idea is simply repeated; for example, in *Civilisation and its Discontents*, he says: ' "Beauty" and "attraction" are originally attributes of the sexual objects. It is worth remarking that the genitals themselves, the sight of which is always exciting, are nevertheless hardly ever judged to be beautiful; the quality of beauty seems, instead, to attach to certain secondary sexual characters.'[11] In a long footnote to this essay, Freud invokes the vicissitude of an original olfactory attraction to the genital zone, which has fallen foul of the exigencies of the so-called civilizing process. In the animal world, smell is often the predominant means of sexual attraction. As the human animal began to walk erect, it turned its nose away from earthly odours, and the sense of sight came to predominate. To the extent that the human animal became progressively 'civilized', even the sense of sight turned away from the genitals and towards other parts of the body. In a chain of civilizing displacements then – from 'animal' to 'human' – we have shifted from seeing and smelling the genitals, to seeing the genitals, to seeing anything *but* the

genitals, to repudiating the genitals entirely as an object of interest (even so far as finding them disgusting and ugly). Freud speaks here of an 'organic repression as a defence against a phase of development which has been surmounted',[12] and from which there derives the taboo on menstruation. Thus, in an historical 'reversal into the opposite', that which formerly attracted has now become repellent. In this scenario, the instinctual energy which had once fuelled an unambivalent interest in the genitals is now displaced upon the line of a cheek, or the colour of an eye. Freud writes: 'The genitals themselves have not taken part in the development of the human body in the direction of beauty: they have remained animal, and thus love, too, has remained in essence just as animal as it ever was.'[13] It is not my purpose here to decide upon the merits of this, or any other, evolutionary model. Contrary to some prejudices, instinctual origins are of little account in psychoanalysis; what is found at play in the analytical experience is rather, in a Lacanian formula, 'the instinct alienated in a signifier'.[14] In a well-known analogy, Ferdinand de Saussure remarked that we need not know the history of the moves in a chess-game in order to describe the current state of play.[15] Neither do I feel the need to seek the roots of beauty in some originary instinct. Strictly, what Freud had to say about the possible origin of the experience of beauty in the cultural perversion of a purported state of nature lies outside the domain of a psychoanalytic enquiry. What then, if anything, *may* be said about beauty within the terms of psychoanalytic theory? The answer, I believe, lies under our nose.

Freud states, bluntly: 'The science of aesthetics investigates the conditions under which things are felt as beautiful, but it has been unable to give any explanation of the nature and origin of beauty, and as usually happens, lack of success is concealed beneath a flood of resounding and empty words. Psychoanalysis, unfortunately, has scarcely anything to say about beauty.'[16] And yet, later in the same essay, Freud suggests that, 'The love of beauty seems a perfect example of an impulse inhibited in its aim.'[17] He thus points us to the fantasmatic dimension of the experience of beauty. It is a dimension in which we turn from the object of instinct (*Instinkt*) to the object of 'drive' (*Trieb*); from the possibility of a punctual satisfaction of need, to the impossibility of fulfilment

of desire; it is a dimension in which desire, forever invoking interdiction and loss, is articulated in processes of defence and the production of symptoms. Thus, when Freud stated, 'Psychoanalysis has scarcely anything to say about beauty', he might well have added: *'other than everything psychoanalysis has already said'* – about the vicissitudes of the instinct, the unconscious, and the formations of fantasy. Fantasy is, after all, 'the fundamental object of psychoanalysis'.[18] To speak of 'fantasy' is to invoke, beyond the spectacle of the isolated 'beautiful' object, the scenario in which that object figures – a *staging* of the 'aesthetic' emotion. What follows, then, is an attempt to describe the *mise-en-scène* of 'beauty', not in any abstract, purportedly 'absolute', sense, but in a particular field of representations – that of the beauty of the woman.

Most of my text is concerned with an etiology, no doubt incomplete, of the symptom of 'beauty' as it appears in images made by and for men. To be more accurate, I should say *symptoms* of beauty. Characteristically, symptoms 'erupt': it is not in the nature of the symptom to take its place in an orderly queue. Correspondingly, the form in which my chapters unfold tends to be episodic: more a 'montage of attractions' than a 'realist narrative', or even 'case history'. In identifying the various instances of the attribution of beauty which comprise the topics of my chapters, I paid attention to my everyday experience. I noted which formulations of beauty returned most insistently. I make no claim that the same formulations impress themselves on the attention of all women equally; I can only describe what I myself found. To say that I found these formulations in my 'experience', however, is not to claim that I encountered them 'raw', as brute and irreducible 'facts'. My everyday impressions can only take form, be made tangible, by way of representations. Just as my experiential point of departure is in the present, so the visual and verbal representations to which I shall refer, and through which I hope to give form to my experience and intuition, are also located in the present. I wish to emphasize that in referring to a text written, for example, in the Renaissance, I intend to make no historical claim about the Renaissance. It is entirely consistent with my analytical project that I take the text 'out of context' – out of its own historical context and *into my own* – for that is precisely the way in which I encounter it. It follows that I am interested in such fragments

from disparately distant moments in history only to the extent that they are actively integrated into the present.

Just as I am, in the following pages, informed by psychoanalytic insights and theories, so I am inspired by the example of 'psychoanalytic attention'. The analyst has less interest in the historical accuracy of what the analysand reports, and more interest in its import in the present. Nor does the analyst enter into arguments with the analysand about the overt content of what is said, but rather listens to what is 'between the lines', or unspoken. Again, the analyst is as attentive to a banal cliché as to a speech which carries all the discursive trappings of 'weightiness', and is attentive even to those 'resounding and empty words' of which Freud spoke. My essay is, in a sense, a 'Remembering, Repeating, and Working-Through'.[19] I stated at the outset that the point of departure of this essay is my own experience as a (White, European) woman in contemporary Western culture: I should add that this experience is often one of distress at the impossibility of beauty. Unavoidably, therefore, it is to this narcissistic dimension of the fantasy of beauty, in which *both* subject and object of the look are mutually implicated, that I return in the final chapter of my book.[20] This 'final' chapter therefore is not a conclusion: it is an 'exit' that returns me to my point of entry.

The visual images that appear in the following pages have a tangential, rather than direct, relation to my text. They are not 'illustrations', nor are they intended to represent past or present canons of feminine beauty. In selecting the images, I have tried to make the same displacement that I attempt in my overall argument: from attributes of beauty to the attribution of beauty. I have chosen these images not because they show beautiful attributes – we all know what these look like – but for their capacity to allude to the *mise-en-scène* of the attribution of beauty, to the staging of the symptom of beauty.

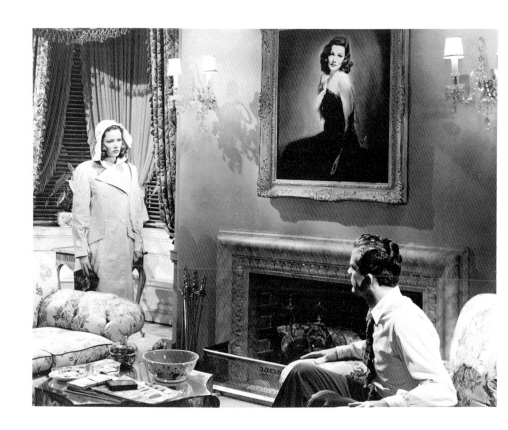

1 The portrait of Laura

> *It was a process not very different, he supposed, from thinking a girl was beautiful because she reminded you of a painting by Botticelli: if you had never seen the painting you would not have noticed her*
>
> J. G. FARRELL[1]

'Beauty (unlike ugliness) cannot really be explained', writes Roland Barthes. 'Like a God (and as empty), it can only say: *I am what I am*. The discourse, then, can do no more than assert the perfection of each detail and refer "the remainder" to the code underlying all beauty: Art.'[2] The girl in J. G. Farrell's novel is beautiful in so far as she invokes a painted simulacrum. Likewise, Stendhal asserts the beauty of Mlle Létourneau in a simile which refers her, and us, to a representation: 'Mlle Létourneau was a beauty of the heavy kind (like the figures in Tiarini's *Mort de Cléopâtre* or *Antoine*, in the Louvre).'[3] Beauty, as Barthes remarks, is 'referred to an infinity of codes'; to recognize beauty is to defer endlessly the question of its origin. Thus Barthes asks: '*Lovely as Venus?* But Venus lovely as what? As herself?' A question of origin, then, of the *model* – a question which Diderot, two centuries earlier, had put to the artist, somewhat condescendingly, and to which the artist had replied, somewhat inadequately:

> —Well, to answer without torturing my mind too much, when I want to make a statue of a beautiful woman, I have a great number of them undress; all offer both beautiful parts and badly shaped parts; I take from each what is beautiful.
> —And how do you recognize what is beautiful?
> —Obviously, from its conformity with the antique, which I have thoroughly studied.
> —And if the antique did not exist, how would you go about it? You are not answering my question . . .[4]

The artist is lost for words. 'Deprived of any anterior code, beauty would be mute', declares Barthes.[5]

When Sarrasine, struck by the beauty of 'La Zambinella', declares her to be 'a masterpiece', he confirms the conventional equation of beauty with art: 'With his eyes, Sarrasine devoured Pygmalion's statue, come down from its pedestal.'[6] With this step, we pass from simile to metaphor: 'La Zambinella', who is 'like' nothing on earth, simply *is* the incarnation of the mythical statue. 'To discover the body of La Zambinella', Barthes comments, 'is to put an end to the infinity of the codes, to find at last the origin (the original) of the copies . . .'[7] The origin of the copies (of which there are many in Balzac's tale: the painting, of the marble replica, of the statue, of Zambinella) is not a living model, but a work of art – an appropriately mythical masterpiece. In the passage from simile to metaphor, we arrive at the coincidence of the woman with the cultural product, which indeed, to cite the otherwise loquacious Sacha Guitry, puts an end to the discussion: 'Is there anything more ravishing than the entry of a woman, a beautiful woman, in a salon? There we were, three men, freely conversing, without constraint, surrounded by *objets d'art*, paintings, and in a cordial atmosphere. She entered. The conversation fell in pieces, the paintings effaced themselves, the *objets d'art* retreated into shadow . . .'[8] In the implicit comparison, here, between the living woman and the work of art, the woman triumphs over the art objects and takes their place as the object of the contemplative gaze of the assembled men. This is not a triumph of nature over culture, it is rather the assertion of the *masterpiece* over mere daubs. It is a triumph, however, which can only be momentary. The event Guitry describes is a snapshot, taken in the blink of an eye, framing the woman in the doorway; after a moment the woman, and the conversation, will move on. Such a finding of the original can only be followed by disappointment. The fiction of the coincidence of the woman and the work of art cannot be sustained.

For the seventeenth-century antiquarian and biographer, Giovanni Pietro Bellori (reflecting on the beauty of Helen of Troy), there was simply no possibility of an adequate living model: the attribution of beauty necessarily required that the woman be replaced by a work of art. Bellori could not believe that the bloody war of Troy could have been fought over a woman of flesh and blood. He reasoned: All products of nature contain 'defects and shortcomings'; Helen was a

product of nature; therefore, Helen was flawed. He deduced from this that, in reality, the Trojan War must have been fought over a *statue* of Helen.[9]

Bellori's logic is consistent with a long Western philosophical tradition, which has tended to subsume the idea of beauty to notions of measure and order. For Plato, at the inception of this tradition, *measure* is the defining principle of the good and the beautiful. Measure is the determination of appropriate relationships through knowledge of proportion and of the mean; it forms the Ideal standard to which all creation that aspires to beauty must conform, and is the rational ground on which all judgement of beauty must rest.[10] For Aristotle, 'the chief forms of beauty are order and *symmetry* and *definiteness*.'[11] For St Augustine, beauty is a product of the unifying principle of *number* – 'number' here meaning, at once, mathematical proportion, rhythmic organization and fittingness of parts (in both elements of the object and faculties of the soul).[12] Ficino finds beauty in the agreement between matter and Idea, as in 'the appearance and shape of a well-proportioned man'.[13] To see beauty in nature is to recognize a harmonious design (which, in the religious version of the argument, represents the imprint of a divine mind on otherwise formless matter). Even when Kant eventually frees beauty of abstract concept and moral purpose by asserting the principle of a 'disinterested delight', or 'restful contemplation', beauty nevertheless remains inextricably bound to the *a priori* laws that govern understanding (common sense). Beauty presents that clarity of delineation which for Kant is 'the essential thing' in all the formative arts.[14] The beauty of nature, like a work of art, proclaims its subjection to this representational principle.

Early in the twentieth century, Benedetto Croce wrote: 'The phrase "natural beauty" properly refers to persons, things, and places whose effect is comparable to that of poetry, painting, sculpture and the other arts . . . the lover's imagination creates a woman beautiful to him and personifies her in Laura.'[15] The particular lover's imagination to which Croce refers is that of the twelfth-century poet Francesco Petrarch. But we must be precise here: Petrarch dedicated his two laudatory sonnets not to an actual or imaginary woman, but to a *portrait* of Laura, painted by Simone Martini:

Even if Polyclitus were to gaze intently, on trial
with the others who had gained fame in that art,
not in a thousand years would he see the least part
of the beauty which has conquered my heart.
 But certainly my Simone was in Paradise
whence comes this noble lady;
there he saw her, and portrayed her on paper
to give witness, here below, to her fair face.
 The work was indeed one conceived
in heaven alone, not here amongst us,
where the body veils the soul.
 It was a courteous deed, nor could he do it
once he descended to feel heat and cold
and his eyes sensed only mortal things.

When Simone, to the noble idea
given him in my name, added his manual skill,
if he had endowed the fair work
with voice and mind, as well as form,
 he would have freed my heart from many sighs
that make what others hold dear seem vile to me:
for in appearance she looks humble
promising me peace in her expression.
 But when I come to speak with her,
she seems to listen very graciously:
if only she could reply to my words.
 Pygmalion, how happy you must be
with your image, since you obtained
a thousand times what I long to have just once.[16]

Having praised the artist who has portrayed such beauty,
Petrarch laments the impassivity of the painted woman: 'if
only she could reply to my words.' Some two hundred years
later, in an almost perfect repetition of Petrarch's gesture,
Pietro Bembo wrote two sonnets about Bellini's portrait of
Maria Savorgnan – an image which proves no less impassively
indifferent to the plea of the lover-poet. In the case of Bembo,
however, as Mary Rogers has noted,[17] the poet addresses the
portrait with a directness that was absent from Petrarch's
sonnets. With Bembo, the oscillation between admiration for
the image and frustration at its impassivity, the confusion
between the discourse on art and the discourse of desire, blurs

the distinction between sign and referent. The desire of the amorous poet is for an image. Unlike a living woman, an image would not be able to evade him: 'At least, when I look for you, you do not hide.'[18] The image, then, promises the peace of undisturbed possession to the tormented lover; as image, the fair tormentor has been captured and disarmed. But although it is an image whose beauty even nature envies, it remains inert, and the poet passionately wishes – to the point of hallucination – that, Pygmalion-like, he might bring it to life: 'And truly it seems to me that she speaks with me, and I with her.'[19]

ફ✒

Although, in his consideration of Helen of Troy, Bellori's argumentative substitution of the work of art for the woman is consistent with a philosophical tradition which equates beauty with an abstract perfection of form, his unequivocal separation of imperfect flesh from flawless artefact is nevertheless unusual. The Petrarchan address, in its subsequent transformations from Bembo to Croce, is more typically ambivalent: at once a discourse of desire, and an appreciation of the artist's skills in giving lasting substance to the ideal, ethereal, object of desire. It is this confusion of mortal beauty with art which (dis)organizes Kenneth Clark's thinking in his book entitled *Feminine Beauty*.[20] In effect, the book is a chronologically structured commentary on a long history of beautiful women, beginning with a carved head of Queen Nefertiti, and ending with a photograph of Marilyn Monroe 'doing a high kick on the beach'. There is no doubt in Clark's mind that, as far back as art history will reach, it was the beauty of the real woman which motivated the artist to paint or carve those portraits; he has no doubt that beauty was out there all along, in the real, waiting to be discovered. Clark even gives us the date and place of 'the discovery of feminine beauty': the second millennium BC, in Egypt. In a familiar displacement, however, Clark's discourse of appreciation of feminine forms slides into a discourse on the merits of the work of representation – a shift already implicit in the publisher's decision to commission a book on 'the concept of feminine beauty' from a well-known *connoisseur* of art. So, for example, Clark writes about, 'the exquisite painting of the

Countess Howe's silk and lace dress, its sophistication and effective contrast to the rustic landscape setting' – and the woman fades beneath the intricate lace of paint and painted plants. Again, he writes of the 'statuesque ideal of feminine beauty' of Guido's figures, 'classical in origin', which, 'form a graceful and flowing composition' – and the beauty of Venus is displaced by the mastery of the painter which, in turn, evokes that of the sculptor. The painted myth is a *statuesque* beauty, and thus twice subject to the work of representation. Clark writes of 'the skill and truthfulness' with which Veláz-quez painted the 'Rokeby Venus' – an emblematic example, and a candidate for inclusion in the pantheon of mythical beauties – whose beauty thus becomes a *tour de force* designed to elicit our 'admiration'.

Kenneth Clark's discourse on female beauty is in direct line of descent from the sonnets describing the portrait of Laura. Moreover, the fact that his book sits unproblematically in the mainstream of modern publishing attests to the extent to which Petrarch's sonnets, and the broader context of assumptions which inform them, have contributed to the foundations of a contemporary doxa. The tradition must, therefore, be of more than historical interest to us, and merits some closer consideration. Here, it is instructive to examine the very form in which beauty is praised. In an essay of 1979, examining the status of all the 'Lauras' of fifteenth-century poetry, Mario Pozzi has traced what may be called the 'evacuation' of the woman to the level of the poetic discourse itself.[21] Pozzi finds no simple prioritization of a painted or sculpted portrait over the living woman, but rather an *undoing* of the woman in the very act of writing about her. Renaissance poetry about beautiful women evolved out of the late medieval models of the *canone lungo* and the *canone breve* – whose exponents included Boccaccio and Petrarch. These forms, in turn, rested on Classical models. When Boccaccio described the beauties of Emilia,[22] he was following specific rules of enunciation, first elaborated in Classical antiquity, but which had since been formalized into a 'system of feminine beauties'. Primarily, these rules concern the order of enumeration of the physical features, and the choice and use of metaphors. For example, physical attributes should invariably be described beginning from the head and working downward; metaphors should be used only to refer to the noblest parts of the body – the upper

part of the head and the breast – and should be selected from a given, fixed, repertoire. In the work of Petrarch, for example, the number of anatomical parts mentioned is restricted to a few sanctioned physical features; some are selected from the head, and one other only from either the neck, the breast or the hand. From its earliest beginnings, then, the depiction of the Renaissance body was governed by a unifying set of regulations which produced the effect, across the poetry of the period, of a highly stereotypical feminine beauty.

The intention was not simply to construct a highly selective representation, it was also to convey actual observation. Alberti was teaching at this same time that beauty is to be found in nature only in a dispersed form, and it is therefore the task of the artist to assemble the fragments so discovered into a harmonious whole, in accordance with an 'idea of beauties' that exists only in his mind (a procedure, of course, already hallowed in the mythic tale of how Zeuxis made his portrait of Helen of Troy). From the physical world, the Renaissance poet might choose fair hair, brown eyes, red lips, white skin, and so on; but whatever coherence these fragments achieved could only be that of the enunciative structure of the poem itself. Most visibly in the *canone lungo*, which took as its object the entirety of the feminine body, the woman comes into 'being' in the unswerving linearity of an enumeration from the head downward – a linearity which, again, does not translate any actual perceptual experience, but rather reflects the desire to *construct* a unified image from disparate, albeit privileged, fragments. And yet the beauty revealed as the enumeration unfolds seems condemned to fragmentation – not only the fragmentation which is inherent in any linguistic construction (as a 'concatenation of signifiers'), as opposed to the apparent 'seamlessness' of the painted image, but also that fragmentation inherent in the poetic structure itself. The admired lady effectively vanishes; in her place, 'there remains only the fleshy and almost brutal mass of the list.'[23] The systematic listing of parts progressively takes over the poetic space, and the substance of the feminine body yields to the actuality of the enumeration; attention shifts from the object described to the *process of describing* – a displacement that twentieth-century formalism would later valorize as the 'foregrounding of the device'.[24]

The *canone breve* (an appreciative description of the upper

part of the feminine body in accordance with the Petrarchan model) sought to solve the problem of the verbal representation of such a conspicuously visual referent by bringing concerns with symmetry and proportion to the poetic structure – concerns which also dominated the visual representational practices of the Renaissance.[25] Implicit in this appropriation of visual strategies by poetry was the wish to free the poetic portrait from the linearity of discourse, in which each word fades in the wake of the next. The aim was to organize an imaginary space that would give an impression of continuous substance to the depiction. Henceforward, the feminine body takes shape in a careful organization of linguistic elements in patterns of alternance, repetition and mirroring – the effect of which, however, does not evoke the actual forms of the woman's body so much as it recalls the formal procedures of drawing and painting. Furthermore, there also existed a semantic structure which obeyed the same rules of symmetry and proportion as the formal structure of the poetic signifiers; for instance, metaphors were often selected and arranged so as to create a pattern of correspondences not at the level of the signifiers, but at the level of the signifieds – the level of visualization.

The use of metaphors in the depiction of the feminine body was a privileged means of lending substance to the linguistic portrait. For each select fragment of the woman's body there was to be found a corresponding metaphor, or set of metaphors, motivated by primarily visual attributes. These attributes were often perceived as real: for example, 'splendour' was ranked alongside 'colour'. The 'brilliance' of the woman's eyes was likened to that of the sun or the stars; her hair was compared to gold; her cheeks to white roses, or snow; her lips to pearls, coral or rubies; her breast to milk or marble; and so on. Pozzi sees the beauty thus evoked as a kind of 'still-life' – an assemblage of essentially heterogeneous elements.[26] Although overt references to the actual tactile attributes of the body were comparatively rare,[27] the overabundance of metaphors nevertheless succeeds in producing the impression of palpable matter. The body it produces is one of cold metal and stone, of ice-crystals that melt at the touch of the lover's hand; or of a liquid body, food to the lover's lips; and so on. As Lecercle comments: 'The "hair of gold", far from compensating, through its suggestive power, for the "lack in seeing" of

writing, produces a contrary effect: rather than increasing the effect of the real, it insidiously undoes it'.[28] This effective evacuation of the feminine body was most fully achieved in the evolution of these sonnets, from the fourteenth century onwards, into a concatenation of brute metaphors, that were divested of any taint of simile, or of any relation to their supposed referents. Thus, Pontus de Tyard waxes: 'This thread of gold, this marble, this ivory';[29] and Ronsard echoes: 'This beautiful coral, this marble which sighs.'[30] What remains here is nothing but brute substance, not only of the elements listed – a heap of raw materials, gold, coral, marble, ivory, to which it is now difficult to assign any definite reference – but also of the metaphorical repertoire itself. The poem becomes nothing more than a laying out of the materials from which a poem may be made. What we are left with is no longer a description of the feminine body, but rather a discourse in the process of representing *itself*. In a variation of the genre, 'comparant' and 'compared' are linked not by a relation of analogy, but by a relation of cause and effect. For example, in a poem by Magny, we read: 'With the finest gold that ever was polished, was this long hair thus gilded/With the whiteness of beautiful lilies, was this ruby complexion skilfully endowed.'[31] What orders these lines is neither simile nor metaphor: we are not told that the hair is like gold, nor is the word 'gold' simply substituted for the word 'hair'. Hair is rather stated as being literally *gilded with* the 'finest gold'. In one reading of this poem – one 'viewing' of the scene it depicts – what unfolds is the metaphorical *act* itself (as in a painting of Daphne caught in the very moment of her transformation). In another reading, the process we witness is one of incarceration, of internment, as a living being is progressively enclosed within a precious casing, a gilded and lacquered shell.

In concluding that the Trojan War must have been fought over a *statue* of Helen, Bellori did no more than make explicit what was implicit in the many poems of a century earlier which had celebrated with transfixed passion the beautiful female images that 'art' had created. Obstinately, however, the inconclusive imperfection of the woman's body reappears in the very structure of the language which attempted to celebrate her transfiguration by art. Here, for example, is Firenzuola's enumeration of parts of the feminine body in his *Dialogo delle bellezze delle donne*: 'Delli occhi, Delle ciglia, Del

naso, Delle guancie, Della bocca, Dei denti, Del riso, Del mento, Degli orecchi, Della gola, Delle braccia e mani, Del Petto, Della gamba, Del piede, Dei capelli.'[32] The form of the incantation guarantees an endlessly spiralling circularity of the descriptive gaze (an endless evasion of what must not be seen and cannot be spoken). It is a description of the feminine body that never amounts to a full picture (the gaps in language marking the presence of censorship). Does this witness a failure of the poetic representation? Perhaps, but all representation is, after all, destined to failure. Is it a support and guarantee of a sustained voyeuristic gaze? Certainly, but this is not all. These poetic discourses on the beautiful woman suggest something more; in the guise of a celebration of the feminine body they in fact celebrate the act of *creation* itself. The desperate failure of the lover-poet is in his attempt to rival Pygmalion, whose mastery of his medium allowed him not merely to imitate, but to create, a woman in the image of his desire.

As he fashions his ideal out of the cold brilliance of precious stones, the poet himself undergoes a metamorphosis:

> And from where this heart? From a rich diamond
> Which dazzles me, and in an instant provokes in me,
> tormented, a thousand metamorphoses.[33]

As Lecercle remarks: 'And the final "thousand metamorphoses" of the transfigured lover evoke . . . the *power* the lover-poet has to transform at will the body of his lady into all the treasures of the Orient.'[34] Description, enumeration, assemblage, metamorphosis – movements which suggest a desire to remain locked in the *act* of making, to prolong the pleasure in the imaginary domination of the actual. I am again reminded of the ageing master Frenhofer,[35] secluded for ten years in the obsessive gesture of retouching the painting which was to be his masterpiece: the portrait of a woman whose beauty no living woman could match; the portrait of the most exquisite form imaginable which, when it was finally unveiled, revealed nothing but coarse layer upon encrusted layer of paint – not the woman, nor the work of art, but the *work* of art.

From Bembo to Clark is but a step. From Petrarch's Laura it is no great distance to the Laura of Vera Caspary's novel, and to Otto Preminger's film adaptation of that novel.[36] The voice

of the poet gives way to that of the detective, obsessed by the image of the woman whose murder he is investigating. Haunted by the portrait of Laura, and under her painted gaze, he methodically searches the dead woman's rooms: fingering her belongings, lightly touching the soft skin of her garments – the enigma of this woman's death becomes inseparable from the enigma of woman. The detective's desire to solve the case becomes his desire to restore substance to a phantom. In Laura's apartment, mentally and physically exhausted, rather drunk, he falls asleep in an armchair, and wakes abruptly to a violent storm:

> 'Thunder crashed again. Then I saw her. She held a rain-streaked hat in one hand and a pair of light gloves in the other. Her rain-spattered silk dress was moulded tight to her body . . . My voice told me that I was alive. I jerked myself out of the chair. The girl backed away. The picture of Laura Hunt was just behind her.'[37]

Behind the woman there is, always, the image to which the question of her beauty must be referred. *As beautiful as. . .* Hence desire reaches beyond mere flesh to painted perfection, which, impossibly, it wills to become flesh – and more than flesh. After ten years confined in his studio, in search of the most perfect feminine beauty, the painter Frenhofer sighs: 'Yesterday, as night approached, I thought I had finished. Her eyes seemed moist, her flesh was restless. You could see movements in the tresses of her hair. She was breathing!'[38]

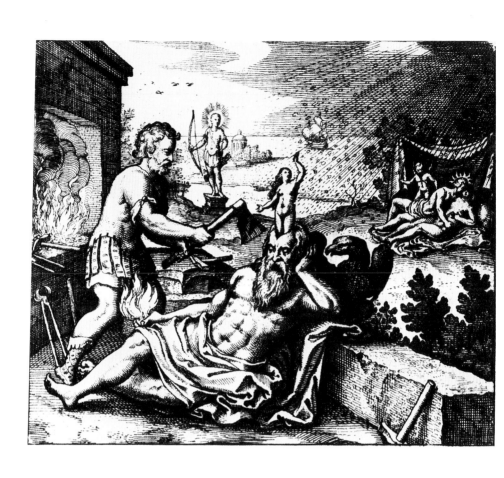

2 The imaginary companion

ễ *This, at last, is bone of my bones and flesh of my flesh*
 Genesis 2: 23

Bellori believed that the Trojan Wars were fought over an
inanimate work of art: an imperfectly human Helen could
hardly have provided sufficient provocation for such bloodlet-
ting. The protagonist of Lester del Rey's science-fiction story,
'Helen O'Loy', encounters an animate perfection: 'I can still see
Helen as Dave unpacked her, and still hear him gasp as he
looked her over. "Man, isn't she a beauty?" She was beautiful,
a dream in spun plastic and metals, something Keats might
have seen dimly when he wrote his sonnet. If Helen of Troy had
looked like that, the Greeks must have been pikers when they
launched only a thousand ships.'[1] Tales about the creation of an
artificial woman are spun from disappointment with the
imperfection of real women. It is his disgust of prostitutes
which impels Pygmalion to retire from the world of the living
and – confined in his self-inflicted solitude – carve a statue
'lovelier than any woman born'. Lord Celian Ewald, the failed
Pygmalion of Villiers de l'Isle-Adam's novel *L'Eve Future*, had
decided to end his days until Edison offered him another way
out of the world of the living: Edison's Hadaly, formed of
electricity and silver, is a perfectly improved replica of the
bewitchingly beautiful but hopelessly 'common' Alicia, whom
Ewald would but cannot love. The creation of Hadaly is a
gesture of reparation; the figure of this new Eve is erected as a
glowing monument to the men who have fallen foul of
deceptive appearances – Lord Ewald, and also Edison's friend,
Mr Anderson, who, enticed by the loveliness of a dancer,
leaves his wife and children, only to be himself later abandoned
by his mistress. Disappointment can easily turn to retribution.
In Fritz Lang's *Metropolis*, the replica is programmed to disrupt
and destruct. Its inventor, Rotwang, loved a woman who first
married another man, the Master of Metropolis, and who then
died while giving birth to a son, Freder.[2] (This founding

scenario of frustrated desire and loss was cut from the English version of the film.) Rotwang has carved a gigantic head of his beloved, a memorial he keeps concealed behind draperies in his house while he obsessively works on the creation of his robot – turning his master's command to invent a substitute for the human worker to the service of his desire to replace his 'imperfect' love. In E.T.A. Hoffmann's *The Sandman*, Clara is unable to show much interest in her beloved Nathanael's sombre poetry. As much as she tries, she cannot conceal her boredom whenever he insists on reading his verses to her. Nathanael soon forgets her for the unconditional, albeit literally wooden, attention of the lovely Olimpia.

In creating their artificial women, in loving them, these men push back the boundaries of the conceivable, unsettling the natural order of things. To tinker with the work of nature is to invoke retribution. Nathanael, Rotwang, Lord Ewald, Frenhofer, Dave, all meet an untimely end: a dizzying fall from the spire of a cathedral, from a tower; a lingering death shrouded in mourning, in madness; a sudden heart attack. It might seem, at first sight, that Pygmalion is the exception to the rule. Certainly, he 'lived happily ever after' – but only to have the retribution visited on his descendants. From his joyful union with Galatea, and the birth of their child Paphos, ensues the tragic love of Myrrha for her father Cinyra. Although, in historical time, this scene of incestuous desire unfolds a full two generations later, in narrative time it is but the turn of a page. The consummation of this illicit passion is duly punished by the gods, who turn Myrrha into a tree as, in mute agony, she gives birth to her child. This deferred and displaced punishment recognizes that to create an artificial woman is to give birth. Hadaly, Olimpia, Frenhofer's Belle Noiseuse, Rotwang's False Maria – all are the brainchildren of solitary geniuses. Immaculately assembled in laboratory or studio, they come to life at the throw of a switch, the turn of a key, the stroke of a brush. For the majority, the delivery is painless, and leaves only a bloodless detritus of metal filings, wood chips or paint. Rotwang alone suffers pain, losing his hand to the robot he had engendered – a 'poetic justice' which amounts to a symbolic castration. This punishment for having interfered with Mother Nature is, perhaps, a symbolic feminization of the man who has given birth.[3]

Such scenarios of male procreation are premised on the

exclusion of the reproductive woman. Of *Metropolis*, Roger Dadoun writes: '. . . let me point out the notable absence of any individualized, homogeneous, and named maternal figure'.[4] Of *The Sandman*, Max Milner writes: 'The feminine and maternal actor is missing . . . This erasure of the mother is to characterize the entire fantasmatic universe of Nathanael, to which neither Clara nor [her brother] Lothair will have access and in which the only possible woman will be Olimpia.'[5] Having forsaken his sweetheart for the taciturn love of Olimpia, Nathanael leaves the gentle world where the maternal principle reigns – he and Clara often sat in his mother's garden – to enter a disquieting universe of procreative men and wombless women. A virginal Maria leads the children into the Edenic Garden of *Metropolis* where she first meets the Master's son, Freder, engaged in lascivious frolicking with a young woman. When Freder falls ill, it is his father who is shown bending tenderly over him, gently stroking his face. Before descending into his underground dwelling, Edison telephones his children, 'for one's children, are really something'.[6] Of the children's mother, we are told nothing. Edison's friend, Mistress Anderson, has two children. Thrown into despair by her husband's betrayal of her, and his subsequent suicide, she becomes violently ill and enters a state of torpescent clairvoyance – a kind of transcendence of her sexual and maternal body. This new all-seeing being calls herself Sowana. It is Sowana who will engender that part of the android Hadaly which even Edison cannot fully understand: her soul. This soul is, in effect, a 'maternal gift', through which, as Peter Wollen has suggested, Hadaly in turn transcends her sterility.[7] However, to create a woman so beautifully perfect, is, strictly speaking, the business of minds – the business of men. The reproductive woman is excluded from that tightly closed circle. The backs of the three men grouped in front of Frenhofer's painting of La Belle Noiseuse – the most beautiful woman that there ever was – form a wall shutting out the living woman's distress.

These immaculate conceptions threaten to disrupt the relations between man and God. In taking it upon himself to engender life, man poses a challenge to his own creator. When Edison first reveals his project to Lord Celian Ewald, the young man considers the disturbing implication of such an undertaking: 'But, to undertake the creation of such a being

would be, I should think, like tempting . . . *God*.'[8] When the robot-maker Rotwang falls to his death, the Master of Metropolis falls to his knees, crying 'Praise God!'. To interfere with the workings of a higher originating principle is to position oneself on the side of the diabolical.

Concealed behind a curtain, the little boy Nathanael watches his father and the loathsome Coppelius attempting to form life out of the flames: 'Good God! as my father bent down over the fire how different he looked! His gentle features seemed to be drawn up by some dreadful convulsive pain into an ugly, repulsive Satanic mask. Coppelius plied the red-hot tongs and drew bright glowing masses out of the thick smoke and began assiduously to hammer them . . .'[9] God and Satan, good and bad fathers, in scenes of monstrous birth. From the splitting of the father figure comes the promiscuous coupling of the separated parts. Thus the gentle and loving father comes to resemble the terrifying Coppelius, whose satanic mask will be stamped upon the father's features at the moment of his violent death, and remain forever impressed upon the mind of the wretched Nathanael: 'On the floor in front of the smoking hearth lay my father, dead, his face burned black and fearfully distorted . . . Two days later when my father was placed in his coffin, his features were mild and gentle again as they had been when he was alive.'[10] It seems that the good father has triumphed in death, but only precariously: when Olimpia's creator, the debonair Professor Spalanzani, comes to retrieve his automaton from the passionate embraces of Nathanael, 'his figure had, as the flickering shadows played about him, a ghostly, awful appearance'.[11]

The Master of Metropolis is at once tyrannical ruler and loving father. As he enters the dark abode of the robot-maker Rotwang, he effectively crosses over into the diabolical, and becomes one with Rotwang, with whom he plots the downfall of his workers. In *L'Eve Future*, Edison is, at one and the same time, a zealous benefactor, attentive father and demonic genius who inhabits a disquieting world of shadows and electrical arcs – a crepuscular universe which will resound, for a brief instant, with the joyful voices of his children: 'Around the two searchers in the unknown, the two travelers into the shades, there burst from every side (thanks to some twist that Edison had given to a commutator) a joyful rain of charming

childish kisses, as of infants crying in their silvery voices: –
"Wait, papa! Wait, papa! Again! Again!" [12] His other child is
the android Hadaly, a veiled creature who dwells in subterra-
nean darkness.

Creators of feminine perfection, and those who have fallen
under the spell of their creations, inhabit an opaque reality on
the edge of everyday existence. Nathanael writes to his friend
Lothair: 'Thus, you see, I have only to relate to you the most
terrible moment of my youth for you to thoroughly under-
stand that . . . a mysterious destiny has hung a dark veil of
clouds about my life, which I shall perhaps only break through
when I die.' [13] Mistress Anderson, become Sowana, exists in a
state of perpetual clairvoyant torpor; companion and co-
creator of Hadaly, she lives in the android's subterranean
sojourn. Lord Celian Ewald will return to his dark and solitary
dwellings to lead, behind the high walls of his castle, a
secluded existence in the company of his tenebrous and
radiant Hadaly. But Hadaly is destroyed in a fire; as is the False
Maria, who is burned like a witch. La Belle Noiseuse goes up in
flames; Helen O'Loy goes up in smoke in a bath of acid.
Olimpia loses her eyes in the fight between Spalanzani and
Coppola. As for Galatea/Myrrha, she was incarcerated inside
the bark of a tree as a punishment for having loved her maker.

> Historically, then, we can conclude that as soon as the machine came
> to be perceived as a demonic, inexplicable threat and a harbinger of
> chaos and destruction . . . writers began to imagine the
> Maschinenmensch as woman
> ANDREAS HUYSSEN [14]

Fredersen, the Master of Metropolis, stupefied by the resemb-
lance of the robot to the real Maria, reaches out to touch her, as
if to verify the materiality of her being. Enter Freder, who sees
his father handling what he believes to be his own beloved
Maria. He faints. To read this scene as the re-enactment of the
primal scene, as suggested by both Roger Dadoun and Patricia
Mellecamp, [15] is to redefine the space of the tale in terms of the
confines of the Oedipal triangle. Elderly male creators, youth-
ful male lovers, and extraordinary women become the three
terms of the triangle – with one term, the woman, the desired

object, ever passing along its lines, between creators and lovers, between fathers and sons.

Maria is the good mother, the Virgin Mother who exists only in relation to the children: the worker's children, but also the workers themselves, infantilized in their adoration of their saintly preacher – as is the young Freder, who falls under the spell of her dazzling apparition in the Edenic Garden. When Maria, pointing to the assembled children, says to Freder: 'they are your brothers', she further asserts her maternal position by symbolically making him one of her children. Mother of all, Maria exists outside any specific family ties; she walks through the city unattached, and appears to inhabit every space, even the forbidden enclave of the ruling elite.

Below the soft appearance of the False Maria, within the metallic envelope, Rotwang has instilled a certain principle of unleashed feminine sexuality which he will control to his own ends. That ethereal presence which effortlessly stole into the fortressed garden of pleasure is now given a vibrant corporeality. The display of the female body during the 'dance of temptation' is the prelude to the tide of corruption that will sweep through the city. Mother of all, shrouded in whiteness, Maria casts off her veils and becomes whore, available to all: 'A large, glowing object, a sort of basin or cup, slowly rises. An enormous cover is raised, and the False Maria, splendidly dressed, slowly emerges. She spreads her veils, exhibits her almost naked body, and begins to dance. Her whole body revolves at a dizzying rate. . .'[16] The materiality of the robot, the rhythm of her movements during the dance of temptation, all echo the materiality and the rhythm of the Lower City – 'cogs and complex mechanisms that throb, churn, reciprocate, or rotate'. Roger Dadoun draws an analogy between the productive drive of Metropolis – 'pieces of machine working without either raw materials or finished products' – and the 'unknown and uncontrollable forces' of which Georg Groddeck spoke[17] and which Freud was to later theorize in terms of 'instinctual' energy (drive energy). It is possible to extend the analogy to the rotating form of the dancing robot; self-replenishing motion, perpetual motion – the False Maria is all raw energy.[18] Peter Wollen speaks of the technological replica as, 'The incarnation of destructive sexuality, seductive and spell-binding.'[19] The False Maria is a *femme fatale*; and, more fundamentally, this man-made machine is the embodiment of

40

'instinctual' forces – a kind of representative of the drive. She exhibits a sexuality which, in that it is *self*-reproductive, can be further defined as infantile. She is the *projected* embodiment of the dynamics of an early sexuality characterized by an unswerving pursuit of pleasure, a polymorphous sexuality which underwent repression in the child's passage to adult sexual organization. By the same token, she comes to represent the threat posed by the return of that repressed and desired sexuality, a threat from within – there is no outside to Metropolis – exiled in the 'other' body.[20] The False Maria drives the workers to rebellion. *'C'etait plus fort que moi.'*[21]

The robot Maria is a man-made machine, soulless, non-desiring, programmed to incite, to excite, 'mechanisms that throb, churn, reciprocate, or rotate', uncontrollable forces, unbridled sexuality; and yet she is regulated from the outset, and finally, by the repressive agency of the 'brain' embodied in the Master of Metropolis. The woman Maria is all reproduction and no sex; she is the Virgin Mother who gathers her children around her. Raised above the mass of workers, she preaches endurance. They gaze at her virginal figure, motionless, *fascinated*, pacified. Following the uprising, and having of their own accord come to their senses, the workers, docile army of robots, will resume their repetitive tasks in the Lower City; all reproduction and no pleasure. Repetition, continuity, order; the possibility of expressing any internal forces is repressed through the agency of a deadening sameness, a gratifying orderliness. Siegfried Kracauer speaks of the 'pictorial structure' of the final scene of *Metropolis*: 'the workers advance in the form of a wedge-shaped, strictly symmetrical procession which points towards the industrialist standing on the portal steps of the cathedral.'[22] In the geometrization of the crowds, Kracauer sees the 'indissoluble formations' of the dancing Tiller Girls, 'whose movements are mathematical demonstrations' similar to the motions of the conveyor belt: 'The hands in the factory correspond to the legs of the Tiller Girls.'[23] The riotous throng of workers is turned into an orderly group of decorative patterns, with Maria as the origin of their symmetry. The fascination with Maria belongs to the *order* of beauty, the beauty of order. Sacred and profane beauty: the fascination for the marshalled quietude of sublimated libidinal energy, as expressed through the woman; the allure of unrestrained libidinal energy, as expressed through

the technological double. If Maria is Mother Nature, then the False Maria is the blind force of Nature, the indifferent 'other side' of motherhood, 'a process without a subject'.[24] If Maria is the idealized mother of early childhood, the exclusive love-object of the narcissistic child, then the False Maria is the mother whose sexual attachment to another shatters the imaginary dyad – the mother become whore in the eyes of the violently jealous child. There is a scene in which the Master of Metropolis watches through the aperture in the wall, as Maria preaches to the enraptured workers below; amongst them, and more enraptured than any of them, is his son. Standing by the Master is the robot-maker Rotwang. This scene of exclusion from the space of maternal love culminates in the Master's command to give the robot the appearance of Maria. At the hands of Rotwang, Maria, Virgin Mother, becomes whore. The Master bends over his ailing child, tenderly touching his face, reclaiming the space of the maternal, reclaiming that exclusive attachment of one's early childhood.

ès

Scalpel in hand, Edison bends over Hadaly, lightly touching one of her rings. The feminine armour slowly opens:

> You are about to witness the birth of an ideal being, since you will be present at an illustrated explanation of the inner workings of Hadaly. Can you imagine a Juliet submitting to such an examination without causing Romeo to faint?
>
> Actually, if one could form a sort of retrospective moving picture of the woman one loves in her first physical manifestations, and *what she was like when she made her very first movements*, I imagine most lovers would feel their passion melt away into a sentiment where the Lugubrious would fight it out with the absurd and the Inconceivable.
>
> But the android, even in her first beginnings, offers none of the disagreeable impressions that one gets from watching the *vital processes* of our own organism. In her everything is rich, ingenious, mysterious. Look here.[25]

The repulsion one is likely to feel at the thought, or at the sight, of the body's internal organs, is explicitly stated in Edison's discourse. However, the discourse on disgust arising from the 'frightful spectacle of the vital processes of our

organism' slides into a reflection on the new-born body, the newly born *feminine* body, the sight of which gives rise to profound anxiety. The new-born body issued from the 'bowels' of the woman is still too much part of that polymorphous inner that makes our stomach turn. The new-born feminine body is also a body that will eventually itself give birth; a body that produces more body – a body that discharges itself in pain. The new-born feminine body to which Edison gives birth, his New Eve, is twice absolved from the messiness of biological birth: as infant *and* woman, she is sterile. The two men stoop over the mechanical entrails of Hadaly, overseeing a birth that is more like the careful dissecting of a corpse. Another body lies under the scalpel here (the choice of this otherwise irrelevant surgical instrument – a screwdriver would have been more appropriate – confirms it). A body of flesh has opened to the scientific gaze of these men, who will feast on its innermost secrets: the reproductive mysteries impenetrable even to she who embodies them.

Lord Ewald watches as Edison, lightly touching the blade of his scalpel to each component of this artificial body, describes their function. Metal touching metal; technology become body at the expense of the flesh. The original poster for the film *Metropolis*, produced in 1927, shows the robot clad in its metallic skin and set against a jagged line of looming skyscrapers; when the False Maria is burnt at the stake, her human envelope is reduced to ashes, revealing beneath it the metallic body of the robot, intact. Lord Ewald first meets the android Hadaly as yet unincarnated:

> A coat of armor, shaped as for a woman out of silver plates, glowed with a soft radiance. Closely molded to the figure, with a thousand perfect nuances, it suggested elegant and virginal forms . . . After an instant of immobility, this mysterious being descended the single step of her platform and advanced toward the two spectators in all her disquieting beauty.'[26]

When Dave and Phil unpack their new robot, Helen, it is to the uncanny beauty of her artifice that they refer when they speak of 'a dream in spun plastic and metals'. The metallic envelope closely fitted about an imaginary body recalls the precious casing of metaphors, the gilded and lacquered shell

with which the Renaissance poet would clothe an absence. The skin of the robot is at one and the same time the 'cover up', concealing an absence – that of an evacuated feminine sexuality – and a straight-jacket, disciplining the body, punishing the flesh. The metallic envelope, the gilded and lacquered shell, the bark within which the living Myrrha was incarcerated. The old master Frenhofer inters the feminine body under a thick crust of paint:

> I see nothing there but confused masses of colours contained by a multitude of strange lines, forming a high wall of paint.
> —'We're wrong, said Porbus, 'look!'
> Moving closer, they noticed in the corner of the canvas the tip of a bare foot emerging from the chaos of colours, tones and vague hues, a shapeless fog; but it was a delicious foot, a living foot![27]

A living foot, a living body interred. Layers upon layers of encrusted paint become a wall, a protective barrier that shields Frenhofer from the woman, just as it holds her captive. Chaos of colours, amorphous haze of indistinct shades – the act of painting is the manifestation of unrestrained expressivity, of bodily egestion onto the canvas.

We are reminded here that the male body is at the origin of the discourse on the disciplining of feminine sexuality. At the beginning of his biography of Plotinus, Porphyry observes that his master, 'seemed ashamed of being in a body'. When asked to sit for a painter or sculptor, Plotinus would refuse, complaining: 'Is it not enough to carry about this image in which nature has enclosed us?'[28] The body becomes prison. The skin on the prostitute's face becomes flint as her sexuality imprisons her soul. The body which Plotinus repudiates is *feminine*, in the sense Kristeva would give this word – that is, fundamentally pre-oedipal, always under the sway of the drives. The drives, Kristeva writes, form a *chora* – a term she borrows from Plato to name, 'an essentially mobile and extremely provisional articulation constituted by movement and their ephemeral stases.'[29] The pre-Oedipal body is forever estranged in the acquisition of subjectivity; it is perceived by the intellect as a prison, but also made into a prison by the intellect. And it is also a body become armour against threats from outside, from an otherness both feared and desired.

44

Plotinus' abjected 'feminine' body is that which belongs not only to the space of the maternal, but to the matter, the *raw material*, from which the social body is formed. Out of this raw material, the man fabricates a gleaming armour of cold steel – a technological prosthesis that is indicated metonymically by the finger/scalpel of Edison.

Out of the raw material of drive heterogeneity, Dr Gideon Ariel[30] attempts to devise a gestural perfection; a careful regulation of the athlete's bodily movements so that he achieves maximum efficiency with minimum physical strain. Iron muscles, automated movements; Dr Gideon Ariel, seated at his computer, dreams up an abstracted corporeality made up of laws of acceleration, velocity and direction – a vision of a body which loses itself in the desensitized void of harmonious motions.

Immovable, untouchable, the armoured male sometimes dreams 'the metallic dream of the human body';[31] and he sometimes imagines a woman who would be as beautiful as a machine.

> After all, to take what among all her works is considered to be the most exquisite, what among all her creations is deemed to possess the most perfect and original beauty – to wit, woman – has not man for his part, by his own efforts, produced an animate yet artificial creature that is every bit as good from the point of view of plastic beauty? Does there exist, anywhere on this earth, a being conceived in the joys of fornication and born in the throes of motherhood who is more dazzling, more outstandingly beautiful than the two locomotives recently put into service on the Northern Railway?[32]

To the hero of J.-K. Huysmans's novel *Against Nature*, the locomotive is a sensuous body; a brute, vibrant body 'imprisoned in a shiny brass corset', 'encased in armour-plating of cast iron'. It is the libidinal energy of this body which threatens to erupt through the machine; a *feminine* energy, surging polymorphously, which is converted into something organized, directed, thrusting – genital, masculine:

> When she stiffens her muscles of steel, sends the sweat pouring down her steaming flanks, sets her elegant wheels

spinning in their wide circles, and hurtles away, full of life, at the head of rapids and tides . . . It is beyond question that, among all the fair, delicate beauties and all the dark, majestic charmers of the human race, no such superb examples of comely grace and terrifying force are to be found; and it can be stated without fear of contradiction that in this chosen province man has done as well as the God in whom he believes.[33]

Pin-ups fastened to the radiator grille, pinned inside the cab – the French woman is said to be 'belle comme un camion'.[34] Isaac Asimov wrote about a masculine machine, a male android of beautiful composure, an artificial perfection, an unfailing metallic erection. Even more than a man, this machine is the new Pygmalion – a robot maker of perfect living women.

> Before the end of the week, he had insisted on cutting her hair, introducing her to a new method of arranging it, adjusting her eyebrow line a bit and changing the shade of her powder and lipstick. She had palpitated in nervous dread for half an hour under the delicate touch of his inhuman fingers and then looked in the mirror.
>
> 'There is more that can be done,' said Tony, 'especially in clothes. How do you find it for a beginning?'[35]

Metal touches the quivering flesh, refashioning it with absolute equanimity.

To create a female android, writes Andreas Huyssen, is to fulfil 'the male phantasm of a creation without mother; but more than that, (it is) to produce not just any natural life, but woman herself, the epitome of nature. The nature/culture split seems healed. The most complete technologization of nature appears as re-naturalization, as a progress back to nature. Man is at long last alone and at one with himself.'[36] There is something more, however, beside the imaginary resolution of the split between nature and culture, between 'feminine' and 'masculine', into a unified coherence, a synthesis. It is the fascination for the ambiguity of a being who is both animate and inanimate. Kokoschka writes to Hermine Moos, who is to make a life-size replica of the woman he loves,

> Is it not, dear Mademoiselle Moos, that you will not allow that I be tortured for years by permitting this malicious and

real object – cotton, material, thread, rag whatever names are given to those frightful things – to impose itself in all its earthly platitude while I imagine embracing with my eyes a creature who is ambiguous, dead and living soul![37]

Villiers de l'Isle-Adam speaks of the strange beauty of the animated silver armour of Hadaly. In the February 1988 issue of Australian *Vogue* it is a question of 'The New Bionic Woman'.[38] Man's technological dream and challenge – to engender woman – partakes of the desire to recognize in his creation his own 'traits', a desire to inscribe the power of his intellect and, more fundamentally, his subjectivity, upon the other. Nathanael's kiss warms the lips of Olimpia into vitality. The fascination that the creator feels for the created arises from the creator/lover's constant marvelling at the recognition of his mastery – a marvelling which can only be sustained in the play of ambiguity which pre-supposes the acknowledgement, rather than erasure, of difference. The beauty of art, and that of nature, Kant writes, arises from a perceptual ambiguity: 'Nature proved beautiful when it wore the appearance of art; and art can only be termed beautiful, where we are conscious of its being art, while yet it has the appearance of nature.'[39]

ɜ❧ *What the child seems to seek from his use of the imaginary companion is an inner sense of perfection and worth*
R. M. BENSON, D. B. PRYOR[40]

L'Eve Future begins with an eloquent monologue by Edison on the invaluable power of insight that would have been afforded humankind had sound – and image – recording technologies been invented earlier. The creation of a perfect femininity arises out of a desire for omniscience, which is also a desire for a kind of omnipresence. Edison imagines himself, concealed behind some bush in the Garden of Eden, shortly after the demise of the first woman Lilith, listening to and recording Adam's 'sublime' soliloquy: 'It is not good for man to live alone.'[41] Edison dreams up his New Eve.

To an important extent, Villiers de l'Isle-Adam's *L'Eve Future* is about the use of an (anticipated) technology in the service of desire; a substantial part of the book is dedicated to a detailed, albeit fanciful, description of how Edison's android was made. Hadaly is possible because of the invention of the

phonograph and the camera, and an anticipation of the talking film; these technologies of replication not only give access to a mythical past (here, the origin of man), but also, in arresting a segment of time in sound and image, return the past in doubly mythical form. The desire for total knowledge that is expressed in the opening monologue is fulfilled in Edison's creation of a female android, replete with those technologies. Hadaly is the very personification of 'Knowledge'. Her feminine form is the receptacle of canonized forms of discourse, recorded on tin tape:

> Here are the two golden phonographs, placed at an angle toward the center of the breast; they are the two lungs of Hadaly. They exchange between one another tapes of those harmonious – or I should say, *celestial* – conversations: the process is rather like that by which printing presses pass from one roller to another the sheets to be printed. A single tape may contain up to seven hours of language. The words are those invented by the greatest poets, the most subtle metaphysicians, the most profound novelists of this century – geniuses to whom I applied, and who granted me, at extravagant cost, these hitherto unpublished marvels of their thought.
>
> This is why I say that Hadaly replaces *an* intelligence with Intelligence itself.[42]

Unlike her perfected replica, and just like the character Clara in *The Sandman*, the woman Alicia does not have much time for poetry or philosophical meanderings. She and Clara are two women who lack 'depth' – 'My dear and subtle confidant, I recognized, myself, though too late, that this was a sphinx without an enigma.'[43] Paradoxically, it is this one-dimensionality of Alicia's character which Villiers de l'Isle-Adam describes as 'the horrible camera obscura' in which Lord Ewald is entrapped, while the mirror becomes the metaphor for Hadaly's infinite spiritual and intellectual depth. (Both metaphors, 'mirror' and 'camera obscura', belong to the register of vision. They are evocations of, respectively, a clarity of vision, and the obscuring of that vision as the distance between bodies is obliterated – as the eyes close in lovemaking and, ultimately, in death. Is Villiers's reference to the camera obscura simply a crude allusion to the threat posed by another sexuality, a kind of technological *vagina dentata*

with shutter rather than teeth, an inhospitable womb, all darkness and sharp angles?) Had Edison been there, behind that bush, he would have interposed his New Eve between Adam and the faulty creation that was to cause his downfall, offering a clear mirror to his desire, saving him from the erring fumblings of sex. 'Oh! What a profound soul you have! My whole being is mirrored in it!' says Nathanael to Olimpia.[44]

Hadaly, Lord Ewald says, could only ever be a shadow of Alicia; in so far as a shadow is the projected shape of a body, and as such moves, and can only exist, with that body, Hadaly is most fundamentally the shadow of Lord Ewald: 'You ask "Who I am"? My being in this low world depends, *for you at least*, only on your free will.'[45] She is at once the clear mirror that reflects a radiant image, and a tenebrous inseparable companion – in Freud's words, a 'shadow of one's past self': 'What he (the subject) projects before him as his ideal is the substitute for the lost narcissism of his childhood in which he was his own ideal.'[46]

> 'What you love is this *shadow* alone; it's for the shadow that you want to die. That and that alone is what you recognize as unconditionally REAL. In short, it's this objectified pro-jection of your own soul that you call on, you perceive, that you CREATE in your living woman, and *which is nothing but your own soul reduplicated in her.*'[47]

> Generally, the projection of the ideal ego allows the Ego to apprehend its own ideal image in the illusion of an objective observation, the effect of which is to win belief.[48]

In their solitary pursuit of perfection, scientists, artists, poets and melancholic *maître-penseurs* revel in the pleasure afforded by the exercise of thought, the masterful reorganization of signifiers according to the whims of their desire. Obsessive isolation and withdrawal into a world of moral suffering; these are the characteristics of the psychical life of our lovers of artificial women, and they are also the characteristics of narcissism.[49] Freud spoke of an infantile narcissism – the unification of auto-erotic drives that were previously dis-persed across a fragmented sensory field onto, or more precisely *into*, a body schema – as the origin and aim of later ego-cathexes. This crystallizing of the auto-erotic drives corre-

lates with the emergence of the ego, which Lacan locates in the child's apprehension of, and identification with, its own reflected image or the image of a counterpart – images that have a coherence that the child's own body lacks.[50] In correspondence with Lacan's idea of the child's identification with an imaginary perfection, Daniel Lagache insists on a primary identification with another being whom the child perceives as omnipotent – namely, the mother – as constitutive of the 'Ideal Ego'.[51] The reflected image before Lord Ewald and Edison returns their demand with infallible immediacy:

> Well, now, with the future Alicia . . . The word that comes will always be the *expected* word; and its beauty will depend entirely on your own suggestive powers! Her 'consciousness' will no longer be the negation of yours, but rather will become whatever spiritual affinity your own melancholy suggests to you . . . Her words will never deceive your delicately nurtured hope! They will always be just as sublime . . . as your own inspiration knows how to make them. At the very least, you will never experience here that fear of being misunderstood which haunts you with the living woman; you will simply have to pay attention to the intervals between the words she speaks. In time it may even become superfluous for you to articulate anything! Her words will reply to your thoughts, to your silences.[52]

The primordial anticipation of a bodily unity gives rise to a narcissistic ideal of omnipotence, when the child further recognizes itself as the originator of instantaneous perceptual stimulations. The constitution of the ego is therefore the constitution of an 'Ideal Ego'. This ideal of primary narcissism has to be relinquished under the pressure of parental prohibitions. However, the tenacity of the narcissistic fantasy of omnipotence, and the impact of interdictions from the idealized parents, give rise to a new formation – the 'ego-ideal' – which Lagache defines as corresponding to 'the way in which the subject must behave in order to respond to the expectations of authority.'[53] The ego-ideal is thus subjected to the agency of the super-ego formed through the internalization of parental prohibitions and demands.

Edison, *bon-vivant* at heart, has provided in his android a multiplicity of femininities which can be summoned by touch-

ing each of the rings on her hands. 'I have so many women in me, no harem could contain them all. Desire them, and they will exist! It's up to you to discover them within me.'[54] Hadaly can, potentially, exhibit a multiplicity of behaviours; what she actually exhibits is a plurality of texts, yet combined together in 'a synthetic and superior form which abolishes every distinction of mode or of genre.'[55] Polymorphism is here abolished in the fusion of texts into a utopian discursive totality that speaks outside history to and of a unified human-ity. This ideal of an omniscient hold on 'humanity' is premised upon the repression of another polymorphism. Hadaly asks Lord Ewald never to summon the other women in her: 'But no! These other feminine potentials that live in me should not be roused. I despise them a little. You had better not touch the deadly fruit within this garden!'[56] Hadaly is the embodiment of the polymorphous sexuality that the child has to surrender in its passage to heterosexual organization and, as enunciator of the interdiction, she is the idealized parent, the repressive agency of the super-ego. She is the phallic mother, the object of the child's exclusive attachment, and she is the mother the little boy has to give up. Her renunciation of sexuality is the little boy's renunciation of the mother. The fantasies of engendering an ideal transcendental self in the guise of a feminine form that has been drained of its sexuality suggest, on the one hand, a radical separation not only from the body, but from the *maternal* body; on the other hand, they suggest a total identification with, and a return to, the primary sexual object, without fear of retribution. Hadaly declares, 'a woman is what I must not become'. She instead becomes 'Virgin Mary' – vessel of the Word. Hadaly, born out of the tension between the imaginary and the symbolic, is a perfect compro-mise-formation; her possibility and the possibilities she em-bodies, limitless it seems, are the confirmation of her creators' boundless influence, yet they are contained within and gov-erned by the symbolic order – the laws of discourse, the laws of science.

With Hadaly, *radieuse Inspirée*, pleasure belongs to the register of ecstasy: 'My love, which all but equals that with which the Angels burn, has seductions more captivating perhaps than those of the earthly senses, within which always slumbers the spirit of ancient Circe.'[57] Guy Rosolato speaks of the narcissistic *jouissance* found in the abandonment of the

quest for pleasure; the lowering of tension into a kind of ascetic beatitude:

> The ideal at play in ecstasy is to be able to hold the challenge of achieving jouissance in the most extreme withdrawal from the object and the world. Even in the greatest proximity, a suspension, an aspiration outside of time through meditation or contemplation tends to dissolve the object. We know the Freudian comparisons: the satiety of the infant and its consecutive sleep, the return to the maternal belly.[58]

Lord Ewald surrenders to Hadaly. 'Phantom! Phantom! Hadaly . . . I resign from the human race – and let the age go about its business!'[59] From mirror, to shadow, to ghost. It is the medium Sowana, disembodied soul, the one who mediates between the living and the dead, who speaks through Hadaly: 'I am an envoy to you from those limitless regions whose pale frontiers man can contemplate only in reveries and dreams. There all periods of time flow together, there space is no more . . . my eyes have really penetrated into the realms of Death.'[60] Thus a sensation is aroused in Lord Ewald 'of "eternity", a feeling as of something limitless, unbounded – as it were "oceanic"';[61] it is the sensation which Freud identified as the desire to restore the limitless narcissism of early childhood. The acceptance of the Ideal, the descent into the 'night of her soul', is a return, a *regression* to a degree zero of tension, and ultimately to a state of entropy. Lord Celian Ewald will return to his solitary dwellings in the company of Hadaly, who will travel across the ocean asleep in her black coffin.

> This Divine Beauty creates in everything love, that is desire for itself, because if God draws the world to himself, and the world is drawn [from Him] there is one continuous attraction, beginning with God, going to the world, and ending at last in God, an attraction which returns to the same place whence it began as though in a kind of circle.[62]

Oskar Kokoschka commissions Hermine Moos to fabricate a replica of the woman he loves and who deserted him. The life-size doll will be his 'double', his 'woman-angel'; she will accompany him wherever he goes. He writes to Hermine Moos, giving her detailed instructions for the production of

what he sometimes calls his 'fetish'. She is to work on the replica from paintings and sketches that Kokoschka had made of his mistress. However, under Kokoschka's instructions, the chiffon doll becomes a composite of different feminine types – all women in one woman:

> The hands and feet must be well articulated. Take, for example, your own hand as a model. Or think of the hand of a well-groomed Russian woman who, furthermore, rides a horse. And the foot, for instance, could be like that of a dancer: Karsavina for example.
>
> You must also take into account that the hands and feet remain attractive, even naked, and that they do not give the impression of inert masses, but should have vivacity. The size should be such that one can put an elegant woman's shoe on them . . .
>
> As for the head, its expression is very, very original and will have to be made even more so, but conceal all traces of its fabrication and the labour performed! Will the mouth open? And are there teeth and a tongue inside? I would be very happy! . . . As for the eyelids, the pupils, the eyeball, the corners of the eyes, the thickness, imitate as far as possible your own eyes. The cornea could be covered with nail polish. It would be lovely if one could also close the eyelids over the eyes. The whole thing should have as much life as the large oil sketch, with as many details as possible! The ear a little more articulated . . .
>
> The breasts, please, I would like them more detailed! No protruding nipples, but rather irregular, and make them stand out only by means of a little roughness. The perfect model is given by the breasts of Hélène Fourment in the little book on Rubens, where she holds one of the small boys against her . . . Finally, the skin, I want it to feel to the touch like a peach, and do not allow yourself any stitches where you think it will hurt me, and remind me that this fetish is a miserable rag doll . . .'[63]

The doll Kokoschka receives six months later is but a stuffed 'shaggy bearskin rug', bristling with pins and wire, spilling out its chiffon guts through the distended seams.

Dear Miss Moos

What are we going to do now? I am sincerely appalled by

your doll which, even though I was ready to reduce my fantasies a little in the interests of reality, contradicts in too many ways what I expected of her and hoped of you . . . I had asked for an appearance so discrete that I could have expected she might bring me a certain illusion, a hope which has now been cruelly torn from me, and I no longer know what will happen . . .[64]

When conversing with Hadaly, Lord Ewald must take care to fit his speech to the gaps left in hers; the perfect orchestration of demands and fulfilment might otherwise break into discord and disjunction. Nathanael kisses Olimpia: 'he bent down to her mouth, but ice-cold lips met his burning ones . . . he felt his heart thrill with awe.'[65] Her lips are as cold as the surface of a mirror, as cold as the water touched by the lips of Narcissus. When Nathanael recognizes the lifeless figure of his Olimpia flung across Coppola's shoulders, he becomes mad at the sight of her 'ugly feet hanging down and banging and rattling like wood against the steps.' Frenhofer cries as he contemplates his Belle Noiseuse, a chaos of colours amounting to nothing. Kokoschka laments: 'This whole story collapses like a bundle of rags.'[66] All these stories end in a fall, prefigured in the small step each ideal creature must take in descending from their pedestal into the world of the living: from the ideal into the realm of matter – rags, wood, paint; from coherence into disorganization – bodies or discourses in pieces. The absurd mechanical failure of these artificial objects of desire represents, finally, nothing less than the failure of the subject – its failure to sustain the *fiction* of its relation to the object. The body whose failure is enacted by these ideal objects is, in fact, nothing other than the subject's own. Nothing more or less, finally, than the creator's own flesh, which his projections return to him as senseless matter – gauche, aching, perishable, imperfect.

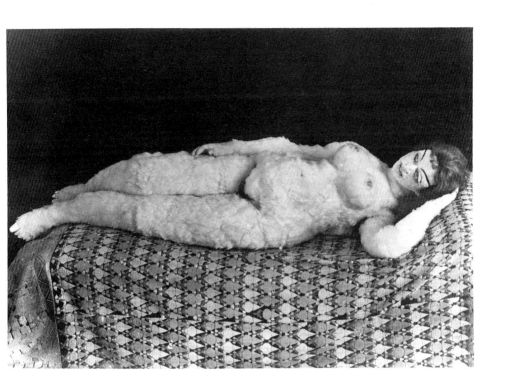

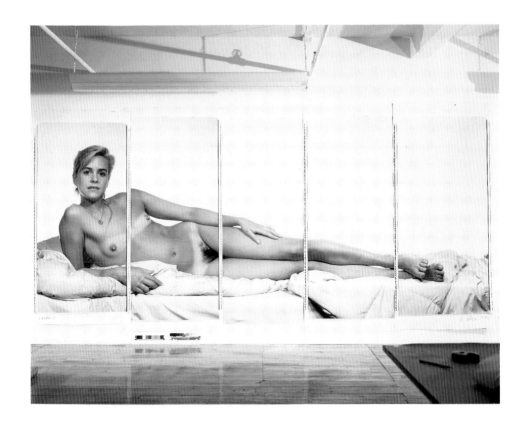

3 Shattered beauty

ೀ *My gaze stays upon a detail? It is the sweep of a hip which retains it,*
 the crescent of a shoulder, the line of a nose, the alternate curves of a
 leg
PATRICK DREVET[1]

In her essay 'On the Eve of the Future',[2] Annette Michelson
locates the model for Villiers de l'Isle-Adam's description of
the beautiful Alicia in *L'Eve Future*, in the erotic art of the High
Renaissance – more specifically, in the literary and pictorial
productions of the School of Fontainebleau under François I.
She does this by reference to the double portrait of Gabrielle
d'Estrées and the Duchesse de Villars in their bath, which was
executed in 1594. Michelson proposes two readings of the
portrait: in accordance with the iconographer, she interprets
the Duchess's gesture of encircling the nipple of her sister's
breast between her two fingers as indicating the coming
maternity of Gabrielle d'Estrées. However, within the broader
context of erotic art practices of the time, the gesture of the
Duchess points to something else. It is a gesture of *demarcation*
which echoes the procedure of fragmentation to which the
feminine body was subjected in numerous contemporary
literary descriptions of its beauties – enumerations which I
discussed in my first chapter. Michelson draws a parallel
between the gesture of demarcation which, in bringing a
particular part of the body to attention, *detaches* it from that
body, and the highly fashionable and somewhat scandalous
poetic form which took as its subject not the entirety, but one
part only of the feminine body. This poetic glorification of the
anatomical fragment was known as the *blason anatomique*, and
there were as many *blasons* as the imaginary fragmentation of
the woman's body into elected zones of pleasure would allow:
*le blason du pied, blason des cheveux, blason du sourcil, blason de la
cuisse, blason de l'oreille, blason de l'ongle, blason du C. (con), blason
du Q (cul), blason du tétin*, and so on.[3]

The analogy that Michelson draws between the structure of

the portrait and the form of the *blason* is suggestive, and I shall pursue it later. For the moment, I wish to return briefly to the text which prompted this analogy, Villiers's description of the beautiful Alicia:

> Her thick dark hair has the sheen of the southern night . . . Her face is the most seductive of ovals. Her cruel mouth blooms like a bleeding carnation drunk with dew. Moist lights linger playfully upon those lips, which reveal in dimpled laughter the brilliance of her strong young animal teeth. And her eyebrows quiver at a shadow. The lobes of her delightful ears are cool as April roses. Her nose, exquisite, straight, with lucent nostrils, extends the forehead plane . . . Her hands are pagan rather than aristocratic; her feet as elegant as those of Grecian statues . . .[4]

To me, the description of the beautiful Alicia, which proceeds, as Michelson notes, 'downward, from shining tresses to elegant feet,'[5] recalls the form of late medieval descriptive poetry – in particular, the systematic listing of physical parts from the head downward, of which Boccaccio's *canone lungo* is an instance.[6] Without denying the connection between the older descriptive tradition and the slightly more recent poetic form of the *blason anatomique*, it is nevertheless useful to differentiate between, respectively, the cumulative process of the enumeration of parts, and the highly selective process of demarcation whereby one part only is abstracted from the totality of the feminine body:

> Little navel, that my thought adores,
>> But not my eye, which never held such treasure,
>> Navel in whose honour,
>> A large city might well be built:
> Divine sign, which once divinely
>> Held the androgynous link
>> How much you, my little lovely, and how much,
>> your twin flanks do I gaily honour!
> Not this beautiful head, not these eyes, not this forehead,
>> Not this sweet laughter, not this hand which melts
>> My heart into a spring, and with tears makes me rich,
> Could with their beauty content me
>> Were it not for the hope that sometime I may touch
>> Your heaven, where my pleasure nestles.[7]

In the single space of the portrait of Gabrielle d'Estrées and the Duchesse de Villars we are given both the totality of the feminine body and its fragmentation. In the seated figure of the working nurse we are presented with a body closed in upon itself and set apart from the dominant *mise-en-scène* of pleasure and desire – a clothed nucleus around which circulate the dispersed fragments of nakedness. Rather than inviting a gathering of those fragments into a totality, the formal pictorial construction of the painting further enhances their disjunction and isolation by presenting us with a number of embedded frames: from the framing edge of the picture as a whole we move to the framing device of the parted and lifted curtains which reveal the sisters d'Estrées, who are further contained within the rectangular surround of the bath; behind these primary figures, a further pair of curtains open upon the scene of the nurse, who in turn is pictured seated before the two framed paintings on the wall behind her. Background and foreground are therefore demarcated as a succession of theatrical 'flats', and form a series of narrow spaces that seem both to emanate from, and to culminate in, the enclosure of the nipple between the finger-tips.[8] The process of demarcation, sustained throughout the painting, is ultimately a process of selection; that is, of exclusion. Not the head, nor the eyes, not the forehead nor the smile, not the hand but the navel. Not the entirety of the woman's body, but a 'detachable' fragment – the nipple, or the legs in the background reduced through perspective to the size of the fingers which enclose the nipple – which, though apparently insignificant, transfixes the viewer's gaze and comes to occupy the space of a poem, the space of a painting, the space of the body.

Commentators on the *blason* are agreed in locating the specific origin of the form in the late medieval tradition of descriptive poetry, and in more generally ascribing it to the will to rationalize the human environment which comes to dominate intellectual and artistic thought in the Renaissance. The term *blason* itself comes out of the earlier tradition of heraldry: it was the name given to a painted miniature of a particular shield, accompanied by a brief description and interpretation of its features. The didactic function of those early *blasons* was

carried over into the production of poetic compendiums such as *calendriers* and *bestiaires*. The *calendriers* provided the reader with a description of the characteristic features of each month and season, and of the work to be done in each of them. The *bestiaires* similarly offered brief poetic descriptions of individual animals, combined with moral reinterpretations of their characteristics. Stones, plants, human types and other products of nature were subjected to the same process of 'rationalization'. The *blason anatomique* emerged out of a major revival in the Renaissance of the didactic form of the compendium, which produced more *calendriers*, more *bestiaires*, and a wealth of emblem-books.

At the same time, in Italy, Olympo da Sassoferrato was writing what Saunders describes as 'anatomical love poetry': *capitoli* and *strambotti* on the beauties of women. The *Capitolo del bianco petto de madonna Pegasea* is a long poem in praise of the beauty of a certain Pegasea's breasts, and is often tentatively cited as the possible inspiration for the first anatomical *blason*, Clément Marot's *Beau tétin*. The *strambotto* is a shorter eight-line poem about one feature of the feminine body, of which Sassoferrato wrote no less than forty-five; these were collected under the heading '*Comparation de laude a la signora mia incominciando al capo per insino a li piedi*'. Whether or not Clément Marot had read Sassoferrato's anatomical poetry before writing his *blason* is still subject to debate, and Saunders indeed stresses the difference between the elliptical discourse of Sassoferrato's poems – 'evoking a series of disconnected and precious images'[9] – and the more direct descriptive approach in Marot's *Blason du beau tétin*. However, for my purpose I wish simply to remark that, in sixteenth-century poetry, the feminine body became the site where desire and the impulse to order, to categorize, to repertorize, and ultimately to master, came together. The most concise poetic expression of this tendency is found in the *blason anatomique* in France during the period between 1536 and 1543.

Renaissance poetic discourses on the body fragment emerged in the context of a wider preoccupation with the structure of the human body, which led to the formulation of the theory of proportions and the articulation of the scientific system of 'anatomy'. In anatomy the idealized body – that is, the body considered as a *whole* – was violently destroyed; it

was sectioned and dissected in the process of creating a new field of scientific knowledge. Fragmentation provided the means of discovering a unified truth. In art, the existential body was idealized. It was given an organic coherence in the drawing of internal correspondences between its constitutive parts – the proportion of one finger to another; of all the fingers to the rest of the hand; of all parts to all others; and so on. The part became the measure of the whole in Leonardo da Vinci's cosmography of the *'minor mondo'*: 'I shall divide the members as he [Ptolemy] divided the whole, into provinces, and then I shall define the functions of the parts in every direction, placing before your eyes the perception of the whole figure and capacity of man in so far as it has local movement by means of its parts.'[10] The works of Leonardo best attest to a concern both for an understanding of the mechanics of the human body, based on anatomical observations, and for the representation of that body as a harmonious totality – a totality based on the formulation of correspondences between as many parts of the body as possible.

Thus defined across two systems, the human body was subjected, by the same hand, both to the aggressive act of sectioning and dissecting, and to the totalizing act of representation. Devon L. Hodges argues that a similar dualism is at work in the illustrations of Andreas Vesalius's *De Corporis Fabrica*; she perceives this dualism as a tension between the belief in the body as an ideal form, and the body as dehumanized parts – fragments of matter scattered across an anatomy textbook.[11] The six illustrations – from the drawing of a heroic standing male figure, displaying the superficial muscles, to that of a poised skeleton – read as a narrative of the destruction of the ideal body. However, the artist never completely surrenders the ideal to the gruesome materiality of anatomical scrutiny. The expressions, poses and settings belong to a rhetoric of art rather than to a more succinct, 'objective', and strictly illustrative, intention.

The Renaissance propensity to categorize and repertorize is also found in the anatomical act of sectioning and dissecting a favoured metaphor. We may note, for example, the emergence of 'spiritual' anatomies – moral works whose aim was to purify by cutting away the sins which conceal the truth. The 'body' here is not the human body, but that of the religious text, which was subjected to aggressive critical scrutiny in

order to rid it of its ailing parts; the process partakes of what we would now recognize as pathology. However, the analogy drawn between the analytical and the anatomical process invites reinterpretation: the violence done to the body of the religious text can also be read as violence done to the sexual body, and as a mortification of that 'flesh' which Christianity perceived as 'diseased'.

In giving a brief account of the context within which the *blason anatomique* came to prominence, I have tried to situate the form within the dynamics of the ambivalence of a totalizing impulse – the search for 'true' knowledge (be it mediated by the scalpel, the paintbrush or the word) which took the human body apart, scattering its fragments across the Renaissance imaginary. This ambivalence suggests a reading of the *blason anatomique* that would take into account the tacit aggressivity of a poetic form which, in praising the part, tears to pieces the feminine body.

ৡ

Tit *perfected*, whiter than an egg,
Tit of brand new white satin,
Tit who puts the rose to shame,
Tit more beautiful than anything;
Hard tit, no, not a tit,
But a little ball of ivory,
In the middle of which is set
A strawberry, or a cherry
Which no-one sees or touches,
But I wager that it is so.
Tit, then, with the little red tip,
Tit which never moves,
Whether to come, or to go,
Whether to run, or to dance.
Left tit, lovely tit,
Always far from its companion,
Tit which attests
To the *condition* of the person.
On seeing you there comes to many
A desire in the hands
To feel you, to hold you;
But one has to refrain

From coming any closer, *bongré ma vie*,
Lest another desire be aroused.

 O Tit neither large nor small,
Ripe Tit, hungry Tit
Tit who night and day cries:
'Marry me, marry me now!'
Tit which swells and stretches
Your gorget by a good two inches,
With good reason will they call happy
He who will fill you with milk,
Making of a virgin's tit
Tit of a woman whole and fine.[12]

In his postface to *Les Blasons anatomiques du corps féminin*, Pascal Quignard speaks of the recognition of our adult body as evolving out of the early perceptual experience of fragments. He speaks of a mouth which encircles a nipple; a thumb; a hand that gently waves good-bye; two eyes, symmetrical and shiny; a mouth that vomits; an inclining head of thick hair; legs that give way; fragments which fill the perceptual space of our earliest days and which we try to assemble into a coherence which we will make our own. He also speaks of the impossibility of sustaining a coherent image of a body which fails us incessantly – an illness, pain, a feature we dislike, perhaps a scar, or birthmark, and the unity is destroyed, as the fragment malignantly invades our perception. The anatomy to which Quignard refers here is not, in Catherine Clément's words, 'the anatomy we are taught in medical schools but the archaic anatomy that acts upon us without our knowledge.'[13] It is an *imaginary* anatomy in that its lines are not drawn according to the rules of biology, but are defined by our earliest fears and desires. This imaginary anatomy is best represented in the works, not of Leonardo da Vinci or Andreas Vesalius, but of Hieronymus Bosch, which Lacan describes as 'an atlas of all the aggressive images that torment mankind.'[14] What Lacan has in mind here is a familiar picture: that of small children playing together or alone, imagining with extreme seriousness the pulling off of heads and the ripping open of bellies (which they may enact by tearing to pieces a doll). In this he sees the acting out of the fantasy of the 'fragmented body', organized around imagos of castration, mutilation, devouring, dismemberment and so on. It is a

fantasy formed out of the human subject's earliest perceptual experiences as it negotiates the satisfaction of its needs through a body that is impaired by physiological prematuration. Lacan speaks of an 'intra-organic and relational discordance'[15] which dominates the universe of the infant in the first six months of life – a universe made up of perceptual fragments, so many punctual stimulations of pleasure and displeasure. For a phenomenology of this perceptual chaos, in which frustration and satisfaction, aggressivity and tenderness, alternate, Lacan refers us to the works of Melanie Klein.

The infant's relation to its external and internal world is to 'part-objects'. These are the body fragments which, because of their role in bringing pleasure and relief, dominate the earliest perceptual experiences; as yet there is no apprehension of a distinct unity, a whole object, a 'person'. Privileged amongst those part-objects is the breast, as the experience of feeding initiates an object-relation to the mother. The 'breast' here does not correspond to the anatomical organ, but to the constellation of tactile, visual, kinaesthetic, auditory and olfactory sensations which make up the experience of somatic satisfaction or frustration. R. D. Hinshelwood writes:

> The object, at the outset, is sensual, emotional and intentional rather than physical. Thus "the breast" cannot conjure up the varied images or the penumbra of associated meanings that it will have in later life. It is an object with a simpler relationship to the baby. It touches his cheek, intrudes a nipple into his mouth . . . In spite of having only these ephemeral qualities it is completely real for the infant. Such objects are called 'part-objects' – although, from the infant's point of view, the part is all there is to the object.[16]

In Melanie Klein's account of the earliest relation to part-objects,[17] the breast is perceived by the infant as being both a 'good' breast and a 'bad' breast: 'good' in so far as it brings relief from hunger and is therefore a source of pleasure; 'bad' in so far as, in its absence, it becomes associated with the frustration and discomfort arising from hunger. The 'good' and the 'bad' part-objects are 'imagos, which are a phantastically distorted picture of the real object upon which they are based'.[18] The infant projects its feelings of tenderness and rage, towards, respectively, the 'good' and the 'bad' breast,

while simultaneously introjecting a 'good' and a 'bad' breast (since sensations of pleasure and pain come from inside its body). Introjection and projection are related to the bodily functions of, respectively, the ingestion and the expulsion of food. The object is thus effectively *split* into a 'good' and a 'bad' object, with a corresponding splitting taking place intra-subjectively. The aggressivity which arises from frustration engenders phantasies[19] of destruction, in which the infant bites and tears up the breast, devouring and annihilating it. The 'bad breast' is thus perceived to be in fragments, while the gratifying 'good breast' is invested with completeness. The breast – 'good' or 'bad' – is in turn phantastically endowed with powers as great as the force of the child's own aggressivity and love. The 'bad' breast, internal and external, is therefore capable of turning against the infant and retaliating. As a safeguard against such retaliation, the power of the 'good' breast is increased to the point of idealization; hallucinatory gratification turns the breast into an inexhaustible source of pleasure, and affords the infant temporary omnipotence – total control over the external and the internal idealized breast. 'Idealization' writes Klein 'is thus the corollary of persecutory fear'.[20]

The degree to which feelings of hate and feelings of tenderness are kept apart in the splitting of the object into a 'good' and a 'bad' object varies considerably. There are times when some degree of synthesis is achieved between destructive impulses and feelings of tenderness. The resulting ambivalence, being anxiogenic to the infant, is kept in check by the process of splitting the object. This process is relatively infrequent in the earliest months of the infant's life, but as development proceeds towards a whole-object relationship, and as the intimation that 'good' and 'bad' comes from the same object grows stronger, the experience of ambivalence recurs more frequently, giving rise to longer states of depressive anxiety. This conflictual state, in which the infant perceives its being as fragmented, triggers the urge to make reparation to the injured 'good' object, to put its fragments back together, to restore it to its state of wholeness. It is important to note that, according to Klein, oral-sadistic phantasies are primarily, but not exclusively, directed towards the maternal breast: 'Attacks on the breast develop into attacks of a similar nature against the entire body which comes to be felt, as it were, as an extension of

the breast before the mother is conceived of as a complete person.'[21] Without attempting an exhaustive mapping of the structure of such early psychic processes onto the poetic form of the *blason*, I nevertheless wish to consider the relevance of the Kleinian dialectic – which takes as its object the infant's phantastical investment in a part of the maternal body – to the poetic veneration of a fragment of the woman's body. As Klein stresses, 'the mother's breast, both in its good and bad aspects, also seems to merge for him (the infant) with her bodily presence; and the relation to her as a person is thus gradually built up from the earliest stage onwards.'[22]

The enumeration of the physical features of beautiful women, in late medieval descriptive poetry, has often been compared to a process of fragmentation of the feminine body.[23] The *blason anatomique* can be regarded as a further stage: from amongst the scattered fragments, a single element is chosen. This is, in its turn, subjected to fragmentation – the poetic scrutiny of the object.[24] D. B. Wilson speaks of the spiralling movement of the poem, 'in the way in which it continually revolves around the object, describing each new angle by a series of qualifications'.[25] To me, the rhythm of the poem, punctuated here and there by the repetition of the same word,[26] suggests a more disjunctive movement, and the description of each new angle of the object is more like a scattering of that object into disparate images. The breast as food and precious ivory; the breast that shouts; the breast that hungers, and so on. A characteristic of the form of the *blason anatomique* is the invocatory address, whereby the body-fragment is spoken to as if it were a person. The part takes on the status of the whole. Like the living woman, it is at times endowed with speech, but it is often given far greater powers:

> . . . O brown brow under whose deep darkness
> I bury in gloomy desires
> My liberty and my sorrowful life
> Which was by you so sweetly ravished.[27]

The ambivalence inherent in the form of the *blason anatomique* – the idealization of the object in laudatory verses premised on the fragmentation of the feminine body – is here echoed in the content of the poems. The body-part is turned into a phantasmatic part-object, purveyor of pleasure and frustration, and ultimately of life and death. In Marot's *Du beau tétin*, the

formulation of the ambivalence between idealization and destruction is of particular interest. *Du beau tétin* was the first anatomical *blason*, and it apparently formed the model out of which the fashion for writing verses about single fragments of the feminine body evolved. It seems significant that the object of the first *blason anatomique* should have been the breast – the first object of infancy. The play of metaphors and metonymies in the opening verses suggests something of that early perceptual experience of the part-object. The poetic breast is made into a tangible object – palpable, even palatable. It has the smoothness of satin, the firmness of ivory. The breast is egg, strawberry or cherry; it becomes the food that it itself contains. The poetic sliding from the breast that feeds, to the breast as food, replicates the fluctuating perception that the infant has of the maternal breast: the 'good' breast that provides nourishment and satisfaction, the 'bad' breast which, in its oral-destructive phantasies, the infant bites, tears up and devours. The anatomical *blason* serves up a fragment small enough to eat, like a bite.

Just as the beginning of the poem suggests fragmentation, the four last verses evoke coherence: the coherence of one idea smoothly carried across, in contrast to the overall movement of the poem, which is punctuated by repetition and broken into a series of brief disparate images. The formal fragmentation thus resolves into formal coherence, just as the tearing apart of the breast resolves into the reparatory act of filling it with milk – of making it whole again. Reparation is made to the injured loved object. Of the dialectic of idealization and destruction at work in the *blason anatomique*, Annette Michelson writes: 'Woman, subjected to the analytic of dissection, is then reconstituted, glorified in entirety and submission: as Marot says in his *Blason du beau tétin*, "He who shall with milk make you swell, makes of a virgin's tit that of a woman, whole and fine." '[28] In another reading of the act of filling the breast with milk, which recalls the latent aggressivity present in idealization (invoking another line of attack derived from the anal and urethral impulses), the poet/infant projects into the object its dangerous bodily substances. 'These excrements and bad parts of the self are meant not only to injure but also to control and to take possession of the object. In so far as the mother comes to contain the bad parts of the self, she is not felt to be a separate individual but is felt to be *the* bad self.'[29]

Encouraged by the success of his *Blason du beau tétin*, Clément Marot promptly launched the idea of the *contre-blason*. However his *Blason du laid tétin* failed to please. The *laid tétin* is the breast of the aging woman, withered and barren. It is the 'bad' breast, purveyor of death, object of the child-poet's most aggressive impulses.

> . . . Dried up Tit, hanging Tit
> Withered Tit, Tit yielding
> Foul mud instead of milk,
> The devil made you so ugly.
> Tit taken for tripe,
> Tit which was borrowed
> Or stolen somehow
> From some old dead goat[30]

The ambivalence at work in the *blason* – the dissection of the feminine body in laudatory verses – is absent from the *contre-blason*, reduced as it is to the sole violence of a deprecatory discourse. Melanie Klein says that early perception does not allow for ambivalence: the breast is simply split into a 'good' object and a 'bad' object. As the child's perception evolves, however, feelings of ambivalence toward the part-object become more frequent. In this light, it becomes possible to consider the productions of *blasons* and *contre-blasons* with more specific reference to those two *positions* in the development of the child's relation to the part-object: the *blason* as the product of an ambivalent perception ('good' and 'bad' qualities are attributed to the same object), when 'aggression becomes mitigated by libido';[31] the *contre-blason* as stemming from a more archaic perception, when the object is absolutely 'bad', and as such becomes the recipient of focused, unconditional and intense hatred:

> On seeing you there comes to many
> A desire in the hands
> To grab you with gauntlets
> To give five or six couples
> Of slaps on the nose of she
> Who hides you in her armpit.[32]

&

It is often observed that, much as Freud discovered the child in the adult, so Klein found the infant in the child. It is to Freud, and the child in the adult, that I shall now turn in order to suggest another reading of the poetic anatomical fragment in terms of the fixation of the drive to a part-object – in this case, the mother's 'penis'. We are now speaking of a different epoch in the subject's development, an epoch dominated by the child's attempts to come to terms with, to make sense of, sexual difference. It is a different maternal body which emerges out of this struggle for meaning – a castrated body which reflects to the male child the possibility of his own castration. It is very likely that the early pre-oedipal persecutory fears of bodily disintegration are revived and intensified by the sight, imagined or actual, of the 'missing' body-part.

The distinction made at the beginning of this text between descriptive poetry that takes as its object the entirety of the feminine body, and the highly selective poetic form of the anatomical *blason*, suggests a further nuance. Speaking of Villiers de l'Isle-Adam's rendering of the beauties of Alicia in *L'Eve Future*, Annette Michelson notes that the description proceeds downwards from tresses to feet, 'rather like the male glance of inspection which, as in French, *toise d'un regard*, takes the measure or stock of its object.'[33] The gaze implied by the enumeration of the parts of the feminine body is therefore a gaze that moves, lingeringly sliding along that body – a gaze which has been formalized in the cinematic tilt. On the other hand, the close poetic scrutiny of the body-part in the anatomical *blason* suggests a gaze which has come to rest – *arrested*, a close-up. I am reminded here of Freud's account of the origins of fetishism – the averted gaze that comes to rest on a fragment which therefore will serve to allay the castration anxiety by serving as a substitute for that which the little boy construes as missing from the woman's body. This 'insignificant' fragment, upon which the imaginary remains fixated, not only comes to represent the absent penis, but is further elevated to the status of the phallus – signified of omnipotence of which the male organ is the (ever inadequate) signifier. Indeed, the *beau tétin* displays qualities not dissimilar to that of the erect penis: it is hard as ivory, it swells, pushing back the garment that shields it, and it is at its best when replete with 'milk'. Furthermore, the idealized tit takes on the status of an idealized whole – not merely the entirety of the body of which

it is a part, but an imaginary wholeness which exists beyond the actuality of the complete body of the woman. The part-object which the man may elect as fetish is not necessarily a body-part, and neither is it necessarily a material object.[34] The logic of displacement which determines the choice of a fetish allows for a variety of objects to become libidinally invested. *Blasons* have been written which took as their objects a tear or a sigh, hence following the earlier tradition of the *strambotto* which, from the description of parts of the feminine body, slid into descriptions of the garment, or a fragment of the garment, worn by the woman, or described objects that she possessed such as a mirror, and so on. Having said this, however, it can be argued that the objects mentioned above are given, in the imaginary, the status of body-parts insofar as they too are detached from the body: the sigh and the tear are expelled from the body; the clothes are stripped from the body; and the mirror is but a reflected fragment of that body.

Having positioned the production of anatomical *blasons* within the dynamics of fetishism, how am I to account for the *Blason du C.*, which takes as its object precisely that from which the fetishist averts his gaze? The *Blason du C.* is a spirited eulogy of the woman's cunt. The *con* is likened successively to the bold lion, the audacious greyhound, the agile and playful monkey or kitten; it is spring, fountain and rivulet; it is a narrow path which leads to a delightful sojourn; it is a small receptacle secured by a ruby clasp, a dainty morsel, and so on. The written cunt is, therefore, *excessive*. That which the male imaginary construes as the mark of an absence is turned, through accumulation and displacements, into a compensatory cornucopia – 'I know very well there is nothing there, but nevertheless *everything* is there'. The *Blason du C.* is a spirited eulogy which nevertheless bears the mark of ambivalence toward its object in the very rhetoric of its construction – a rhetoric dominated by antithesis. Source of both pleasure and anxiety, the *con* is at once lion and dainty morsel; it is at once the devouring mouth and the delectable food to be devoured.

In her essay, 'Diana Described: Scattered Woman and Scattered Rhymes',[35] Nancy J. Vickers considers the dynamics of fragmentation in Petrarch's writings on Laura[36] by examining a myth of disintegration – that of the male body in the Ovidian myth of Actaeon. Upon seeing the naked body of

Diana, Actaeon is turned into a stag by the vengeful goddess; he is then hunted to death by his own hounds, who dismember his body. Petrarch's *Canzone XXIII* relates an imaginary encounter between the unrequited lover and the dazzling nakedness of the woman he desires. Like Actaeon, the poet undergoes metamorphosis at seeing a forbidden nakedness, but unlike Actaeon he escapes the fate of dismemberment. Vickers writes:

> The Actaeon-Diana encounter . . . re-enacts a scene fundamental to theorizing about fetishistic perversion: the troubling encounter of a male child with female nudity, with a body that suggests the possibility of dismemberment. Woman's body, albeit divine, is displayed to Actaeon, and his body, as a consequence, is literally taken apart. Petrarch's Actaeon, having read his Ovid, realizes what will ensue: his response to the threat of imminent dismemberment is the neutralization, through descriptive dismemberment, of the threat. He transforms the visible totality into scattered words, the body into signs.[37]

The link thus established between the discursive fragmentation of the feminine body, and the imaginary dismemberment of the male body, upon seeing 'naked femininity', succinctly and effectively reinserts the materiality of the male body into the space of the text, reminding us of the fact that the poetic discourse issues from within that body – a social body, without doubt, but more fundamentally a *sensuous* body. It further brings to the forefront the intensity of affect with which the threat is perceived – an intensity which turns an imaginary threat into its literary 'actualization', in an hallucinatory impulse which invokes the dynamics of those early stages of perception when 'reality' and fantasy were indistinguishable.

Vickers's reading of the tale of Actaeon, as a literary *re-enactment of a trauma*, affords us a further insight into the narratives that underlie the poetic productions of 'beautiful fragments'. I think particularly of Freud's story of the child at play, who repeatedly throws out of sight a wooden reel attached to a piece of string, and retrieves it to the joyful utterance of 'da'.[38] Freud interprets this game of loss and recovery (the 'fort-da' game) as the re-enactment of the departure, and return, of the child's mother. He first suggests

that the symbolic repetition of the distressing experience of the disappearance of the mother is but a necessary prelimi-nary to the revival of pleasure at her return. This explanation, however, does not account for the fact that the first part of the action – the re-enactment of the loss – is performed far more often than the second. Unsatisfied, Freud seeks another interpretation, one based in his perception of a play of power relations. In staging the disappearance of the object/mother, the child takes an *active* part in a scenario in which it previously had been the passive victim. The drive for mastery, therefore, would operate independently of the affects attached to the memory. Still within the dynamics of such early power relations, Freud further attributes a meaning of defiance to the act of throwing the object, which would thus provide a means of satisfaction of the child's aggressive, vengeful impulses towards his mother.

Petrarch re-writes the tale of Actaeon's encounter with the goddess, casting himself in the role of the unfortunate voyeur, and re-enacting, on paper, the violent vivisection which is the climax of Ovid's tale. The repetition of a pre-Oedipal trauma at the level of language is a re-assertion of symbolic mastery over the imaginary threat that is embodied in the feminine form – it is, at least structurally, a sort of grown-up version of the 'fort-da' game. In the privileged role of author/actor, in a further act of mastery, Petrarch suspends the narrative at the moment of its climax, sparing himself the bloody fate of dismemberment. This fate is to be displaced onto another. The body he will scatter across the page in a constellation of literary fragments is that of Laura, and it is also the archaic maternal body – the phantasmatic object of the infant/poet's amorous hatred.

4 The girl of the Golden Mean

ટ≫ *Like the gardener who forces the box-wood to live in the shape of a*
ball, a cone, a cube, man imposes on the image of the woman his
elementary certitudes, the geometrical and algebraic habits of his
thought
HANS BELLMER[1]

From *Honey*, 1986:

> *How to become a model –*
>
> BASIC PHYSICAL REQUIREMENTS: You must be, or have: At least 5'7" tall. Slim and well-proportioned – most models are size 10/12 . . . A regularly shaped face. A straight nose, with no bumps or curves . . . Regular, white teeth with no gaps.[2]

From *The Photography of Women*, 1965:

> Give or take one or two inches, hips and bust that measure 36 inches at their largest parts should have a waistline 10 inches less or 26 inches in all. These dimensions may be scaled up or down. However, proportions should be about the same, with measurements changing with the model's height. As an example, hips and bust that measure 34 inches should have a waist measuring 24 inches. For photographic purposes, the model's height is relatively unimportant if her proportions, on a vertical plane, divide into four equal parts.[3]

From *Atlas of Foreshortening*, 1984:

> 'During the course of making the photographs, one of the models asked, "what are you after, anyway, definition?" . . . No, we were not aiming to capture definition of the body . . . Rather, what we were after was *proportion*, the relation of parts of the body under special viewing conditions. We also wanted to capture the sense of design that the various masses of the body create when they are deployed in space under a wide variety of arrangements. We chose as our models, therefore, those with the most

harmoniously developed, well-proportioned, and normal bodies we could find.'[4]

When the enamoured young hero of Villiers de l'Isle-Adam's novel, *L'Eve Future*, praises the beauty of his mistress, he does so by likening her physical features to those of the *Venus Victorious*, thus invoking a Classical tradition of representation which applied the apparatus of arithmetic and geometry to the harmonious rendering of a body otherwise afflicted with irregularities. To take a modern and non-fictional example, when plastic surgeon Marc-Henri Bon remodels a nose, a chin or a breast, it is also to the Classical tradition that he turns. In his waiting room in the 16th *arrondissement*, stands a life-size bronze statue of a naked woman. The contingent fact that it was made in the 1920s is irrelevant; it is the projection into the present of a Classical ideal. Thus Dr Bon defines the 'objective criteria of beauty . . . symmetry in relation to a vertical line . . . Clearness of surfaces. Proportionality of volumes through the application of the golden rule.'[5]

&❧ *The human intellect, from its peculiar nature, easily supposes a greater order and equality in things than it actually finds; and while there are many things in Nature unique, and quite irregular, still it feigns parallels, correspondents and relations that have no existence*
FRANCIS BACON[6]

Most chronological accounts of the changing concept of proportion in Western representation begin in the sixth century BC, with Pythagoras. Believed to be the founder of theoretical geometry, Pythagoras is also attributed with, amongst other things, the foundation of a theory of musical harmony and, somewhat more contentiously, the first sketch of the calculation of proportions. The theological framework within which Pythagoras formulated his theory of numbers encouraged abstract speculation, freeing mathematics from its formerly utilitarian function. From his considerations of the interrelation between sound, space and numbers in the musical consonances,[7] he conceived of a universal harmony that was premised upon the belief that number is the origin of all things. Numbers were henceforth to be represented spatially as bounded plane figures – '4' as a square, '3' as a triangle, and so on. Pythagoras' mystical cosmology evolved

out of a way of life constrained by taboos and interdictions of all kinds and punctuated by rites of purification; it was a way of life grounded in a system of collective education that shaped the body through physical exercise and the regulating of nourishment. Such asceticism was the retort of Pythagoras and his followers to the excesses of the aristocracy; it was a complete religio-political project which aimed to bring about the triumph of virtue over vice, of egalitarianism over inequality, of harmony over discord. Alongside the strictest physical training, the Pythagorean curriculum included the teaching of the art of music – an art the virtue of which (and this is Plutarch speaking on behalf of Pythagoras), 'should be perceived by the intellect'.[8] Pythagoras turned a deaf ear to Marsyas' reed-pipes and the testimony of the senses; he stretched the arithmetic harmony of the lyre to the purest register of nature, to the sky and its stars. In the Pythagorean system, 'Nature appeared in harmony with mathematical thought, and beauty with both nature and mathematics.'[9]

When, in the *Timaeus*, the Demiurgos begins to work on the creation of the universe, in 'the deliberate constructive capacity of a craftsman',[10] he resorts to two kinds of Pythagorean mathematic. To create the soul of the world he first mixes the raw material of Indivisible and Divisible Existence, Sameness and Difference, into an 'Intermediate' state; he finally arrives at a mixture in which the Same and the Different, 'by nature allergic' to each other, are forced into union with Existence. He then proceeds to divide the long strip formed by the mixture according to numerical ratios derived from the harmonic intervals of the musical scale. He then cuts it into two narrower strips, which he places crosswise and bends around to fasten their ends into two rings: the outer circle of the Same for the fixed stars, the inner circle of the Different for the planets.[11] To create the body of the world out of primordial chaos, the Demiurgos resorts to the incommensurable measurements of geometrical figures, thus departing from the simple arithmetic harmony of the integers to arrive at a superior form of harmony established between magnitudes which have no common measure.[12] His initial task is to give 'a definite pattern of shape and number' to that which lacks definition. He works from two basic geometrical units, the scalene and the isosceles triangles. From these he arrives at the five regular solids, which Wittkower describes as 'the most

perfect geometrical configurations' because they are the only five solids with equal sides, equal faces and equal angles.[13] Having thus defined the 'proper' nature of the elements, the Demiurgos goes on to order them into a coherent whole according to the rules of 'continued geometrical proportion'. Having chosen air and water as the connecting middle terms between fire and earth, he 'placed water and air between fire and earth, and made them so far as possible proportional to one another, so that air is to water as water is to earth; and in this way he bound the world into a visible and tangible whole.'[14]

According to the Platonic tradition, the Demiurgos had set aside the 'smoothest' triangles for the production of the mortal body. The sculptor Polyclitus sought to establish mathematical relations between anatomically distinct parts and the body as a whole – of one finger to the other, of all the fingers to the hand, of all parts to all others. The human body was measured and nature was discovered to be perfectly rational. In the words of Vitruvius, 'if Nature has planned the human body so that the numbers correspond in their proportions to its complete configuration, the ancients seem to have had reason in determining that in execution of their works they should observe an exact adjustment of the several members to the general pattern of the plan.'[15] In the play of projections, reason became naturalized, while nature became rationalized. Vitruvius suggested that human proportions be identified with those of buildings; the artists of the Renaissance undertook to establish the architectonic symmetry of the living body, and the anthropomorphic dynamism of architecture.

The Pythagorean-Platonic concept of numerical ratios was wholeheartedly endorsed by medieval theological, philosophical and aesthetic thought; however, it remained marginal to the visual practices of the times. To the commensurability of common ratios, the medieval artist preferred the incommensurability of geometrical figures – the stuff from which the Demiurgos had created the body of the world. Wittkower remarks that the medieval artist tended 'to project a pre-established geometrical norm into his imagery'.[16] The example of this approach that is most often cited is Villard de Honnecourt's drawings, where the structure of the body is practically ignored as 'the system of lines – often conceived from a purely ornamental point of view and at times quite

comparable to the shapes of Gothic tracery – is superimposed upon the human form like an independent wire framework.'[17] De Honnecourt's representational system was a technical expedient, a constructional aid; but as well as forming a set of guidelines for 'lively and realistic drawing', it was also, as Umberto Eco suggests, 'a reflection . . . of the theory that beauty resides in the proportion which reveals and is produced by the splendour of form.'[18] Saint Augustine had praised the beauty of geometrical figures, particularly that of the circle and, above all, the beauty of the point – indivisible, centre, beginning and end of itself. In the Byzantine canon the configuration of the face, expressed as multiples of the nose-length, was rendered (halo included) by three concentric circles which had their common centre at the root of the nose. The inscription of the human body in plane geometrical figures made for a more schematic rendering of that body which, it is often argued, best served the symbolic function of images. By asserting the regularity of geometrical configuration – irreconcilable with the organic structure of the human figure – the intellectual and the spiritual imprint of the organising power was emphasized, rather than the physical presence of the represented.[19]

The Renaissance artist favoured the neatness of integers as he worked 'to extract a metrical norm from the natural phenomena that surrounded him.'[20] Vitruvius had formulated proportions as common fractions of the length of the figure: for example, the face from hairline to chin is one-tenth of the total height. In order to check the accuracy of the data recorded by Vitruvius, a few Florentine artists of the fifteenth and sixteenth centuries made measurements of ancient statues, and occasionally came upon divergent results. They applied the same method to the living body, and arrived at the formulation of three canons: the ten-face length, the nine-face length, and a shorter length, each to be related 'according to taste, with specific gods, with the three styles of classical architecture, or with the categories of nobility, beauty, and grace.'[21] There thus appeared to be no single and absolute relation between canons of human proportion and physical beauty. Systems of proportion were developed to establish ideals of different physical types – types perhaps not always described as beautiful, but arguably imbued with that idea of purity and absoluteness that was indissociable from contemporary notions of beauty.

Indeed, when Leone Battista Alberti worked out his own original system of proportion, based on the observation and measurements of many individuals belonging to different physical types, his aim was to represent not merely the beauty of this or that body but, 'that perfect beauty distributed by nature, as it were in fixed proportions, among many bodies.' He divided the total length of the body into six *pedes*, sixty *unceolae*, and six hundred *minuta*. This smallest unit Albrecht Dürer would subsequently subdivide into three, to arrive at the *Trümlein* – a measurement of less than a millimetre. Like Alberti and Leonardo, Dürer grounded his work on human proportion in the observation of nature. Unlike Alberti, but in accord with Leonardo, he rejected the idea of a singular human beauty in order to assert a plurality of physical beauties; a plurality expressed, nevertheless, in terms of the ruling principle of arithmetical exactness – there was equal beauty in the short type, the thin type, the fat type, so long as they were 'well proportioned'.

Leonardo da Vinci's observation of nature took him beneath the criss-crossed skin of metrical data, beneath the protective human envelope, to another body, 'quartered and flayed and horrible to behold'.[22] 'I have dissected more than ten human bodies', Leonardo writes. He meticulously examined, measured and drew the bones, sinews, muscles, tendons and veins; these abject and pathetic body-parts he articulated into a harmonious totality: 'Though human ingenuity may make various inventions answering by different machines to the same end, it will never devise an invention more beautiful, more simple, more direct than does Nature; because in her inventions nothing is lacking, and nothing is superfluous.'[23] Each limb, each organ was designed to serve perfectly its particular purpose in the service of the whole; each movement was governed by the unifying principle of 'continuous and uniform circular motion'. The arm described a perfect circle; the body as a whole was contained within a square and a circle, and further inscribed in the receding grid of perspectival space.

Panofsky concludes his survey of the 'History of the Theory of Human Proportions' at the end of the sixteenth century. The methods of measurement established by Dürer were further developed in their application to the new sciences of criminology, anthropology and biology. In the domain of artistic practice, however, the development of theories of

human proportions was arrested in a set of rules stripped of their metaphysical character. From the late sixteenth century onwards, canons of proportion, together with perspective, were taught in the Academies. Books of engravings of all the most famous Classical statues, together with a careful analysis of their proportions, were published. The purpose of such books was to provide the artist with models, believed to be endowed with mathematically 'correct' proportions, that he could simply emulate, freeing him from the arduous task of having to construct them himself. Moreover, as Reynolds would assert: '. . . the works of ancient sculpture were produced, not by measuring but in consequence of that correctness of eye which they had acquired by long habit.'[24] Numbers had been the means through which to arrive at beauty, and the Renaissance had spent itself 'recognizing' in all the products of Nature the imprint of mathematical ordering. From the seventeenth century, beauty no longer resided in the numerically expressible regularity of the object. It had become the manifestation of a sensibility, a subjective phenomenon, as expressed in de Piles' truism: 'But according to general opinion there is no definition of the beautiful: Beauty they say is nothing real; everyone judges of it according to his own taste, and 'tis nothing but what pleases.'[25] If there was beauty in order, then it was in the recognition of the forming power of the human mind. Shaftesbury affirmed: '". . . the beautiful, the fair, the comely, were never in the matter, but in the art and design; never in body itself, but in the form or forming power." Does not the beautiful form confess this, and speak the beauty of the design whenever it strikes you? What is it but the design which strikes? What is it you admire but mind, or the effect of mind?'[26]

Without the context of a metaphysics of numbers, and without the correlated developments of theories of proportions, considerations of beauty nevertheless remained bound to an ideal of harmony. Descartes had spoken of beauty as 'an agreement and equilibrium of all the parts so exact that no one part dominates the other',[27] a definition later echoed by Diderot. In finding objects beautiful, Diderot wrote, 'I mean nothing other than that I perceive, between the parts of which they are composed, some order, arrangements, symmetry, relations (for all these terms designate nothing but different ways of conceiving the relations themselves).'[28]

However, the order of which Diderot spoke is not simply to be found in nature, it is to a certain degree produced by the beholder in the encounter with the object: 'the relation, in general, is an operation of the understanding . . . it nonetheless has its foundation in things.'[29] Burke took issue with the old belief in the beauty of exact measurements in the sections of his *Enquiry* headed 'Proportion not the cause of Beauty', while Hogarth questioned the rigidity of the rules of proportion with a little playfulness: 'Intricacy in form, therefore, I shall define to be that peculiarity in the lines, which compose it, that *leads the eye a wanton kind of chase*, and from the pleasure that it gives the mind, entitles it to the name of beautiful.'[30] That 'peculiarity in the line', Hogarth names 'serpentine' – a sinuosity more evocative of a caress, or the outline of a body, than the pure formality of mathematical ratios.

The dogmas of the Academies gave way under the pressure of a new subjectivity which was to find diverse expressions from the nineteenth century to the present day. The subject matter of art shifted from the Ideal to the existential: the representation of human passions in Romanticism; the translation into paint of the perceptual experience of the environment in Impressionism; the picturing of a world viewed through the prism of emotions in Expressionism. André Masson writes: 'Expression tends to replace beauty, in the romantics certainly, but ever since the sixteenth century: of a painting by Greco, one says that it is expressive, one does not say that it is beautiful.'[31] The inscription in the work of art of a subjectivity that is seemingly unmediated by the principles of reason is felt to run counter to aesthetic pleasure.

From the end of the nineteenth century up to the 1960s, the aesthetic value of mathematical ratios became the subject of heated debates – mainly in the field of architecture and mathematics. Books were published on the aesthetic value of the Golden Section; on the aesthetic insignificance of the Golden Section; on the beauty of the Root-five Rectangle; the beauty of commensurable ratios; and so on. In the 1920s, Le Corbusier designed his Modulor, a scaling system which was also a system of proportion based on the ratio of the Golden Section. The norm extracted from these measurements was a man whose height was 1.83 metres; or, with his arm raised above his head, 2.26 metres – a position which made the centre of the body coincident with the navel, and thus used a

convention familiar from the Renaissance. We may note that the 1920s was the age of the machine and of Taylorism, when everything from architecture to the feminine figure (in its cloche hat, closely cropped hair and straight dress), displayed the bare lines of calculated efficiency.

The First International Congress on Proportion in the Arts was held in 1951. Philosophers, painters, architects, musicologists, art historians, engineers and critics gathered together around a common belief, 'that some kind of controlling or regulative system of proportion was desirable.'[32] However, in 1957, at the Royal Institute of British Architects in London, a motion that 'systems of proportion make good design easier and bad design more difficult' was defeated, with forty-eight voting for and sixty against. Nevertheless, the belief in the aesthetic value of exact measurements did not die. Today, what began in Classical times as an explicitly elaborate theoretical and practical apparatus, has devolved into a set of fuzzy assumptions that pervade the everyday language of aesthetic appreciation of the body – particularly the feminine body. Such assumptions punctuate the pages of fashion and glamour magazines and linger in technical manuals of art practice and in art history books. For example, a contemporary historian writes: 'Painting this woman from a race noted for its beauty of proportions and colouring, Delacroix captures the subtle range of Circassian flesh tones and characteristic chestnut hues of hair and eyes.'[33] Furthermore, proportional assumptions are necessarily implicit in the discourse of any artist who looks back to the Classical tradition. In the words of Masson: 'For me, Greek art remains the pivot for all discussion on beauty . . . there is something magical in beauty, that is why crowds still file in front of the Venus de Milo, where she remains *whole*, where she remains *untouched*.'[34] Here, precisely, beauty resides in the *integrity* of the body. *Integrity*: from 'Integer' – 'L. Integer intact, f. in- + tag-, teg- root of tangere touch.'[35]

 . . . *two kinds of photographs. The first represents a room bathed in light, the second the face and breast of Jane Russell. The central room of the Maubergeon tower in Poitiers, built according to the 'golden mean', gives the tower such proportions that a man can stand in it at midday without casting a shadow on the ground*

JEAN-MICHEL RABATÉ[36]

Can you not . . . call to mind some other forms of a fair kind among us, where the admiration of beauty is apt to lead to as irregular a consequence? I feared, said I, indeed, where this would end, and was apprehensive you would force me at last to think of certain powerful forms in human kind which draw after them a set of eager desires, wishes and hopes; no way suitable I must confess, to your rational and refined contemplation of beauty. The proportions of this living architecture, as wonderful as they are, inspire nothing of a studious and contemplative kind. The more they are viewed, the further they are from satisfying by mere view. Let that which satisfies be ever so disproportionable an effect, or ever so foreign to its cause, censure it as you please, you must allow, however, that it is natural . . .

A. A. COOPER, EARL OF SHAFTESBURY[37]

In a letter to his friend, Paul Fréart de Chantelou, Nicolas Poussin writes: 'I am sure that the beautiful girls you saw in Nîmes would have delighted your mind's eye no less than the sight of the beautiful colonnades of the Maison Carrée, since the latter are nothing else than old copies of the former.'[38] The living architecture which so worries Shaftesbury's *maître penseur* is indeed, in the words of Poussin, 'delectable'. However, the pleasure it brings is not, we are told, the 'feared' sensual *frisson*, but the intellectual appreciation of the form achieved through 'studious contemplation'. The likening of the Corinthian columns of the Maison Carrée to the feminine form lends sensuality to the carved stone, as sensuality is drained from the body of the passers-by who are turned to stone. I recall here a drawing from Francesco di Giorgio's *Trattati*:[39] the naked figure of a young woman enveloped by the outlines of a column; in the foreground, a fully clothed man poised as if about to deliver a learned commentary on this strange incarceration. Francesco's drawing refers to the Vitruvian tradition of identifying human proportions with those of columns according to male and female canons, a tradition to which Poussin alludes in his letter. The Ionic and Corinthian columns, characterized by grace and slenderness, were on the side of the female (the latter, being even more slender than the former, were associated with virgins). Another familiar image comes to mind here, that of the self-portrait of the artist with his model: she, posing, partially or wholly undressed; he seated at his canvas, brush poised. What brings this other picture to my mind as I look at Francesco's instructive drawing, is the structural similarity

between the two representations. In both, three elements combine to form the pictorial space, a place of work: the sovereign male creator; his sexual object, the model; and the intervening cultural product, the work of art. The cultural and the sexual objects, which normally occupy distinct spaces in the formulaic self-portrait, are conflated in Francesco's drawing. Shaftesbury's interlocutors, for fear of the 'irregular' and 'disproportionable' consequences which the thought of such 'wonderful proportions', may bring, return to the topic of architecture with renewed passion. Poussin continues: 'It is, it seems to me, immensely satisfying when, in the course of our work, there is something sweet to soothe the pain of it. I never feel so stimulated to make an effort, and to work, as when I have seen some beautiful object.'[40] Viewing and reading the scenarios of cultural production described above, I am caught in an oscillation between the woman's body and the cultural product which, in Francesco's revealing drawing, fuse, inter-laced within the same space. I have already briefly discussed the 'sliding' between the female form and the work of art in the context of descriptive poetry about the woman's body. Here I wish to look at the psychodynamic aspects of this particular movement from the real to representation – a movement which is concerned with the opposition 'sexual/non-sexual'. The more particular object of my inquiry is this associative sliding from, in Jean-Michel Rabaté's words, the 'formal beauty' of the Golden Ratio, to the 'mammary . . . rather regressive beauty' of Jane Russell, and the fusing of the two in the 'mathematisation' of the woman's body.

In the words of Schelling, the movement from real to representation would be:

> . . . the complete intellectualizing of all natural laws into laws of intuition and thought. The phenomena (the material element) would have to disappear fully and only the laws (the formal element) remain. Hence it is that the more the lawful element appears in nature itself, the more the material husk disappears; the phenomena themselves become more mental and in the end entirely cease to be.[41]

The total dissolution of phenomena into abstraction would be the highest form of perfection. The direct passage from a solid to a gaseous state is known in chemistry as 'sublimation'. The same term evokes the idea of 'sublime', used in the discourse

of aesthetics to qualify works that are terrifyingly grand or uplifting. In the context of psychoanalysis, 'sublimation' is 'the process postulated by Freud to account for human activities which have no apparent connection to sexuality but which are assumed to be motivated by the force of the sexual instinct' (sexual drive)[42] – socially valued activities such as artistic creation and intellectual inquiry. Although Freud invokes the idea of sublimation throughout his work, he does not offer a coherent theory of the process. In his lectures on sublimation, Jean Laplanche systematically unpacks Freud's writings on the subject.[43] Again, we are not offered a unified theory, but rather the complexities of the concept which Laplanche shatters into countless ramifications. In bringing some of the theoretical fragments together, I am not attempting to present a coherent account of sublimation; I simply wish to make use of the theory as it is, fragmented, underdeveloped, problematical, but nevertheless suggestive.

Freud writes: 'The sexual instinct (sexual drive). . . places extraordinarily large amounts of force at the disposal of civilized activity, and it does this in virtue of its especially marked characteristic of being able to displace its aim without materially diminishing in intensity. This capacity to exchange its originally sexual aim for another one, which is no longer sexual but which is psychically related to the first aim, is called the capacity for *sublimation*.'[44] In other words, the energy that goes into cultural productions is sexual energy which has been diverted from its original sexual aim. One should note here that the status of the object in Freud's writings on sublimation is uncertain; sometimes the change in the aim is accompanied by a change of object: sometimes the change concerns the aim alone. In the particular instance I am concerned with here – the representation of the female body – there is a change of object: from the living woman to the work of art. However, the object of the sublimated drive still bears, to a varying degree, the features of the sexual object. The closeness of the sexual object to the sublimated object in imitative representation takes on a more literal meaning if we recall the self-portrait of the artist at work, which we may now read as a *mise-en-scène* of sublimation. Alongside traditional forms of representations such as photography, painting and so on, I wish to add a relatively new form of representation whose sublimated object is no less than the sexual object itself. Plastic surgery is

the practice by which bodies – mainly female bodies – are remodelled according to an ideal of physical perfection. I am not talking here of the youth-restoring function of plastic surgery, but of its 'corrective' function, with its strict adherence to a discourse of deviations, asymmetries, broken lines and correct proportions.

The structural support for the diversion of sexuality into other paths is provided by the early interdependence of the sexual and the self-preservative drives, and their subsequent splitting. Because of the founding relationship between sexual drives and vital functions – a relationship described as 'anaclitic' – it is always possible for the non-sexual functions to be later tainted by sexuality (as they are in psychogenic disturbances of eating, vision and so on). It is also possible for the sexual drives to take the pathways thus laid out to arrive at aims which are other than sexual, as in sublimation. Laplanche insists that sublimation is *not* anaclisis 'the other way round' – from the sexual back to the self-preservative. He makes a clear distinction between the self-preservative drives and the ego-drives: the former having to do with, for instance, eating in order to survive, which becomes, in the latter, eating for the love of the ego. The ego-drives take charge, at the level of sexuality, of the interests of self-preservation (here Laplanche notes that the ego often fails in its capacity as representative of the 'general interest'). Laplanche therefore situates the 'desexualized' drive of sublimation not on the plane of self-preservation, but on the plane of the ego, that is, of the sexual – but that portion of the sexual which is kept in check, bound to, invested in, an object; that portion which does not exhaust itself in discharge, but obeys the principle of *stasis*. This notion of equilibrium, of constancy, is central to the ideal of harmony within which theories of human proportion are inscribed. It is made manifest in the application of these theories as the organization of disparate parts around a common mean – a metrical unit or the median line that divides the body into two symmetrical parts. Galen (*c.* AD 129–99), in *De Temperamentis*, described symmetry as that state of mind which is equally removed from both extremes.

Sublimation is a consequence of the failure of the component drives to achieve a complete integration into the form of genitality. During the development of the sexual drive from

the autonomy of the erotogenic zones, to their subjection under the primacy of the genitals:

> . . . part of the sexual excitation which is provided by the subject's own body is inhibited as being unserviceable for the reproductive function and in favourable cases is brought to sublimation. The forces that can be employed for cultural activities are thus to a great extent obtained through the suppression of what are known as the perverse elements of sexual excitation.[45]

Sublimation is premised upon the fact of the repression of infantile polymorphous sexuality in the process of socialization. It is made possible by the whole or partial suppression of the non-integrated component-drives, and the re-directing of energy into other aims. Sublimation is therefore contingent upon the fundamental plasticity of the sexual drive.

In a later essay, Freud suggests that the diversion of sexual energy towards non-sexual aims could be contingent upon the withdrawal of the libido onto the ego, and the transformation of object-libido into narcissistic-libido. Freud writes: 'Indeed the question arises, and deserves careful consideration, whether this is not the universal road to sublimation, whether all sublimation does not take place through the mediation of the ego, which begins by changing sexual object-libido into narcissistic libido and then perhaps goes on to give it another aim.'[46] Sublimation would depend on the narcissistic dimension of the ego, when it is the ego in its entirety which is taken as love-object. The notion of 'socially-valued activities' has to be understood in terms of this narcissistic dimension – the dimension of infantile omnipotence and the subjection, in identification, of this early ideal to the exigencies of authority. As for the product of these socially-valued activities – the sublimated object – it 'may be expected to display the same appearance of a beautiful whole which Freud here assigns to the ego'.[47]

In his essay on Leonardo da Vinci,[48] Freud discusses two types of cultural activity: scientific research and the practice of art. He initially distinguishes between the two activities – the intellectual inquiry only is the outcome of sublimation – but finally opposes the two as one sublimation to another. What is at stake in Freud's initial distinction is the inscription of the body in art practices, as contrasted to the relative 'disembodi-

ment' at work in the exercise of mental faculties. For instance, the act of painting is a highly sensual experience – tactile and olfactory as well as visual. The brush stroke is a bodily trace on the canvas, and the manipulation of the paint parallels the pleasure children take in playing with their faeces ('It is not really a metaphor to say that the recent market for freshly-done expressionism has been dealing in shit'[49]). From the seeming unruliness of expressionism, to the explicit observance of rules of representation in figurative art, to the very rules themselves, we witness degrees of sublimation, degrees of *mise-à-distance* of the sensuous body.[50] To recall Schelling's words, 'the phenomena themselves become more mental and in the end entirely cease to be'. The mathematization of the 'well-proportioned' body offers a privileged instance of sublimation. The material body dissolves into the abstraction or mathematical equivalences. In the play of intellectual faculties the artist becomes disembodied, and the depicted body surrenders to the angular regularity of grids of measurement. The most perfect instance of this form of sublimation must have been Dürer's elaboration of the proportional system to a degree of refinement whereby he could no longer see the body for the *Trümlein* (shades of Frenhofer).

In an essay on sublimation, based on the analysis of one of his patients, Hans Thorner finds it necessary to differentiate between 'attention' and 'concentration'. He writes: 'Concentration is splitting to exclude other things. Attention is perceptiveness to stimuli which emanate from other objects.'[51] Concentration, therefore, is here interpreted as a process of defence: by means of concentration, Thorner's patient 'created a barrier against disturbing external and internal influences.'[52] In this light, the close attention to 'correct measurements' in the representation and aesthetic appreciation of the body would be best characterized as concentration, and as a means of shutting out the sensuous body. Thorner's patient was alarmed, 'when thoughts and feelings emerged which could establish bonds and links, and these appeared as physical links'.[53] Without assigning a pathological dimension to the aesthete's interest in 'correct' measurements, there is nevertheless a telling symmetry in the compulsion to draw equivalences, internal relations between parts, and a defensive attitude towards establishing links with the outside world, towards being seduced. What I earlier

called 'the criss-crossed skin of metrical data', recalls Nietzsche's 'citadel of the Apollonian'; it offers a protection for the plastic artist, 'against becoming one and fused with his figures'.[54]

With respect to the idea of 'concentration', and in view of the particular structure of sublimation, I wish to cite one of Laplanche's suggestive elaborations of the concept of sublimation:

> So, if one speaks of the primacy of the genital as a means to coordinate the partial drives in a kind of unity which is the adult sexual relation, could we not say also, of the sublimated activity, that it is a kind of substitute for the primacy of the genital; it, too, is a way of coordinating the pre-genital activities under a kind of primacy, that of an artwork, a work, a result to achieve; but a synthesis which, unlike the genital synthesis, would perhaps take place under the sign of repression or disavowal, precisely under the sign of the disavowal of the genital?[55]

The sublimated activity, which makes use of the energy of inhibited partial drives, would therefore be a way of *organizing*, of concentrating, these drives under the primacy of a work, or more generally an 'achievement' – an organization which would, in effect, be a substitute for the unification of partial drives under the genital primacy of adult sexuality. Laplanche does not further elaborate on this. I would suggest, however, that if we were to search for evidence of this organizing principle of the sublimated activity, we would find it most manifestly in the application of theories of proportion to the representation of the body. Indeed the mathematization of the body offers itself as a privileged instance. Firstly, the activity of synthesis is literally present in the *drawing* of internal equivalences between body-parts. Secondly, the object of this organizing activity is the body (desired and desiring). Thirdly, in the very act of organizing this body, its sexuality is disavowed.

From the above remarks, sublimation appears as the unconditional, albeit punctual, surrendering of sexuality to the demands of culture. There is no repression of sexuality, but rather the redirecting of sexuality into a non-sexual aim; there is, therefore, neither the possibility nor the need for a return of the repressed. This is why Freud described sublimation as the

most 'perfect' vicissitude of the sexual drive: there is total subjection to socialization, and no symptom is produced. Laplanche has indicated how this 'perfect' state of non-sexual production is achieved through the synthesis of partial, anarchic drives under the primacy of an achievement. Sublimation therefore involves mastery – at the level of its very structure and at the level of its object. (Indeed, broadly speaking, the production of culture always involves a restructuring of our environment, which amounts to an act of mastery over it). According to Freud, the original aim of the drive to master is to control the external world, to fend off aggressions. As such it is self-preservative; that is, at a very fundamental level, it is preservative of the subject's bodily integrity. The ordering of the female form along the lines of an actual, or a conceptual, grid of measurements would be one such act of mastery over the object. Bearing in mind the particular ordering principle at work – the synthesis of body-parts around a common metrical mean – it further presents itself as a privileged instance of the subject's active re-affirmation of his own integrity. Laplanche and Pontalis suggest that the sublimated object may display the appearance of a beautiful whole assigned to the imaginary dimension of the ego – what Freud calls the 'ideal ego';[56] it seems particularly relevant here to recall Jacques Lacan's account of the emergence of this ideal ego out of the infant's imaginary anticipation of the apprehension and mastery of its bodily unity.

I spoke earlier of the sublimated object of plastic surgery. The mathematization of the female form inevitably takes on another dimension when the object is no longer an image of a woman, but the living woman herself. The conceptual grid of measurement is now inscribed with a scalpel into the living flesh itself. In one of Kafka's tales, the words of a judgement passed on a prisoner are cut into his flesh; women daily submit to similar inscriptions of the aesthetic judgement of proportion. Freud tells us that the self-preservative drive to master may, and most often does, become sexualized, and takes on a sadistic aim. A practice which involves destroying, at times violently, parts of the living body to then re-create them according to an ideal of correct measurements, clearly operates on the edge of sadism and/or masochism.[57]

I previously mentioned the infantile pleasure that the child

takes in playing with its faeces. Young children ascribe great value to their bodily products. This valorization is contingent upon various related factors. For example: the child's gradual acquisition of a sense of a separate identity which allows it to recognize the faeces as the products of its own body; the exercise of self-will over its bodily functions which is correlative to the sensuous pleasure experienced in defecation. The drive to master dominates this scenario. Through the exercise of the sphincteral musculature the child controls its own body and the object it produces. In playing with its faeces, the child not only masters the object through manipulation, but it also inscribes itself in the environment by proudly leaving its bodily marks all over the place. Why return to this scenario? It is the earliest prototypical instance of cultural production. It is an organizing instance which involves the mastery of the subject's own body, and through this the mastery of the environment. Significantly, however, the child fails to produce a *properly* cultural object. The infant's bodily production meets with parental disapproval or, at best, indifference; it is not socially valued. In his essay on 'Character and Anal Erotism', Freud suggests that the character traits of cleanliness and orderliness 'give exactly the impression of a reaction-formation against an interest in what is unclean and disturbing and should not be part of the body'.[58] The body Freud refers to here is an imaginary body, a 'skin-ego'[59] whose unity is premised upon the disavowal of the heterogeneous mass of internal organs, fluids and faeces which lie beneath its surface. In order to retain this imaginary unity, internal organs and bodily wastes must remain concealed beneath the human envelope, or be quickly flushed out of sight. Freud writes, 'Dirt is matter in the wrong place'. The mathematical ordering of the female body may be seen as another manifestation of the anxious desire to keep the body clean and integral, with all bodily material contained and ordered within the bounding grid-lines – with all matter 'in the right place'.

> The golden mean has certainly dissipated the shadows, and staged the anonymous disappearance of the subject . . . it perpetuates only the cold neutrality of the death of names and subjects. Such a neutrality can allow me to arrive at a form of beauty: sublimated, harmonious, transcendental, monadic, beyond accidents, reserved, encrypted crypt of a

code forever lost. . . . Contrary to this model of a formal beauty which offers nothing to see, a famous poster representing Jane Russell, looking sullen, the dark eyebrow slanting towards the curl on the temple, then the right shoulder, naked and offered to the gaze as far as the beginning of the breast, on a background of straw in the imaginary heat of a barn.[60]

The man who stands in the central hall of the Tour de Maubergeon under the midday sun casts no shadow. No shadow, therefore no body. The erasure of the body here is mythically attributed to the particular proportions of this hall, which was built according to the most 'perfect' mathematical ratio: the Golden Mean. This achievement of perfect beauty entails the loss of corporeal subjectivity in the purely formal play of mathematical ratios. It is the type of beauty which, as Rabaté says, offers nothing for the viewer to *see* – nothing but the intuition of the laws of the intellect. And then there is the other type of beauty, that of Jane Russell, all breasts in what Rabaté imagines to be the suffocating heat – *touffeur* – of a barn. The 'touffeur' here contains 'touffe' – a tuft of hair. Here is a beauty that is excessive in the display of signifiers of sensuous pleasure: the pointed breasts, the promise of genital pleasure. From sublimation back to sexuality, from one form of subjective annihilation to another. We may recall the publicity story, put about by the film studio, that Howard Hughes hired a structural engineer to design a bra capable of adequately containing Russell's breasts. Structurally, at least, we must assume that the engineer failed. Here, in the stifling barn, the protective grill of proportion, the restraining of mensuration, disappears like a midday shadow in the Tour de Maubergeon.

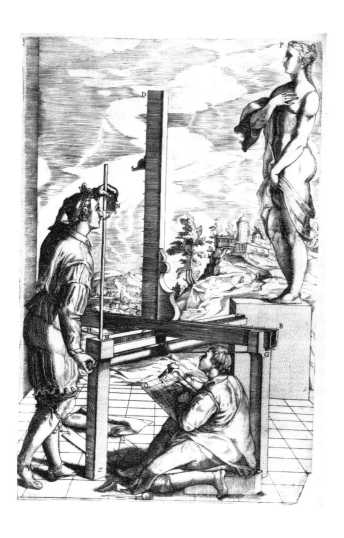

5 Woman as hieroglyph

❧ . . . *the most humanly sensitive and most beautiful passion, to*
abolish the wall that separates woman from her image
HANS BELLMER[1]

'Her beauty remains hidden, no-one could lift her veil.'[2] In
1911, Moret began his chapter on 'The Decipherment of
Hieroglyphs' with this line from a hymn to Isis; the line also
heralds certain of the key elements to be discussed in this
chapter and – more to my point – introduces the idea of a
beautiful and veiled woman. Between 1925 and 1932, Sig-
mund Freud worked on his essay on femininity: 'Throughout
history', he wrote, 'people have knocked their heads against
the riddle of the nature of femininity'; and he quotes from a
poem by Heinrich Heine:

> Heads in hieroglyphic bonnets
> Heads in turbans and black birettas,
> Heads in wigs and a thousand other
> Wretched, sweating heads of humans[3]

In an essay written in 1982 about the female spectator, Mary
Ann Doane puts woman and hieroglyph together by way of
this invocation of a hieroglyphic language in Freud's dis-
cussion of feminine sexuality. She writes:

> The semantic valence attributed to the hieroglyph is two-
> edged. In fact there is a sense in which it is inhabited by a
> contradiction. On the one hand, the hieroglyphic is sum-
> moned, particularly when it merges with a discourse on the
> woman, to connote an undecipherable language, a signify-
> ing system which denies its own function by failing to
> signify anything to the uninitiated, to those who do not
> hold the key. In this sense, the hieroglyphic, like the
> woman, harbours a mystery, an inaccessible otherness. On
> the other hand, the hieroglyphic is the most readable of all
> languages. Its immediacy, its accessibility are functions of
> its status as a pictorial language, a writing in images.[4]

For Doane, to speak or think of 'woman' is instantly and inevitably to evoke the woman's *body*. This (always already given) corporeality suffuses the woman's relationship to the environment of signs. Doane writes: 'For the female spectator there is a certain over-presence of the image – she *is* the image.'[5] Woman then, paradoxically, is both the enigma which eluded Freud, and a self-evident image. Doane's essay focuses on the status of the woman as subject of the look, in an order which produces her only as subject *to* the look – as object. For my part, I shall first discuss this 'objectification' of the woman (her reduction to an appearance, an image), and I shall then concentrate on her correlative production as *enigma*. I would stress that I shall not view the hieroglyph from the vantage point of Egyptology – which has taught us that hieroglyphics is a form of writing – but from the beliefs we may hold onto *in the face* of that scientific knowledge. These beliefs we can trace back to the Renaissance, to the inception of the myth of hieroglyphics as the iconic embodiment of a lost knowledge – a myth which speaks of a desire for the unmediated communication of a unitary truth. The Renaissance humanist explanation of the hieroglyph, in turn, draws its authority from Classical literature, and particularly from Plato's doctrine of the 'two worlds'.

In Plato's philosophy, birth is a trauma in which the soul is torn from the forms which it beheld directly in a state of wholeness. The now *embodied* soul sinks into the lower world of ordinary, everyday experience, always striving, through all its actions and creations, to regain access to the lost world of Ideal Forms. Above: the true and permanent world of eternal Forms or Ideas (the two terms are used interchangeably), of which the Good is the primary; the Good includes Beauty and Truth and is the source of all other Forms, such as Justice and Courage. Below: the unstable, 'sensuous', finite world of illusions, where everything is but a copy of an original in the Upper Region, and where we are condemned to attempt to communicate through the confused medium of verbal discourse. The Forms exist independently of consciousness. Plato does, however, grant us access to the Upper Region: we may apprehend the Forms, however imperfectly, in those privileged moments when, freed from the materiality of things, we experience such abstractions as 'Truth', 'Justice', 'Beauty'. The experience of Beauty takes place in our

encounter with objects which partake of the perfect Form of Beauty. Through these objects, imperfect representations of fragments of the Ideal, the embodied soul tries to possess (or more correctly, re-possess) Beauty, thus endlessly altering the World around it in its desire to shape that world in what can only be an imperfect image of the perfect, ideal Form.

The knowledge of Beauty that Plato urges us to seek beyond the materiality of things, then, is a *recollection* – the memory of the Forms that the soul beheld before its embodiment, a kind of return 'to a home we had forgotten'.[6] Some five hundred years later, Plotinus returns to Plato's theory of reminiscence in observing that the experience of beauty occurs when an object is fit to receive the Ideal Form, this fitness being, 'something that is perceived at the first glance, something which the Soul names as from an ancient knowledge and, recognising, welcomes it, enters in unison with it.'[7] It was, perhaps, with a similar kind of recognition that the 15th-century humanists returned to the ancient Egyptian scriptures in that 'reminiscence' on a grand scale that is known as the Renaissance. Writing about hieroglyphics, Plotinus had stated that the Egyptian sages '. . . drew pictures, engraving . . . a separate image for every separate item . . . for all manifes-tation of knowledge and wisdom is a distinct image, an object in itself, an immediate unity, not an aggregate of discursive reasoning and detailed willing.'[8] In citing this passage, Ficino adds that 'the Egyptian priests did not use individual letters to signify mysteries, but whole images of animals, plants, trees; because God had knowledge of things not through a multipli-city of thought processes, but rather as a simple and firm form of the thing.'[9] (It is important to note that hieroglyphics often depicted objects as a composite of different viewpoints – as if attempting to grasp them *whole*.) A complete, hieroglyphic image, therefore, does not represent a concept so much as it *embodies* it. Alberti stresses the universality of an imagistic language as opposed to the local application of words that can only be understood by respective nations – a universality which is, however, restricted to 'the ingenious Men of all Nations to whom alone they [the Egyptians] were of Opinion that Things of Moment were fit to be communicated.'[10] To Renaissance scholars, then, hieroglyphics were at one and the same time an imagistic system of writing which held the promise of unmediated access to a singular truth, and *a*

signifying system which did not signify.[11] Speaking of the Renaissance in their book on Michel Foucault (with reference to *The Order of Things*), Mark Cousins and Athar Hussain suggest that '. . . it may have been held that language had possessed an originary transparency before Babel in which the word had resembled the thing for all to see. But that knowledge had been lost and had to be reconstituted by interpretation.'[12] Cousins and Hussain identify the specificity of the Renaissance mode of interpretation in the principle that there is no difference between 'signs in nature' and 'signs upon parchment'. What the Renaissance humanists had glimpsed in this ancient writing in pictures, was the promise of a knowledge outside of any mediation – a knowledge gained through *things*, simply *seen*. Science was to eventually refute such fantasies. Nevertheless, when Champollion finally opened the door upon the secret of the hieroglyphs, his key was the name of a woman of mythical beauty – Cleopatra.

ই► *. . . this is the privilege of beauty that being the loveliest she is also the most palpable to sight . . . we find her . . . shining in clearness through the clearest aperture of sense. For sight is the most piercing of all our bodily senses*
PLATO[13]

In psychoanalytic theory, the infant (*infans* – 'without speech') occupies an essentially visual space. The child is born premature, 'unfinished', incapacitated by as yet incomplete motor faculties, but is very soon watchful. At the beginning, the neonate does not have a sense of itself, of the limitations of its own body; it incorporates its environment in a state of perceptual undifferentiation. It is only gradually that the various perceptive modalities – tactile, olfactory, auditory, visual – are distinguished, and that through these a sense of both self and other is eventually acquired. René Spitz gives the following account of the passage from non-differentiation, when tactile and visual perceptions merge, to differentiation, when seeing, no longer fused with touching, becomes 'distance perception' proper:

 . . . when the infant nurses at the breast, he *feels* the nipple in his mouth while at the same time he *sees* the mother's face. Here contact perception blends with distance

perception. The two become part and parcel of one single experience. This blending opens the path for a gradual shift from orientation through contact to orientation through distance perception. The experiential factor in this shift is that during nursing, e.g., when the infant loses the nipple and recovers it, contact with the need-gratifying percept is lost and recovered and lost and recovered, again and again. During the interval between loss and recovery of *contact* the other elements of the total perceptual unit, *distance perception* of the face remains unchanged. In the course of these repetitive experiences visual perception comes to be relied upon, for it is not lost; it proves to be the more constant and therefore the more rewarding of the two.[14]

At the early phase of development described here by Spitz, the neonate who gazes at the mother's face while suckling can be said to be ingesting the milk not only through the buccal cavity, but through the eyes and other sense organs. Seeing, as yet undifferentiated from contact perception, participates here in the life-preserving activity of feeding. In this context, we may recall Lacan's notion of the eye as an incorporative organ – 'the eye filled with voracity'.[15] This privileged moment, when all the senses are fused in the experience of oral satisfaction, affords the infant a plenitude which the inevitable loss of the nipple, and the consequent displeasure, interrupts. The primitive and ephemeral experience of an all-encompassing plenitude may be seen as providing a visual impression – not yet an image – which could be described as 'full'. Full, because at this moment there is no absence, and therefore no disjunction between need and satisfaction; no disjunction between perceptual experiences. The eye sucks in the milk, incorporating the visible as the need is gratified. The visible is both full (of milk) and filling. It is to this privileged instance of undifferentiation that I wish to link the fantasy of the hieroglyph – a 'full' 'sign' that admits of no disunity between seeing and knowing, signifier and signified.

The gradual shift from contact to distance perception, described by Spitz, initiates a different modality of looking. Now the infant fixes on the mother's face in order to sustain the pleasurable experience denied to him by interruption of tactile contact. We encounter, in this scenario of loss and displeasure, the first intimation of an extraneous object which

the infant attempts to master, however tenuously, by 'holding it' in view. In the distance between itself and the breast, whose comings and goings the infant cannot control, and the consequent delay of the gratification of need, desire is born. Freud considers the loss of the breast to be primary – a model for all subsequent losses which the subject suffers in its accession to subjectivity. The above account of subjective development further establishes this loss as inaugurating the infant's spectatorship. From these fleeting, and already imperfect, states of fusion with the mother in its earliest moments of life, the infant will gradually begin to view part of the maternal body as other than itself – as 'image'. Insofar as the object of the gaze evokes the lost experience of fulfilment there is now a pleasure in looking. Insofar as that object is evoked *as lost*, there is now also an ambivalence, an anxiety or melancholy, inhabiting the pleasure. The pleasure in looking may thus be overdetermined by a legacy of affect, which is displaced upon the present object of the gaze from the primitive experience of satisfaction. However, this same legacy includes an inseparable component of knowledge that the past pleasure was lost, and that this loss can, *will*, be repeated in the imminent future.

For Freud, the activity of looking has both a self-preservative and a sexual aspect; looking is a means of orientation, and as such he likens it to the exploratory act of touching or, more precisely, 'prodding'. Jean Laplanche provides the image of the tentacles of a protozoan, or the feelers of a snail, which bear its eyes, moving back and forth, in a kind of 'rhythmical emission'[16] – Lacan chose the image of the 'shoot'. Laplanche goes on to note that this non-sexual, self-preservative, activity of looking becomes a drive as it becomes representative: the infant gazes at the mother's face, which now comes to signify the polymorphous pleasure experienced at the breast. Pleasure in looking is afforded here on the model of oral incorporation, through the internalization of the scene of sensual gratification, a scene which Laplanche describes as 'extremely rudimentary . . . ultimately composed of partial objects . . . for example, a breast, a mouth, a movement of a mouth seizing the breast.'[17] Pleasure in looking is thus premised upon a necessary distance between viewer and viewed, and the subsequent erasure of this distance, when the viewer takes the viewed into itself. Internalization, Laplanche stresses, always involves mastery.

Pleasure in looking becomes jubilation when the infant comes to apprehend, for the first time, a *whole* body that is *its own*. This prototypical instance is described by Lacan as an *identification*, which he defines as 'the transformation that takes place in the subject when he assumes an image'.[18] Identification evolves out of the more archaic form of oral incorporation. The infant assimilates the bodily form of a counterpart, makes it its own; in doing so it anticipates a corporeal unity that its own body, still incapacitated by motor incoordination, does not possess. The term 'image', here, implies a corporeal form which is perceived as coherent and fixed – in a way that the child's own disjointed and turbulent phenomenological body is not. The first outline of an ego is thus an ideal image which the existential subject is unable to sustain in actuality. No sooner than it is found, this ideal image is lost: not only does it not tally with the actuality of the subject, but it is given, in the first place, 'as a *Gestalt*, in an exteriority . . .', that is, as already 'other'.

Loss is doubly inscribed in the drive to look. The loss of the breast is followed by the loss of the ideal self-image of the mirror stage ('lost' in that it is impossible to sustain in actuality).[19] To these two prototypical instances of loss, we might add a further, later, instance – one bound up with the recognition of sexual difference. Catherine Clément speaks of the mirror phase as the instant when 'one becomes oneself because one is no longer the same as one's mother'.[20] For the male child, the acknowledgement of sexual difference is a further instance of this realization, when the boy's belief in the 'phallic' mother is shattered; the mother is lost to him in that she is now perceived to be irreducibly and inauspiciously 'other'. It is a traumatic instance for the small boy for whom the recognition of the existence of another sex is inseparable from the realization that his own sexual integrity is now in question. I wish to stress here that what is perturbing is not the sight, real or imagined, of the female genitals, but that which the sight comes to mean: the possibility of castration for the small boy. Behind the tranquil pretence of the visible, the male child is suddenly confronted with the potential loss of its sexual integrity. That imaginary 'knowledge' the child had of things is literally shattered in his accession to the symbolic – to a knowledge now structured by language. (Language, we may recall here, is the mark of an absence, that of the referent, and

the site of a disjunction between signifier and signified). That which the child knew now becomes strange. Central to this estrangement, for the small boy, is the image of the 'castrated' woman. The castration complex marks the end of the Oedipal attachment to the mother. The relationship between viewer and scene, as described by Jaqueline Rose, 'is no longer a relationship of plenitude, but one of fracture, partial identification, pleasure and distrust.'[21] Cast down, dragged down under the weight of its *social* body, the now split and desiring subject incessantly strives to recover, in all its actions and creations, the lost state of plenitude.

℘ *I do not know if all the women in the photographs are beautiful, but I do know that the women are beautiful in the photographs*
GARRY WINOGRAND[22]

> Once lately, as I went up the steps to his house, I perceived that beside the curtain which generally covered a glass door, there was a small chink. What it was that excited my curiosity, I cannot explain; but I looked through. In the room I saw a female, tall, slender, but of perfect proportions, and splendidly dressed, sitting at a little table, on which she had placed both her arms, her hands being folded together. She sat opposite the door, so that I could see her angelically beautiful face. She did not appear to notice me.[23]

Nathanael watches Olimpia at a distance – a familiar scenario of voyeuristic pleasure. Olimpia is beautiful – framed in the gap, perfectly still, silent, her look strangely fixed as if 'it had no power of vision' – an *image*. In Hitchcock's *Rear Window*, James Stewart will awaken to the charms of his lover played by Grace Kelly only at the moment when the 'correct distance' is established, and he sees her three times framed: by the viewfinder of his camera, the frame of the window he is sitting at, and the window frame of the apartment she is searching. Victor Burgin describes a scene from the film *Funny Face* when Audrey Hepburn 'has moved to a position where her head appears as if framed by the mask of the enlarging easel on the wall behind her. Caught in the spotlight of the enlarger beam her sharply delineated features are now dramatically set apart from the dull red monochrome surround of the darkroom.

The camera slowly tracks in to close-up of Hepburn's flawless face, until it is framed only by the movie screen itself as, on the soundtrack, we hear Astaire finish his song: '. . . Your lovely, funny face'.[24] It is at this moment that Hepburn, having until then opposed the idea, agrees to become a model. This scene diagetically and formally establishes her as an image.

Laura Mulvey speaks of the way in which the visual presence of the woman in mainstream cinema, 'tends to work against the development of the story line, to freeze the flow of action in moments of erotic contemplation.'[25] Similarly, the narrative flow of popular fiction is typically *interrupted*, by the descriptive image of the woman:

> The elevator had a carpeted floor and mirrors and indirect lighting. It rose as softly as the mercury in a thermometer. The door whispered open, I wandered over the moss they used for a hall carpet and came to a door marked 814. I pushed a little button beside it, chimes rang inside and the door opened.
>
> She wore a street dress of pale green wool and a small cockeyed hat that hung on her ear like a butterfly. Her eyes were wide-set and there was thinking room between them. Their colour was lapis-lazuli and the colour of her hair dusky red, like a fire under control but still dangerous . . .[26]

Or, again, in a popular magazine:

> A tall girl strolls down the Champs-Elysées. Slender-toned to perfection, loose-limbed, dressed to kill. Every contour of her drop-dead body is wrapped tight in black leather; every measured step a statement of intent. Broad shouldered blouson clinched into a waspish waist, silky fine body-stocking, short skirt panelled to uplift firm buttocks with side zips that open to reveal only flesh. She stands still a second: unadorned, a streak of red lipstick for colour . . .[27]

The eye slides over the corporeal surface, detailing its particulars – the hat, the lipstick, the cut of flesh – as if it were taking bites, choice morsels, out of the picture it composes. Note that here the corporeal surface is a sartorial skin, a second skin of fripperies and colours which detains the gaze. Note also that a double arrest is inscribed in the brief *mise-en-scène* of fashionable display: the description interrupts the narrative as the model is stopped in her stride: 'she stands still a second', long

enough for the camera shutter to blink and for another picture be made. Similarly, the *wandering* description of the interior in the first extract above comes to a halt as the detective stops in front of the door, which opens to frame a woman: all that came before is but a preparatory staging. Both viewer and viewed have now become immobilized, *petrified* in the process of description.

To say that a woman is beautiful is a double abstraction. It is the invocation of something outside the representable – and thus in a sense a Platonic Form – but it is also the abstraction of an image from a continuum. The above scenarios are so many literary and filmic renderings of those instances when the gaze comes to rest, is arrested – instances which Barthes describes as mental acts of selection, of framing and cutting out, of *découpage*. I would stress that I am not using Barthes' term to refer to a wilful act of consciousness; by *découpage*, I mean the movement of abstraction of a part from a whole which is the result of the libidinal entrapment of the subject's helpless gaze by a privileged configuration. In Jensen's *Gradiva*, Norbert searches the streets for the womanly gait that has come to fascinate him.[28] It might seem that his fascination is with a motion, but in the tale the stated origin of his obsession is an image carved in stone from a fossilized past. When Norbert eventually finds the gait he seeks, in the streets of Pompeii, it proves to be that of his childhood sweetheart. The most desired, the most beautiful woman, is the woman from whose living movements a petrified image can be abstracted and inscribed in memory as if carved in stone – just as, in his dream of the destruction of Pompeii, Norbert witnesses the living Gradiva turn to stone.

Jean-Paul Sartre describes the experience of beauty as 'a sort of recoil in relation to the object contemplated which slips into nothingness so that, from this moment on, it is no longer *perceived*; it functions as an analogue of itself, that is, an unreal *image* of what it appears to us through its actual presence.'[29] Sartre's phenomenological description suggests that the experience of beauty takes place in a movement of defence, a drawing back from the object (perhaps in fear, or even in disgust). We may recall here the gaze of the infant, intently fixed upon part of the maternal body, feeding off its sight. Melanie Klein has shown us how these early experiences are inevitably fraught with privations and frustrations, how the

'good' providing breast can turn into the 'bad' breast which inflicts discomfort and pain, and how, therefore, the hungering eye will seek the maternal body with a desire that is soon inflected by distrust. We also know how this pre-Oedipal malaise comes to overdetermine castration anxiety at the moment of the recognition of sexual difference, and how the maternal/female body comes to signify the lack behind which all previous losses lurk. There is something of a disavowal with regard to the object in Sartre's description of the experience of beauty, when the actuality of the object – here the woman – is momentarily displaced by her 'image'; I know very well that here is a woman of flesh and blood and difference, but nevertheless, here is only this 'unreal image'. The mental *découpage* which interrupts the movement of the gaze, produces the seen, the woman, as an image that is detached from her corporeality, petrified, arrested in time – an image which, in Sartre's words, 'can be purely and simply the object, "itself" neutralized, annihilated . . .'[30] Seen in the light of those 'offensive' terms, the object of contemplation appears definitively threatening. Sartre concludes: '. . . as when I contemplate a beautiful woman or death at a bull fight.' The beautiful woman is associated with death. A particular death, however; one which in its ritual staging is offered as *spectacle*, an excess of visibility, and not as the brute fact of annihilation, the void of non-existence. The viewer can sustain the spectacle of death in the arena. Similarly caught up in the *appearance* of the woman, the man is able to disavow this 'nothing to see', this void which her difference comes to signify.

The experience of beauty described here by Sartre smacks of fetishism. It bears the quality of arrest and suspension which characterizes the election of a fetish. It is inhabited by a split in belief between the acknowledgement of the corporeality of the woman and its 'neutralization' in an image abstracted from the course of existence. It revolves around an excess of visibility which comes to fill or mask the imaginary lack embodied in the female form – just like the fetish. It is worth recalling here that the inception of the castration complex is a matter of deferred action – it is only after the castration threat has been internalized that the image of the female genitals, which had until then remained *insignificant* to the boy, is invested with a threatening meaning. The recoil of which

Sartre speaks would thus be a retreat from signification into the imaginary dimension of the 'purely visual'.

Silenced in an image, there is no more to her than that which meets his eyes: her eyes with the strange green fire, the streak of red lipstick, the dress of pale green wool with side zips that open to reveal only flesh . . . It is as if the feminine form had been emptied of its content, or, to keep to a one-dimensional metaphor more suited to the image, it is as if the form had been peeled away from its substance, its meanings. The fantasmatic production of woman as image bespeaks the desire for a presence, a fullness of the seen which would preclude ambiguity, disjunction, loss and lack. Paul-Laurent Assoun speaks of 'the obscure vocation of beauty to make believe, bolstered by the image, that the real is without fault.'[31] The beautiful woman is an appearance which the man *knows* 'at a glance', a 'plenitude' which is also, in Sarah Kofman's words, a 'platitude'.[32] The 'knowledge' he arrives at however, in an imaginary act of mastery over the object, 'a distancing of lack',[33] entails a loss in the real: 'The object at once appears to be *behind* itself, becomes untouchable, it is beyond our reach; and hence arises a sort of sad disinterest in it.' Sartre adds, 'It is in this sense that we may say that great beauty in a woman kills the desire for her.'[34] Sartre's assertion of the extinction of desire is consistent with the defensive dimension that he attributes to the experience of beauty; it further suggests a narcissistic fantasy of self-sufficiency which revolves around the unreal image of the woman, whose 'fullness' the man identifies with, *en miroir*. The child sees, for the first time, the totality of its own body, reflected in the image of an adult standing next to it. 'My eyes alighted by chance on the massive mirror that hung opposite and I let out a cry: our reflections in its golden frame were like a picture of extraordinary beauty. It was so strange and fantastic that I felt a deep pang of regret that its forms and colours would soon vanish like a cloud.'[35] By a whim of the physical world, the man recovers himself as complete, for a fleeting instant, in the illusory plenitude of the image. It is an ideal unifying instant in which the man becomes image in the interplay of identification with the virtual image of the woman, and like the image, detached from the symbolic, he does not desire. However, the image, 'marvellously beautiful', is already 'strange'. Lacan has shown us that the subject in the making

recognizes itself as subject in an exteriority; the gaining of an identity is therefore already a process of alienation: loss is woven into the very fabric of this ideal image.

Arrested in an image, 'the' woman stands on the edge of time – freeze-frame – but only for a fleeting instant; the suspended gesture is completed, she is swept back into the narrative flow, the passing of time. Unless another picture be made of her:

> Would not the most famous painter be proud if you allowed him to immortalize you? I shudder to think that this extraordinary beauty, these mysterious green eyes and wild fiery hair, and all the splendour of this body should be lost for ever. It fills me with the terror of death and nothingness. But the hand of the artist must save you from this. You must not, like the rest of us, vanish irrevocably without leaving any trace of your existence. Your image must survive long after you have turned to dust; your beauty must triumph over death.[36]

The beautiful woman, a fleeting image caught in a glance, surrenders for an instant, but completely, to the man's desire to annihilate the wounding difference. This is an image which has been exorcized of its disquieting meaning, and confined to the 'purely visual'; it is an insignificant image, which is also 'a screen, a protective veil against the intolerable, the unthinkable'.[37] For Diderot, beauty in a woman is precisely a *vacuous* face, 'a face of a young woman . . . innocent, naïve, still without expression.'[38] It is an unmarked surface upon which the loving man inscribes the exact answer to his questioning – at time, in the infinity without depth of mathematical ratios. Commenting on this, Paul Hoffmann adds:

> When we speak of the meaning beauty reveals and establishes in things and beings, we understand those significations that man gives himself in response to his questioning, to calm an unease in him. The things and beings around him, a discursive intelligence will never allow him to know perfectly, impotent as he is to recreate their living presence. Beauty is the rediscovered language of the world, 'a language of nature', beyond words.[39]

A language of nature, beyond words; beauty is nothing if not hieroglyphic.

ठ*	*The brightest clarity of the image did not suffice us, for this seemed*
	to wish just as much to reveal something as to conceal something
	FRIEDRICH NIETZSCHE[40]

Beyond the appearance of beauty, lies the unknowable presence of she who is not man. Difference is *disavowed* through the integration of woman as phallic into the man's narcissistic system. Woman made image is the outcome of the tensions between the imaginary and the symbolic, between a subject that wants itself whole and a subject that can only exist as split. The knowledge of a 'beyond' the visible that marks the recognition of sexual difference, tears the smooth surface of the image to reveal an otherness, but an *excessive* otherness that takes on the status of a mystery:

> Woman with a delicate profile, with a small straight and pretty nose, with a mouth of such witty expression, with the hair of a bacchante which, today, gives her physiognomy an unruly and wild grace, woman with a stranger's eyes which appear to laugh, when her words are serious. All women are enigmas, but this one is the most undecipherable of them all. She is like her gaze, which never settles, and through which pass, mixed in the space of a second, all the diverse gazes of woman. Everything is incomprehensible in this creature who, perhaps, understands little of herself; observation cannot get a foothold there, and slips, as if on the ground of caprice. Her soul, her mood, the beating of her heart has something precipitous and fleeting about it, like the pulse of Madness. One would believe that one saw in her a *Violante*, one of those XVIth century courtesans, one of those instinctive and dissolute beings who wear, like a mask of enchantment, the nocturnal smile of la Gioconda.[41]

Note how the descriptive discourse, which unswervingly traces the straight line of a nose and the cut of the lips, wavers and rambles, *s'affole*, as it attempts to frame the 'otherness' of the woman. The depiction breaks up into so many frantic words, which scatter around the final, fleeting image; not the image of a woman's face, but of a mask, 'bewitching' – 'the nocturnal smile of la Gioconda'. The image becomes mask, the mask a smile, the evocation of that other 'unfathomable smile' inscribed upon a canvas centuries ago which possesses, in Walter Pater's words, 'subdued and graceful mystery'. 'We all

know the face and the hands of the figure, set in its marble chair, in that cirque of fantastic rocks, as in some faint light under sea', writes Pater; but we still puzzle over the smile of the Mona Lisa, not content with the explanation that it was produced by artificial means – that it was only through 'the presence of mimes and flute-players, that [that] subtle expression was protracted on the face.'[42] No historical evidence would constitute an adequate answer to the question which has been asked, and is still being asked, of the portrait of the Mona Lisa. Behind the riddle of her smile lies the question of the woman's pleasure, which is also that of her desire. A question to which Tiresias alone – who was no regular man – could bring some sort of answer: women, Tiresias concluded, get far more pleasure out of love than men do. But Mona Lisa's smile, unlike the smiles of the Virgin Mary and St Anne to which it is often compared, is also a *demand* addressed to the viewer at whom she gazes. Thus implicated in her desire, the viewer might ask: 'What does she want from me?' The answer comes, indirectly and diversely; in the past, by way of a myth attributing to the woman's sexuality a surplus of pleasure (which leaves the man lacking and Tiresias without eyes); now, in the discursive excess surrounding the painting, which speaks of 'the fancy of a perpetual life, sweeping together ten thousand experiences':

> Hers is . . . a beauty wrought out from within upon the flesh, the deposit, little cell by cell, of strange thoughts and fantastic reveries and exquisite passions . . . All the thoughts and experience of the world have etched and moulded there, in that which they have of power to refine . . . the animalism of Greece, the lust of Rome, the reverie of the middle age with its spiritual ambition and imaginative loves, the return of the Pagan world, the sins of the Borgias. She is older than the rocks among which she sits; like the vampire, she has been dead many times, and learned the secrets of the grave; and has been a diver in deep seas, and keeps their fallen day about her; and trafficked for strange webs with Eastern merchants . . .[43]

Like the hieroglyph, (the image of) the 'woman' embodies an ancient knowledge, a knowledge lost in time. Like the hieroglyph, she is at once the undecipherable riddle, and the promise of a knowledge beyond words and even beyond life.

J. M. Barrie, echoing Pater, once spoke of '. . . a smile, like Mona Lisa's, which came surely of her knowing what only the dead should know.'[44]

ح *And if I never see her again? I would not* know *any more*
ANDRÉ BRETON[45]

Writing about the drive for knowledge, Laplanche draws a distinction between intelligence, as a combinatory adaptive activity, and investigation, which posits a *hidden object*. He remarks that, in early childhood, this hidden object always takes shape in an enigma posed by the parental world, 'a mystery, a secret, an aside, a reserve, in short precisely something which, in a realist, material, way, is supposed to be hidden behind appearances'.[46] These enigmas almost invariably revolve around questions of sexuality. At the outset, the child's investigative activity is mobilized by the anxious intuition that its well-being may be jeopardized, an intuition which parental secrecy or inadequate explanation will unwillingly reinforce. The arrival of a new baby is one such instance, for Freud the primary instance, when the desire for knowledge arises with the anxiety the older child experiences at the presentiment that it will lose the love and care of the mother/parents. This well-founded anxiety finds expression in a series of 'burning questions' revolving around the enigma of, 'where do babies come from?' Confronted with the inadequate and fumbled explanations that most parents provide, the sceptical child attempts to find its own answers to the riddle, formulating 'sexual theories' which bear the distinctive inscriptions of infantile erotogenic experience. It is clear that in asking questions about the provenance of babies, which is essentially a testing of parental love, the child will inevitably stumble across a further enigma – that of adult sexuality. The desire of the other is here apprehended in the secretive silences, the bungled explanations, but also in the uncharacteristic abandon of love-making that the small child may witness and probably imagines. Writing about this scene, which he calls 'primal', Freud states: 'It is, I may say, a matter of daily experience that sexual intercourse between adults strikes any child as something uncanny and that it arouses anxiety in them.'[47] This anxiety, Freud argues, results from the sexual

excitation which the small child experiences through its identification with the adults/parents – an excitation that, as yet, the child has no means of comprehending.

Similarly, the infant does not possess the means to understand and to act upon the sexual messages emitted by the adults who attend to its needs. In the everyday care of the child, the adult, most particularly the mother, will emit verbal and non-verbal signifiers pertaining to the satisfaction of the child's needs. However, these signifiers will also carry within them something in excess of satisfaction, 'the purely interrogative potential of other messages'[48] – sexual messages. The most obvious instance is the mother's sexual cathexis of the breast in the process of suckling her infant. Another instance arises out of the concern the mother lavishes upon her infant in her care for its bodily hygiene; this concern focuses on the sites of transit and exchange, thus contributing to establishing them as erotogenic zones. Without negating the conscious motivation of the mother's solicitude, her unconscious fantasies are also at work here. In other words, the mother's sexuality is always something in *excess* of the satisfaction of the infant's need – an excess which cannot be accommodated within an infantile psychosomatic structure that is still predominantly situated at the level of need. Thus, the mother's sexuality is perceived by the infant as a message which does not figure within the everyday signifying interplay of need and satisfaction; it is a signifier which Laplanche therefore qualifies as *enigmatic*. Borrowing the image from Lacan, Laplanche likens the enigmatic signifier to 'the hieroglyphs in the desert', or the 'cuneiform characters carved on a tablet of stone': 'We know that they signify, and that, as such, they have their own kind of existence, an existence which is phenomenologically different to that of things; they are intended to signify something to us, but we do not necessarily have a signified which we can ascribe to them.'[49] The origin of babies, the sexual act, gender difference, are privileged amongst the enigmatic signifiers of early life in that they pertain to the child's relation to its first love-object – the mother – a relation which furthermore involves the erogenous being of both child and mother. 'Seduction' is the term Laplanche ascribes to these infantile encounters with the adult unconscious, and they present a close analogy with the model of precocious seduction through maternal care that Laplanche

now refers to as 'primal'. Seduction brings into play the pair 'activity/passivity' in a situation that Laplanche calls traumatic – in that the child's immature psycho-somatic apparatus (still characterized by passivity, that is, the inadequacy to master), is acted upon by the adult's undeniably richer psyche – a richness which is, however, the product of a split subjectivity. In other words, the trauma lies not only in the excitation, nor just in the child's psychic incapacity to attach this excitation to an affective and ideational representative, but in the correlation of these two factors with a third – the intrusion, into the universe of the child, of unconscious fantasies, from the adult world (that is, fantasies which the adult also does not master). Insofar as the small child is lured into the universe of adult sexuality by way of these opaque messages, and its sexual curiosity is aroused with its erogenous being, it makes sense to say with Laplanche that the enigma is itself seduction.

When Freud turns to the enigma of Mona Lisa's smile – 'the unfathomable smile, always with a touch of something sinister in it', writes Pater – he arrives at a scenario of precocious seduction. Central to this interpretation is a fantasy, of a clearly sexual nature, involving a bird and the infant Leonardo: a kite flew into the room where the little Leonardo lay in his cot, parted the infant's lips with its long tail and then struck them many times – again with its tail. In view of the 'intensity of the erotic relations' between Leonardo's mother, who had been deserted by the father, and her only child – an intensity to which Leonardo's writings attest – Freud concludes that the fantasy of the kite is compounded from two memories: the memory of being suckled, and that of being kissed by the 'poor forsaken' mother. From the smile of the Mona Lisa, to the smile of the loving mother, to her lips that kissed her child's lips, to the infant's lips around her nipple.

Freud argues that the child's persistent questioning is but a series of displacements, a circling around the one question it cannot ask. At the basis of this question Lacan locates the desire of the parent: '. . . and all the child's *whys* reveal not so much an avidity for the reason of things, as a testing of the adult, a *'Why are you telling me this?'* ever-resuscitated from its base, which is the adult's desire.'[50] The question that the child asks is a demand for love, a *'What do you want from me?'*, directed most intently at the mother. Beyond the love the

mother gives her child there is her desire, which eludes the small being as it is directed towards another place which the father or any significant third-party is seen to occupy. The child's desire is to be its mother's exclusive desire, which requires that the question of this elusive desire of hers be answered. However, the subject's anxious curiosity is answered only by the lips of a Mona Lisa, sealed in a vague and solitary smile, which shuts him out; it is a message which fails to communicate, an enigmatic signifier which reflects the subject's own desire in the form of a question.

If we turn to another painting by Leonardo, his *Madonna and St Anne*, we are given an intimation of the answer in the gentle cascade of smiles (that same 'Leonardesque smile') which, from the features of St Anne descends to those of her daughter, and is passed on by the Madonna to her son – who returns a childish grin to the women watching over him. Here there is no question as to what the mother's desire may be – it is her child; the answer is a wish-fulfilment. Leonardo's *Madonna and St Anne* is a picture of maternal love which, however, also points to something else. The Madonna is shown reaching for her son whose back is turned to her, gently pulling him away from the lamb with which he is playing a little violently. The manifest meaning of this is the mother's concern for the well-being of the small animal that her child is tormenting (I am choosing to ignore any allegorical dimension of the depiction). However, the structure of this scene suggests another meaning: her arms reaching out for her son, her hands on his naked skin, her gentle smile as she gazes at him, suggest a demand on her part that intrudes into the universe of the child at play. Interrupted in his game, he turns towards her, confused – 'What do you want from me?'

At this point it is important to remember that the intimation of a demand on the part of the mother, is also the intimation of a lack. We know that the recognition of gender difference provides the male subject with a means of symbolizing her lack, with a representation of her lack. We also know that the castration anxiety which arises out of the recognition of sexual difference is inseparable from the prohibition on incest. For the male subject to be the exclusive desire of his mother now comes to mean committing incest, and provoking the paternal retribution in the form of castration. In her book *The Enigma of Woman*, Sarah Kofman suggests that to answer the riddle of

feminine sexuality would be to commit incest – had Oedipus not answered the riddle of the Sphinx he would not have made love to his mother, and he would not have lost his eyes. Catherine Clément argues that, 'Wherever there is enigma then there is incest.'[51] When Freud himself addresses the question of feminine sexuality, he does so by way of the poem by Heinrich Heine that I quoted at the beginning of this chapter. As Mary Ann Doane remarks, it is a question in disguise: the final sentence in Heine's poem is not 'What is woman?' but 'What is man?' The question to which the man returns, whenever he turns to the woman, is a question about the nature of his being, that is, his being as a desiring subject. If we are to learn from Oedipus, the question must remain without an answer.

ε❧ *I might caress her, pass my hand slowly over her, but, just as if I had been handling a stone which encloses the salt of immemorial oceans or the light of a star, I felt that I was touching no more than the sealed envelope of a person who inwardly reached to infinity*
MARCEL PROUST[52]

To be her exclusive desire is to know her desire. Her enigma must thus remain; there must always be something hidden behind her appearance, a knowledge withheld. I understand better the recoil Sartre experiences when he 'encounters' beauty in a woman; it is a recoil from the spectre of incest, which has arisen with the stirring of mnemic traces belonging to the earliest relation to the first love-object. It is a moment of wondrous recognition and dread, to which the male psyche responds by divesting the woman of her reality, and thus re-establishing the *correct distance*[53] which society requires of those who were once one. The woman is turned into an *insignificant* image – the enigmatic signifier refigured in a process of defence. She is all surface, the closed envelope over which the desired man lingeringly passes his hand, but will not penetrate, the lips sealed in a vacant smile; and behind the painted smile, the streak of red lipstick, beyond the skin of her appearance, there is the intimation of a profound knowledge. It is the fantasy of a knowledge which, in Plato's words, '. . . is not a stranger in something strange to it'[54] – a knowing outside of the symbolic which the woman, always potentially

mother, embodies with the possibility of a shared corporeality. When the child, confronted with the strange and estranged body of its pregnant mother, asks about the origin of babies, what it wants is the confirmation of unconditional maternal love, not a lesson in natural sciences. When the forty-one year old father of four, quoted below, is shown the physical facts of reproduction by a woman, it comes as a blow to his narcissism, a denial of his uniqueness, and a reminder of his mortality which leaves him lacking:

> There are no men any longer because there is no feminine mystery left. Everything has been demystified. We are being shown naked women all day long, so one doesn't feel like undressing them anymore. It is like this fashion of watching childbirths, it is a remedy against women. There are some famous stories where some blokes have watched their wives giving birth, and have never touched them again, or have even divorced . . . One is so well informed that one doesn't want to know any longer . . .[55]

The beautiful woman, like the mythical hieroglyph, stands for *both* the possibility and the impossibility of the fulfilment of desire, for a privileged moment when the subject's 'infantile' questioning is suspended in expectant fascination. Plato's Beauty, although it may be glimpsed in material reality, lay beyond the reach of human touch. Baudelaire's Beauty, no less extra-worldly, is a 'dream of stone' who intones 'I reign in the sky like an unfathomed sphinx.'[56] The riddle of the sphinx must not be answered, for to answer it is to destroy desire.

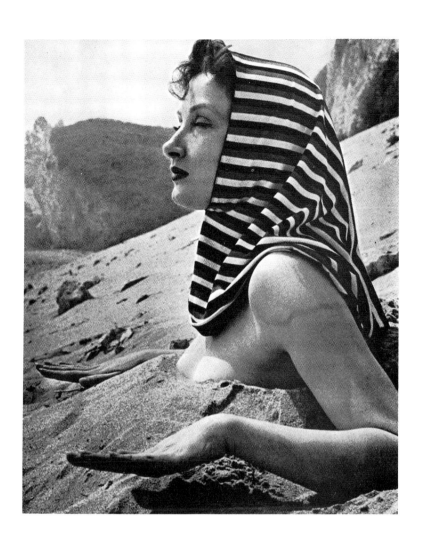

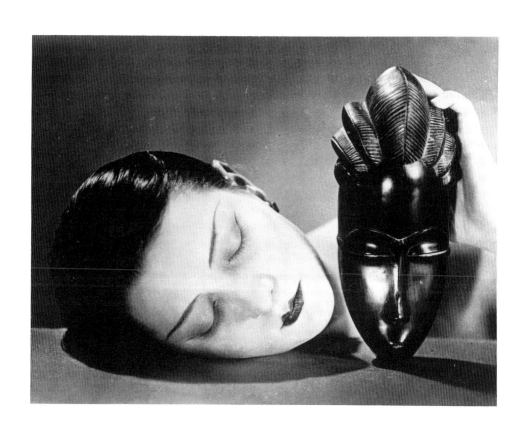

6 Dark continent

ع

Where is she?
Activity/Passivity
Sun/Moon
Culture/Nature
Day/Night
Father/Mother

Head/Heart
Intelligible/Palpable
Lagos/Pathos
Form, convex, step, advance, semen, progress.
Matter, concave, ground – where steps are taken, holding – and
dumping-ground.
Man
Woman

. . . Thought has always worked through opposition . . . Night to
his day – that has forever been the fantasy. Black to his white . . .
HÉLÈNE CIXOUS[1]

Hélène Cixous' set of binary oppositions makes clear the
position of the feminine in a patriarchal system of difference –
a system in which femininity is always defined as the second-
ary, subordinate term. In a repetitious replay of the creation,
'woman' is granted meaning from the stuff of a fully realized,
perfectly complete sign. As such, 'woman' comes into signifi-
cation as a 'supplement' to the prior term 'man' (a supplement
often reconceptualized as 'complement' in the service of an
ideology of heterosexual plenitude). It is a dangerous supple-
ment (after all, it was the cause of the Fall of man) which ever
threatens to corrupt the 'natural' state – that ideological state
of nature in which culture is presented *as* nature – the 'natural
order'. The system of difference which posits 'man' as the
primary term from which 'woman' derives cannot signify her
alterity. She can only ever be a man with a difference – a man
with a deficiency.

If woman's entry into signification is through the term
'man', the black woman's access to intelligibility, in a Western

order of difference, is through the modified term 'white man'. Black to his white; that is, not man, not white. In an essay on racism, Victor Burgin writes:

'White' . . . has the strange property of directing our attention to colour while in the very same movement it exnominates itself *as* a colour. For evidence of this we need look no further than to the expression 'people of colour', for we know very well that this means 'not White'. We know equally well that the colour white is the higher power to which all colours of the spectrum are subsumed when equally combined: white is the sum totality of light, while black is the total absence of light.[2]

Western discourse construes blackness as palpable, entirely visible, and yet empty, null – the presence of an absence. It opposes the reflective 'power' of white – black does not reflect – to the absorptive property of black. Blackness, thus defined in a parasitic role, feeds off light, ever threatening its luminosity with total absorption and extinction. In 1840, Alexander Walker wrote:

That, independent of any association blackness is naturally disagreeable, if not painful, is happily determined by the cause of the boy restored to sight by Cheselden, who tells us that the first time the boy saw a black object, it gave him great uneasiness; and that some time after, upon accidentally seeing a negro-woman, he was struck with great horror at the sight. This appears to be perfectly conclusive.[3]

He then cites Richard Payne Knight, scholar and connoisseur, who proposes the following explanation of the boy's reaction:

As to the uneasiness which the boy, coached by Cheselden, felt at the first sight of a black object, it arose either from the harshness of its outline, or from its appearing to act as a partial extinguisher applied to his eyes, which, as every object that he saw, seemed to touch them, would, of course, be its effect.[4]

The opposition between white and black becomes, in Walker's discourse on the aesthetic of the woman, an opposition between beauty and ugliness.[5] Walker's account moves, in a semantic *crescendo*, from the 'great uneasiness' experienced at the sight of the dark object, to the downright 'horror' felt at

accidentally seeing the Negro woman. In order to assert the inherent unattractiveness of blackness, Walker calls upon the 'immaculate' vision of the blind boy, newly born out of a state of purported innocence – an existence supposedly outside of the symbolic order. Walker's very schematic and decontextualized account of the event does not allow us to test the validity of Knight's interpretation. It is not really this, however, that interests me here; it is rather that Walker chooses to tell a tale of the fear of loss, here the loss of the power to see, in which the principal actors are the (threatening) black woman and the taintless (frightened) white male subject.[6]

'Black to his white', writes Cixous, and nature to his culture. The positioning of the black woman on the side of nature is overdetermined by her being both black and female. In the colonial discourse of the West, Africa has historically been associated with nature and femininity; a femininity which was expressed, alternatively, as domesticated sensuality, or uncontrollable lasciviousness. Written between 1853 and 1855, Joseph Arthur de Gobineau's influential *Essai sur l'inégalité des races humaines* formulates racial difference in terms of gender difference. Blacks and Jews, considered to be very sensual, are defined as feminine and are credited with aesthetic superiority. The masculine races, on the other hand, possess, 'a more precise, abundant, and richer language than the female races.'[7] Thus Gobineau restates a thesis already present in, for instance, Gustave Eichtal and Ismayl Urbain's *Lettres sur la race noire et la race blanche*, which was published fourteen years earlier:

> The black appears to me to be the female race in the human family, while the white is the male race. Just like the woman, the black is deprived of political and scientific faculties; he has never created a great state, he is no astronomer, mathematician, or naturalist; he has done nothing in industrial mechanics. But, on the other hand, he possesses to the highest degree the qualities of the heart, the feelings and the domestic virtues; he is the man of the house. Like the woman, he also loves with a passion adornment, dance and singing; and the few examples I have seen of his native poetry are charming idylls.[8]

The discursive construction of a feminine Africa, like Paul Gauguin's quest for a native, unchanging world peopled by

languid pleasure-seeking girls, is, in Abigail Solomon-Godeau's words, a 'fantasmatic construction of a *purely feminized geography*'.[9] Within that imaginary geography, the black woman comes into signification as *extremely* 'other'. It is this polarization which I wish to address here and, more particularly, the negotiating of desire within this structure of exclusion. Confronted with an excess of difference, the white male subject will excel at defensive ingenuity, making her blackness becoming to his light, brightening up his day with her night.

> *Mountains and abysses, such is the relief of the grotesque body; or speaking in architectural terms, towers and subterranean passages*
> MIKHAIL BAKHTIN[10]

In 1810, in London, an African woman was exhibited to the public, stark naked, so as to allow the viewer to observe 'the shape and frame of her body'.[11] Her name was Saartjie Baartman, Saat-Jee for short; she became known as the 'Hottentot Venus'. After having been exhibited for a period of five years all over Europe, she died in Paris at the age of twenty-five. Her body was whisked away and promptly cut open, cut into pieces. We can, to this day, examine Saartjie Baartman's anatomical particularities at the Musée de l'Homme in Paris. Alive, she was simply a shape, a breathing silhouette, displaying the outline of her protruding buttocks; dead, she is reduced to a couple of cuts of flesh – buttocks and genitalia – preserved in glass jars. The titillating fascination with Saat-Jee's 'formidable' posterior was greatly heightened by the widespread knowledge of her 'exceptional' genitalia (which she never exhibited to the public). Saartjie Baartman's elongated labia and nymphae, obtained through manipulation of the genitalia, were a sign of beauty amongst certain African tribes. To the nineteenth-century anatomists and pathologists they represented a 'hypertrophy', an 'anomaly', which was promptly enrolled in the service of a theory in which the 'primitive' genitalia were taken as the external sign of a 'primitive' sexual appetite. Such a theory was not entirely original: the purported particularity of the black woman's genitalia had been invoked before to argue for the distinct nature of all black peoples. In 1829, another Hottentot woman

known as the 'Hottentot Venus' was displayed, naked but for a few ornaments, for the amusement of the Duchesse de Berri's jaded guests.

The salient buttocks of the Hottentot woman, a physical characteristic of all the Hottentot people, were pathologized as an 'abnormal accumulation of fat', and were given the name, 'Steatopyga'. The Hottentot woman's genitalia became known as the 'Hottentot Apron'. This appellation evokes at once the domestication and disavowal – the apron protects by concealing – of a sexuality to which medicine had assigned a nature different to the point of abnormality. The Hottentot Apron was classified as a malformation, alongside other genital malformations supposedly caused by concupiscence and other sexual excesses such as 'lesbian love'. The Hottentot woman became associated, in the discourse of physical anthropology, with 'deviant' sexuality and most particularly with the purported lasciviousness of the prostitute. Nineteenth-century physiologists, physionomists and phrenologists were busy scrutinizing the prostitute's body for external signs of her deviancy and immorality. Such signs they 'found' in the configuration of the bumps of her head, the asymmetry and masculinity of her facial features, the *embonpoint* of certain regions of her body, and the unusual size of her genitals.[12] In his analysis in 1870 of the external form of the genitalia of no less than eight hundred French prostitutes, the dedicated researcher Adrien Charpy comments on the 'characteristic' elongation of the *labia majora* of the prostitute and likens it to the apron of the 'disgusting' Hottentots. In Cesare Lombroso's 1893 study of the criminal woman, subtitled *La Donna delinquente, la prostituta e la donna normale*, two of the plates carry drawings of the 'Hottentot Apron' and the 'Steatopyga'. In a publication of 1905 by a student of Lombroso, *Staetopigia in prostitutes*, the Italian prostitute is depicted quite literally as a Caucasian version of the Hottentot woman.

Nineteenth-century physical anthropology was firmly grounded in an evolutionist ideology. Within that ideology, the prostitute's deviancy was interpreted as degeneracy. Her physical 'particularities', whether genetically acquired or developed, were signs of her descent; they were 'atavistic throwbacks' to an archaic nature, long forgotten, which the Hottentot woman with her 'grotesquely' protruding buttocks and elongated labia, had come to represent.

Drawing on Bakhtin's analysis of the carnivalesque, Allon White and Peter Stallybrass describe the 'grotesque' body and its bourgeois 'other' – the 'Classical' body – in the following terms:

> To begin with, the classical statue was always mounted on a plinth which meant that it was elevated, static and monumental. In the one simple fact of the plinth or pedestal the classical body signaled a whole different somatic conception from that of the grotesque body which was usually multiple (Bosch, Bruegel), teeming, always already part of a throng. By contrast the classical statue is the radiant centre of a transcendent individualism, 'put on a pedestal', raised above the viewer and the commonalty and anticipating passive admiration from below. We *gaze up* at the figure and wonder. We are placed by it as spectators to an instant – frozen yet apparently universal – of epic or tragic time. . . . The classical statue has no openings or orifices whereas grotesque costume and masks emphasize the gaping mouth, the protuberant belly and buttocks, the feet and the genitals. . . . The grotesque body is emphasized as a mobile, split, multiple self, a subject of pleasure in processes of exchange; and it is never closed off from either its social or ecosystemic context. The classical body on the other hand keeps its distance.[13]

The grotesque body, then, is the sensuous, material body signified as excessive and transgressive. In Bakhtin's words, it is 'the body that fecundates and is fecundated, that gives birth and is born, devours and is devoured, drinks, defecates, is sick and dying.'[14] It is the body that bears and ostentatiously displays the inscriptions of its physical needs as 'deformities'. This clamouring affirmation of physicality represents a transgression of the limits of the social; the domesticated body reverts to a state of nature, 'primitiveness'. The grotesque body is a disarticulated body, whose internal chaos threatens to externalize itself violently in the form of contagious symbolic disorder. Stallybrass and White enumerate the discursive norms of the grotesque body: 'impurity (both in the sense of dirt and mixed categories), heterogeneity, masking, protuberant distention, disproportion, exorbitancy, clamour, decentred or eccentric arrangements, a focus upon gaps, orifices and symbolic filth . . . physical needs and pleasures of

the "lower bodily stratum", materiality and parody.'[15] 'Protu-berant distentions', excess of matter pushed, expelled to the surface of the body; 'gaps and orifices', passages between the inside and the outside, zones of pleasure, excretory sites though which the body wastes itself. The social body seems to burst at the seams under the pressure of a recalcitrant physicality, which breaks out, out of place, as dirt, as disease. Coming into being at the edges of our existence, straddling the dividing line of formative binary oppositions, threatening to infect, pollute, the sanitized zones of our subjectivities, the grotesque body partakes of the abject.

Sociality and subjectivity are premised upon the exclusion of the disorderly, the unclean, the improper – an exclusion which defines them, in Julia Kristeva's words, as *non-objet du désir*. However, what would be excluded 'hovers at the edges or borders of our existence, haunting and inhabiting regions supposedly clean and free of any influence or contami-nation.'[16] It is the recognition of the impossibility of an uncontaminated site of subjectivity which elicits the response that Kristeva terms 'abjection'. In the pre-Oedipal, abjection is the condition of the emergence from undifferentiation, the distinction between inside and outside, the precondition of identity. Abjection becomes manifest in the movements of ingestion and evacuation, at the various sites of transition between inside and outside – mouth, anus, genitals – through which the objects – food, vomit, spit, faeces, urine (later semen and menstrual blood) – are ingested and/or evacuated. In a prototypal instance, the infant vomits the mother's milk; like all trauma, this visceral movement of expulsion leaves its mark, the inchoate marking of a boundary between inside and outside, between infant and mother. In the double movement of ingestion and evacuation, however, the objects of abjection can never be *fully* separated from the body. Indeed it is precisely this indeterminate status which will mark them as 'abject'. Here, the first intuition of a subjective boundary is both the convulsive expulsion of the 'self' and the vomiting of the archaic mother. In the post-Oedipal, abjection is in the impossibility of maintaining clear boundaries between inside and outside, clean and unclean, proper and improper – lines of demarcation which are constitutive of, and constituted by, the symbolic order. That which provokes abjection, 'the abject', is 'necessarily and undecidably both inside and out-

side (like the skin of milk); dead and alive (like the corpse); autonomous, yet engulfing (like infection and pollution).'[17]

Kristeva speaks of the abject in terms of three main categories: food, bodily wastes and signs of sexual difference. The most archaic form of abjection is oral disgust. Kristeva writes: '. . . food is the oral object (this ab-ject) which founds the human being's archaic relation to the other, his mother, who enjoys a power as vital as it is formidable.'[18] The infant vomits the mother's milk. Kristeva speaks of the retching as the lips touch the skin of the milk, the nausea which separates her from she or he who offers it. The refusal of the food is the rejection of maternal/parental love; more fundamentally, it represents the expulsion of the body of the archaic mother. As the subject only exists in the desire of the (m)other – since the subject only exists through the body of the mother – the subject violently *expels itself* in the very movement through which it would define itself: 'In this trajectory where "I" become, I give birth to me in the violence of sobbing and vomit.'[19]

Bodily fluids, wastes and refuse constitute the second main category of the abject – corporeal by-products which are both internal and external. When inside the body, they are the condition of its regeneration, the very stuff of life. When externalized, expelled, they come to signify the unclean, the filthy. However, wastes are never completely external to the subject, as they are part of the subject. In expelling its bodily wastes, therefore, the subject expels part of itself. Kristeva writes: 'It is not then an absence of health or cleanliness which makes something abject, but that which perturbs an identity, a system, an order; that which does not respect limits, places or rules. It is the in-between, the ambiguous, the mixed.'[20] The corpse is the most sickening of bodily wastes, intolerable because, 'in representing the very border between life and death, it shifts this limit into the heart of life itself.'[21] Here, in the presence of the dead body, the subject confronts the most extreme and complete form of expulsion: 'it is no longer I who expel, "I" is expelled'.[22]

The corporeal signs of sexual difference constitute the third category of the abject. Kristeva speaks of the cultural horror at menstrual blood. We may recall here Plotinus' repudiation of the materiality of the woman's body – 'Now what is the beauty here? It has nothing to do with the blood or the menstrual

process.'[23] What is at stake here is not just sexual difference, but the differentiation between men and mothers. Like all other bodily wastes, menstrual blood partakes of a cyclical crossing of the border between inside and outside. In this case, however, the waste is the internal food which may sustain a nascent life; it is the expelled link between the foetus and the mother. Disgust towards menstrual blood is the refusal of that original corporeal link.

The abject, then, is both the precondition of subjectivity, and simultaneously its greatest threat. Kristeva speaks of abjection as a *crise narcissique* – a testimony to the ephemeral nature of the narcissistic state, to its status as semblance. In reminding the subject of its relation to animality, corporeality and death, the abject asserts the facticity of a disembodied, unified subjectivity. 'The abject confronts us, on the one hand, with the fragile states where man wanders in the territories of the *animal* . . . On the other hand, the abject confronts us in our personal archaeology, with our most original attempts to mark ourselves out from the maternal entity even before existing outside it thanks to the autonomy of language.'[24] From these early visceral movements of rejection and demarcation, to the later repetitive re-assertions of identity in abjection, the subject remains caught up, in Kristeva's words, in a perpetual *'corps à corps'*.

In Pierre Loti's novel *Le Roman d'un saphi*, the white protagonist's sexual intercourse with a black woman is perceived as a fatal passage, a process of defilement from which he will tentatively purify himself by breaking off the relationship: 'It seemed to him that he was about to cross a fatal threshold, to sign with this black race a sort of mortal pact'; later, 'He had recovered his dignity as a white man, soiled by the contact with this black flesh.'[25] Symbolic defilement shades imperceptibly into medical disease. Sander L. Gilman writes that, 'medical tradition has a long history of perceiving this skin colour as the result of some pathology. The favorite theory which reappears with some frequency in the early nineteenth century, is that the skin colour and attendant physiognomy of the black are the result of congenital leprosy.'[26] It was in this same period that Africa was declared to be the homeland of syphilis, from which the infectious disease had spread into Europe during the Middle Ages. We are told that the threat of syphilitic contagion was originally to have

been inscribed in Picasso's celebrated painting of *Les Demoi-selles d'Avignon*, celebrated for purportedly introducing Afri-can art into Western painting. Phyllis Rose writes: 'When he finished *Les Demoiselles d'Avignon* in July 1907, the faces of the two prostitutes on the right and one on the left resembled African masks.'[27] Rose continues '. . . people have begun to realize that the African masks were painted in for their emotional impact – to express the terrifying aspects of female sexuality. Thus the painting in its final form expresses the contradictory attraction and repulsion which was handled narratively and somewhat conventionally (through the images of sailor and medical student – the latter presumably warning about disease) in the first version.'[28] Before painting *Les Demoiselles d'Avignon*, Picasso visited the Musée du Troca-déro:

> Picasso had seen African masks and figures before this, in the studios of some of his friends, but they were isolated objects held up for aesthetic contemplation. In the Troca-déro, he encountered a jumble of objects whose ethno-graphic interest and ritual purpose was paramount. . . . They were not tastefully displayed on black velvet or in glass boxes or against neutral carpeting. They were jammed together on hastily constructed tables and in cases. The place was badly lit and evil-smelling. There was something horrifying about the setting. . . . It was a shock, a reve-lation. He was repelled by the place, but couldn't leave. 'It was disgusting. The Flea Market. The smell . . . I wanted to get out of there. I didn't leave. I stayed.'[29]

In another account, Picasso recalls his first visit to Le Troca: 'When I went for the first time, at Derain's urging, to the Trocadero Museum, the smell of dampness and rot there stuck in my throat. It depressed me so much I wanted to get out fast, but I stayed and studied.'[30] It was then that Picasso decided to depict the faces of his *Demoiselles* as African masks, or so goes the legend. Whether or not Phyllis Rose's version of Picasso's words, punctuated by an ellipsis full of menace, is an accurate representation of what Picasso meant to say, the myth of the painting's origin appears to be founded on the association of the stench of decay with the image of black femininity, which in turn, in the painting, is assimilated into a dangerous sexuality. If we are to take Kristeva at her word, it

is doubtful whether the abject can ever be absent from the relation to the other. Disgust is an ever-present undertow in the otherwise adulatory discourses on feminine beauty. The Black woman however, doubly marked with difference – as woman, as Black – throws the role of the abject in the attribution of beauty into a particularly sharp relief. The difference between the White woman and the Black woman, in the characteristic reaction of the White heterosexual man, is not one of kind, but one of degree.

In the 1920s the Charleston swept Europe. The Vicar of St Aidan's, in Bristol, commented: 'Any lover of the beautiful will die rather than be associated with the Charleston. It is neurotic! It is rotten! It stinks! Phew, open the windows!'[31] The Charleston was strongly associated with black 'Jazz' music, and Josephine Baker was its incarnation. The image of Josephine Baker's dislocated and mobile nakedness appeared to the commentators of the time as both 'grotesque' and 'beautiful'. A reviewer for *Vogue* wrote: 'She brings to her dancing a savage frenzy inherited from distant African ancestors, and the result is a masterpiece of grotesquerie and beauty unlike anything previously seen in Europe.'[32] André Levinson, dance critic: 'Certain of Miss Baker's poses, back arched, haunches protruding, arms entwined and uplifted in a phallic symbol, had the compelling potency of the finest examples of Negro sculpture. The plastic sense of a race of sculptors came to life and the frenzy of African Eros swept over the audience. It was no longer a grotesque dancing girl that stood before them, but the black Venus that haunted Baudelaire.'[33]

Baker's commentators construe her well-rehearsed moves as a spontaneous 'savage frenzy', the disjointed movements of a body out of control, gone 'wild'. They invoke the influence of 'distant African ancestors' in order to explain away, faraway, the deliciously threatening possibility of a body unrestrained by symbolic laws. Aroused, they freeze her movements in the familiar discourse of an aesthetic of the static. Josephine Baker is a statue; her ancestors, 'a race of sculptors'.[34] They watch her, poised between contempt and idolatry. In a catalogue essay for the 1990 exhibition *Envisioning America*, John Czaplicka cites a German critic writing about Josephine Baker's appearance in Berlin in 1926: 'Her dance is instinct against civilization, is uproar of the senses. She reveals the unconscious which overthrows our whole world

view.'[35] At the Los Angeles County Museum of Art, *Envisioning America* was housed under the same roof as *The New Vision*, an exhibition of the Ford Motor Company photographic collection that was compiled during the 1920s and 1930s. The 1990 explanatory text to a 1930 photograph of Josephine Baker unselfconsciously speaks of the 'primitive sensuality' that Baker embodied.

The Hottentot Venus had been the object of the pseudo-scientific 'anthropological' gaze of the nineteenth century, which scrutinized the body of the sexually and racially 'other' for signs of its difference, its deviance. As the explicit reference to the Classical body of Greek statuary indicates, the Hottentot Venus, with her physical 'exhorbitancies', came to represent the 'other' of beauty in its Classicist insistence on rules of symmetry and proportion. Josephine Baker was the representative of an imaginary Africa, come to Europe by way of America; she was the embodiment of a primitivism inflected by a view of American culture as dominated by technology and the machine.[36] Josephine Baker's dynamic body moved against the Classicist notion of a static, statuesque beauty to the rhythm of the urban jungle of modernity. Her 'impossible anatomy' and disjuncted body echoed the formally controlled fragmentation of the object in Cubist art. The 'other' of Classicism, the 'other' of the West, became conflated in the legend of the painting of *Les Demoiselles d'Avignon*. The modernist challenge posed to the beauty of the Greek Venus in the visual arts – a challenge brought about in part by the influence of non-Western cultures – left 'beauty' without its specific cultural and historical grounding. And yet this modernist challenge did not lead to the assertion of a different beauty, but to the abandonment of the concern with the beauty of the object, and the eventual renunciation of the object as modernism moved towards the highly abstract beauty of the form of the work itself. While the body triumphs on the stage of the 'Folies-Bergère', it is evacuated from 'high art', which celebrates the 'beauty' of abstraction. This is really a reassertion of the ideal by another route, prefigured by the masterpiece imagined by Balzac – the portrait of the most beautiful woman that could ever be, which showed nothing of the woman but encrusted layers of paint.

The body celebrated in the graphic manipulations of artist/ publicist Jean-Paul Goude[37] – most particularly, that of singer/

performer Grace Jones – is an abstract body in that it displays an impossible female anatomy reminiscent of Velázquez's 'Rokeby Venus' (with her famous extra vertebrae). Abstract, also, in that what first appears to be a singular body proves to be an assemblage of citations. The question of beauty here refers us to an infinity of identities without depth, quotations which do not so much point us to a history as they remain caught up in the one-dimensionality of Goude's luscious air-brushed spaces. However, as the black female body spreads itself thinly across the synchrony of paper-cut identities, it takes on an omniformity which, as we shall see, often translates into omnipotence. History, evacuated from the one-dimensionality of the image, returns by another route. In the pages of *Jungle Fever* we find a discourse of otherness in which blackness is still essentially 'bestial' and 'primitive', but this primitivism is now transposed to the sleek orderliness of Jean-Paul Goude's constructions. Of Grace Jones, Goude writes: 'The strength of her image, then as now, is that it swings constantly from the near grotesque – from the organ grinder's monkey – to the great African beauty. You are constantly looking at her and wondering if she's beautiful or grotesque, or both and how can she be one if she is the other.'[38] The object of Goude's ambivalent fascination is a truly *hybrid* construction which, brilliantly displayed in the refined mini-malism of his designs, clearly speaks of the idealization of a *different* body, the fantasy of an other beauty that is multiple, excessive, exhorbitant.[39]

ਦੇ *So for Radiah, I devised the complete African look, with removable scars. This made the papers . . .*
JEAN-PAUL GOUDE[40]

Goude said that Grace Jones's face was 'something more than just pretty. It was more like an African mask.'[41] The mask serves the double function of displaying and concealing; it is at once surface and depth. Writing about the racial stereotype, Homi Bhabha observes: 'Colonial discourse produces the colonised as a fixed reality which is at once an "other" and yet entirely knowable and visible.'[42] Seen in this light, the conver-sion of living features into a mask becomes a particularly apposite instance of, and metaphor for, the discursive

petrifaction of another culture into a set of *idées fixes*. The stereotype, Bhabha writes, is 'an arrested and fixated form of representation', which denies 'the play of difference'.[43] As such, Bhabha argues, it is structurally and functionally analogous to the fetish. Like the fetish, it is the corollary of a defensive strategy of disavowal: the acknowledgment of 'otherness' and its reduction to one specific characteristic, culturally intelligible, familiar. Like the fetish, it is the certainty to which the subject repeatedly returns when the threat of difference forces the reassertion of identity. Indeed, always delivered as if it were an informed statement, the stereotype functions to reassure the subject confronted with difference, with the possibility of lack, of the integrity of its *own* identity. Bhabha begins his argument by stating that, 'within the apparatus of colonial power, the discourses of sexuality and race relate in a process of functional overdetermination',[44] and eventually conflates sexual and racial difference in his formulation of the 'stereotype *as* fetish'. For my purpose here, I wish to retain the idea of a relation of *overdetermination*, which produces the black woman as 'excessive', while also retaining the strictly Freudian specificity of the notion of fetish – a substitute for the absent penis in the defensive process of disavowal of sexual difference. Bhabha's analogy between the fetish and the stereotype is most useful *as* an analogy – one which allows us to formulate the ambivalent nature of the racial stereotype as *disavowal*. To say that Grace Jones's face is like an African mask is to suggest, however subliminally, that these features and this colour could be removed, like a mask; and, like a mask, they could be put on and worn for the excitement of a temporary transgression. The racial particularity of the woman is conceptualized as a masquerade. 'Her face . . . was more like an African mask', says Goude; in other words, 'I know very well that this woman is black, but nevertheless, under her African mask she is just like me'. The disavowal of racial difference duplicates and reinforces the fetishistic structure (erected to fend off the threat posed by the recognition of sexual difference). In the process of fetishization, Grace loses her specificity to the stereotype; she becomes the generic 'African mask'.

The African mask speaks of distant rituals to the Western subject. More generally, the mask worn at festivities permits the wearer to assume another identity, to transgress for a day,

a night, the boundaries of gender, class and race. Goude imagines a black identity which would be worn like a mask, and thus invests blackness with an inherent transgressive value. Richard Dyer discusses such a scenario of transgression, taken from the 1938 film *Jezebel* – a literally and figuratively black and white film – in which blackness is assumed by the white woman in the form, not of a mask, but of a dress. 'The most famous scene in the film is the Olympus Ball, at which all the unmarried women wear white. Julie, to embarrass Pres [her fiancé] and to cock a snook at outdated convention ("This is 1852, not the Dark-Ages – girls don't have to simper about in white just 'cos they're not married''), decides to wear a red dress.'[45] The red dress, described by Julie as 'saucy' – 'vulgar' says her aunt – is the dress that Julie's black maid, Zette, most covets; after the ball, Julie gives it to her. Dyer remarks that, '. . . the red dress looks merely dark in this black and white film.'[46] The white woman exudes sensuality and will be punished for it. She will shed the coloured skin of the dress, and expiate in luminous white. When the black woman takes on the burden of this sensuality in the form of the red dress, sensuality ceases to be a problem – the dress is returned to its *natural* owner, who it fits like a second skin.

Jean-Paul Goude had a brown dress made for Radiah, a previous lover, 'exactly to match the color of her skin, skintight.'[47] The black skin is here seen as mask or dress: it is a detachable object, the function of which is to conceal by displaying itself – a fetish. This discursive insistence on the surface is made manifest in Goude's manipulations of Jones's image. He often depicts Grace Jones in a one-dimensional space, against a light background, where she appears flattened and sharp like a cardboard cut-out. In these epidermal spaces, Goude displays her skin, airbrushed into a darker shade of blue-black-brown, sleek, shiny as if oiled, not in the manner of the body-builder to show off the muscles underneath, but to turn the skin into a reflective surface. Grace Jones can never be 'just naked'. Her skin is endowed with a presence which eclipses any perception of the absence of clothes: the White viewer sees not her nudity but her black skin. What Franz Fanon has called the 'epidermal schema' – the reduction of another identity to its corporeal surface, the colour of which is further equated with negativity – is emphatically re-presented here, no longer in terms of de-

ficiency or lack, but in terms of plenitude: blackness, no longer a signifier of the 'total absence of light', is endowed with luminosity. Black reflects.

Plenitude turns into excess in Goude's work: 'When I described her [Grace] to friends, I couldn't help exaggerating, making her appear bigger than life in every way.'[48] To make her 'bigger than life in every way', is precisely and literally what Goude applied himself to doing. He had already made Radiah into a seven-feet tall 'giant African beauty' by having her wear very high platform shoes concealed under a long brown dress. He had given Toukie a 'race-horse's ass'. He retouched the photographs he took of her; he remodelled plaster replicas – 12-inch-high white Toukies which he then coloured – so as to 'exaggerate her proportions': 'There she was, my dream come true, in living colour.'[49] Then he turned Grace Jones into an elongated anatomical anomaly:

> First I photographed her in different positions – to get all my references, which I combine, as you can see in the cut-up version of the picture. I cut her legs apart, lengthened them, turned her body completely to face the audience like an Egyptian painting. . . . Then I started painting, joining up all those pieces to give the illusion that Grace Jones actually posed for the photograph and that only she was capable of assuming such a position. . . . If you really study it, the pose is anatomically impossible.[50]

Grace Jones called this image of her impossible self, 'Nigger Arabesque'. Baudelaire, who wrote of a 'bizarre deity, brown as the nights', spoke of *bizarrerie* as the condition of beauty, rhetorically asking: 'try to conceive of a beauty that would be commonplace!'.[51] Whatever '*bizarrerie*' comes to mean, it always hovers at the extremities of our existence, while banality occupies the middle ground (the banality of the 'predictable, gray, middle-class, boringly normal' suburb of Paris, the 'nowhere' where Goude grew up, or the sense of banality that inevitably assails us when we are confronted with difference, with the exotic). Goude turns his Black lovers into unique creatures, whose difference he stresses to the point of exorbitancy, lifting them out of the 'normal', the everyday, and displaying their 'particularities' to a White public who, more than a century ago, might have been ogling, with fearful fascination, at the protuberant buttocks of Saartjie

Baartman, wishing to catch a glimpse of her 'exceptional' genitalia. To the European of the time, the Hottentot body was an impossible body which could only be conceptualized as malformed or even diseased. Goude's aesthetic of the excessive and the impossible invokes the distensions of scarifications of a native African aesthetic, and the possibility of a totally different anatomy. It also recalls the angular and dislocated form of Josephine Baker's dancing body, or the impossible anatomy depicted in Ernst Ludwig Kirchner's painting of the *Tapdancing Negro*, whose body has been 'turned and twisted into an angular cipher of the syncopated motion and speed of tap dance'.[52] In positioning his 'impossible objects' within familiar spaces, Goude emphasizes the unsettling moment of the White subject's encounter with difference. In a 1979 image, entitled *Grace and Fashion Crowd, Imagined*, the homogeneous space occupied by two symmetrically positioned groups of seated White spectators is ripped asunder by the eruption of Grace Jones, who appears, like a tall, shiny, winged insect, emerged from another dimension, from behind luxuriant green draperies (suggestive, perhaps, of the edge of a jungle).

Grace Jones is transgressive to the point of transcendence: 'She has become a creature whose unique beauty transcends both the gender of her sex and the ethnicity usually associated with the colour of her skin. She looks barely human. She is more like a strange alien, blue-black, in black.'[53] Difference is here emphasized to the point where the Black woman crosses over into another register of being and meaning. Grace Jones is 'barely human'. Her difference is disavowed. Excluded as she might be from the order of the human, her difference would no longer make any difference. Indeed, Jones is 'barely human', even unequivocally bestial, in Goude's depiction of her, naked, on all fours in a cage which bears the sign 'DO NOT FEED THE ANIMAL'. On the ground scattered morsels of raw meat and bloody bones echo the red lips of her growling mouth; in the foreground, the back of the heads of an audience. Goude recalls going to the *Foire du Trône* as a small child: 'This is where I saw the fire-eaters. They were chained inside a cage. I remember they were four or five black wild men. But there was one who was my favorite – one with a bone in his nose. He would hold the bars and shake them like a gorilla. There was a rattling of chains and the savage would

spit out enormous flames over our heads. It was very dramatic.'[54]

In 1980, Helmut Newton photographed Jones, crouching in profile, holding a black leather whip with a red lash; she is naked but for the red and black make-up, the brilliant red on her nails and lips, the slash of yellow on her forehead, the ring around her finger, the bracelet around her forearm, the lash of the whip around her neck, and the chains around her ankles. She glances over her shoulder back at the viewer, with the hint of a smile.[55] Encaged by Goude, enslaved by Newton? In Newton's photograph, the instruments of enslavement do not tear the flesh; they are worn like fashion accessories. The chains, loosely draped around her ankles, do not seriously restrain her; she wraps the lash around her neck in the same way that she might a scarf or a tie. Her hands are free. She holds the whip as if to lead, to restrain herself, or to control someone else. Is this Grace Jones as the black slave of a white master's erotic fantasies, actively engaged in her own subjection? Or Grace Jones as the Black *Maitresse?* The image is uncertain: Jones appears neither submissive nor threatening. Her look towards the camera is irresolvably ambivalent; it leaves me with the impression of a performer who has not yet quite entered her role, who is perhaps unconvinced by the act she is required to play out for the camera: 'You mean like this . . . ?'

Jean-Paul Goude's growling Grace is definitely menacing. No longer the subjected bestiality of the organ-grinder's monkey, but the raw animality of the carnivorous wild beast threatening to break loose. The live performance, designed by Goude, on which this image is based involves the enactment of a fight between Grace Jones wearing a tiger costume and a real tiger. She wins and is shown, still in her furry outfit, chewing on the bloody remains of her victim. A small photograph showing the fight between Jones and the tiger is reproduced on the side of Goude's airbrushed image of Grace Jones naked in the cage. Were we to carry over the symmetry of one image – tiger fighting tiger – to the other, then the bloody remains would be human remains, and Grace a cannibal. On the other hand, were we to interpret the shedding of the tiger costume as the passage to another level of condensation, then the black skin would now *be* the tiger skin.

While the awkwardness in Newton's photograph suggests the self-conscious production of the stereotype, Jean-Paul Goude creates a seamless image of femininity and blackness *as* animality in the simple play of condensation.[56] However, this is not a simple reiteration of a colonial stereotype, but the re-presenting of that stereotype in the present context of post-colonialism: as the microphone held by the hand of a White man (off-frame) indicates, the encaged woman (the personification of Black Africa in certain colonialist allegories) is now to be heard, loud and clear, by the silent White spectators. The fairground barker has had to surrender his megaphone.

Goude plays up to the anxieties of Whites who fear the retribution of history; fear that they will be in their turn colonized, invaded by an army of 'strange, alien creatures'. Through the use of masks, he creates a multiplicity of Grace Joneses in black suits, their gazes obliterated by dark glasses. 'I made an army of marching Grace Joneses – soldiers, same size, wearing perfect masks of her face, goose-stepping in formation across the stage.'[57] A dark phalanx, without even the breach of a white smile (the ever-present smile of the 'good Negro', the smile of Josephine Baker). When, as a child, Goude drew pictures of cowboys and Indians, he would lavish all his attention on the detailed depictions of the Indians: 'The good guys, the Indians, were all different.' The white men he drew as an undifferentiated throng of generic 'cowboys': 'to help you understand that [they] were all crummy guys'.[58] Goude creates an army of similarly identical Grace Joneses – 'whatever Grace couldn't do, a clone was made by me to do it for her'[59] – in a replay of his childhood war games. But there is a difference: he endows Grace Jones with omnipotence; Jones can do anything. He multiplies the image of his obsession, drumming her particular features into our head: 'they all look like Grace'. At the same time, and in the very movement of multiplication, he denies Grace Jones her specificity; she becomes a mask amongst masks, a dark figure amongst dark figures who now 'all look alike' – just as, subsumed under their common difference, all Blacks may 'look alike' to the distant White.

She became the threatening, blue-black male-female, erotic menace I
wanted her to be, crashing cymbals and chanting to music, breaking
out of my frozen stop-time drawings through my direction to surges
of gesturing rage
JEAN-PAUL GOUDE[60]

Grace Jones as a wild beast, a boxer who 'throws jabs and
hooks, just like a pro',[61] a samurai, a demolition man whose
brow is pearled with sweat, a dark domineering deity, a force
to be reckoned with, the imaginary embodiment of the
threatening animality and corporeality which hovers at the
limits of our existence. However, the menacing physicality
that Goude attributes to his creation – from the 'savagery' of
the beast to the choreographed force of the professional
fighter – is represented with meticulous formalism. There is
no cluttered jungle, battlefield or ring, but the orderliness of
sanitized spaces, straight lines minimalism, in which Jones
stands, trimmed, geometrized and polished into a glorious
objet. Homi Bhabha speaks of the chain of signification of the
racial stereotype as being 'curiously mixed and split, polymor-
phous and perverse, an articulation of multiple belief. The
black is both savage (cannibal) and yet the most obedient and
dignified of servants (the servant of food); he is the embodi-
ment of rampant sexuality and yet innocent as a child; he is
mystical, primitive, simple-minded and yet the most worldly
and accomplished liar, and manipulator of social forces.'[62] Of
Toukie, Jean-Paul Goude writes: 'She was a combination of
innocence and aggressive sexuality.'[63] Of Grace Jones, he
says, 'Grace is modern because she is all new and yet reflective
of what she has been all along.'[64] Is she the organ-grinder's
monkey or the black and shiny 'demi-Goddess'? Is she the
growling beast or the *Bête Humaine* of modernity, 'blue-black,
shiny, aerodynamic in design'?[65] The subject's ambivalence,
articulated in the discursive chain of binary oppositions,
marks its object as either 'good' or 'bad'. However, from the
space of discourse to the space of the book *Jungle Fever*, from
the fixity of binary dualism to the multiplicity of identities, the
object of Goude's fascination becomes endowed with that
polymorphous perversity which marks it as both omnipotent
and transgressive. By virtue of her difference, the Black
woman can be all that the White male subject has had to give
up in his 'ascent' to subjectivity.

Kristeva writes of the encounter with *l'étranger*:

First, it is his singularity which arrests me: those eyes, those lips, those cheek-bones, this skin unlike other skins, distinguish him, and remind me that there is *somebody* there. The difference of this face reveals that which all faces should disclose to the attentive gaze: the inexistence of banality in humans. And yet it is banality which constitutes a community for our everyday habits. But this captivating seizure by the foreigner's features both attracts and repels me: 'I am as singular as he and therefore I love him', 'I prefer my own singularity and therefore I kill him', he could conclude.[66]

In 1925, artist Paul Colin was commissioned to design the poster for *La Revue Nègre*. At Colin's request, Josephine Baker posed for him at least three times, naked but for her underpants. The finished work, which was posted all over Paris, includes the image of a thick-lipped, pop-eyed Baker which, as Phillis Rose observes, 'barely rises above the stereotypes of Sambo art'.[67] The triumph of representation over the real – here, of stereotype over individuality – could not have been more complete. Jean-Paul Goude turned Grace Jones into a product of his imaginary – 'a vision entirely my own'. But, again, the 'private' vision emerges via a public preconscious that is heavily invested with the historical accretions of representations. The conflicting impulses (to annihilate or to love) find expression in the very structure of these representations of Black femininity – a femininity whose difference is stressed to the point of excess. Identifiable as the subject's 'own' construction, without ever totally losing its identity as 'other', as singular, the racial and sexual other is thus able to fulfil its role as mirror image of the White subject's own desired singularity.

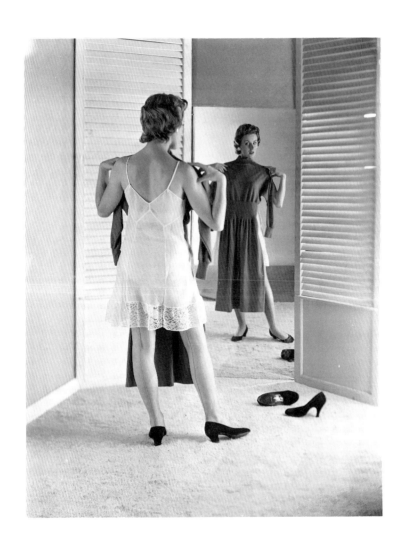

7 Skin deep

The November 1987 issue of the French magazine *Femme*
carries a black and white portrait photograph of a young
Audrey Hepburn in black polo-neck sweater and 'pony tail'.
The image appears alongside the results of an opinion poll,
addressed to both women and men (a smaller reproduction of
a portrait of Cary Grant graces the bottom of the page) aimed
at establishing which physical attributes of others most com-
monly arouse our envy. The article is entitled 'La beauté
idéale'. Audrey Hepburn's accession to the status of represen-
tative of 'ideal beauty' in the pages of *Femme* echoes her earlier
fictional consecration as the 'Quality woman' – archetypal
fashion model and cover girl for *Quality* magazine – in the 1956
film *Funny Face*. In this film, the character Hepburn plays is a
mousy bookstore assistant whose potential as a model is
discovered by a fashion photographer, played by Fred
Astaire. Hepburn's metamorphosis – her production as an
image – is effected through both the movie camera, in the real,
and the still camera, in the diegesis. Most conspicuously,
however, it is achieved through clothes.

 In the film *Now Voyager*, Bette Davis plays Charlotte, the
'unattractive', 'overweight', self-deprecating 'spinster' who is
literally transfigured as she puts on the apparel of the fashion-
conscious *femme du monde*. It is true that the narrative of her
ascent to beauty includes psychiatric treatment, which res-
tores both her mental equilibrium and her previously slender
figure; however, these concessions to narrative realism appear
inconsequential to the magic of her metamorphosis. Just like
the slovenly Cinderella, who blossoms into lush finery at the
touch of a magic wand, Charlotte's transformation occurs with
dazzling abruptness as – in the now-famous scene – she steps

out onto the gangway in her make-up and new clothes. From then on, she will slip in and out of her showy garments with an ease that increases each time her desirability is confirmed. While the labour involved in Charlotte's transformation is represented as primarily mental – she has to gain the confidence to wear the clothes – that involved in the transmogrification of Hepburn is acknowledged as industrial. However, although the labours of the fashion and the photography industry are acknowledged, and even emphasized, by the ever-sceptical fashion editor – 'A *lot* had to be done' – this labour is never shown. Hepburn's metamorphosis, from 'lowly caterpillar' to 'bird of paradise' (the expressions are from the script) is achieved with the effortless magic of a fairy tale. The French fashion designer in *Funny Face* speaks of 'opening the cocoon' out of which Hepburn emerges shrouded in draperies, a birth that expels its subject into the world fully dressed. The topos of the Cinderella myth, of which *Funny Face* and *Now Voyager* are versions, is of the revelatory instant in which a beauty that had previously been concealed is exposed, *never indecently*, but in the donning of a garment. There is a scene in the film *Follow the Fleet* in which a hunky sailor in a dance-hall, dazzled by the sight of a woman in a long body-kissing satin gown, fails to recognize her as the ineffectual woman in 'plain' dress he had spoken to, without interest, only a few moments earlier. Cinderella, Davis, Hepburn, they all become desirable to the man when they change their clothes: from the 'shapeless' and unadorned garment that renders its wearer invisible – quite literally so in *Funny Face*, in which Audrey Hepburn's first 'appearance' is in a dress of sombre brown that merges with the similarly coloured surroundings of the bookshop – to the *spectacular* dress that lures and traps the gaze. I am not suggesting here that the desiring man is particularly interested in the cut and finish of a woman's dress. Contrary to what these filmic narratives may seem to say, fashion design is not the crucial element in these scenarios of transformation; it is rather a matter of the man's imaginary investment in the feminine dress as such.

These transformations through clothes often, but not always, imply the transition to a higher social status. While Audrey Hepburn goes up in the world from shop assistant to fashion model, Bette Davis's social status is already high

enough to be unaffected by her transformation. At the time I am writing, a local cinema is showing *Pretty Woman*. This film is the Cinderella tale served with a pinch of *Pygmalion*: a working-class woman turned prostitute is picked up by a rich businessman, who turns her into a high-class sophisticate. In an early scene he entrusts her with his credit card and sends her shopping – in the exclusive boutiques on Los Angeles's Rodeo Drive – for a dress she can wear to accompany him on their first dinner date. Ever so predictably, her change of clothing – from 'vulgar' mini-skirt and boots to a sophisticated black cocktail dress – is enough to ensure that he fails to recognize her at their appointed rendezvous. From then on, the film progresses, with minor dramatic interludes, as sheer sartorial spectacle, as she pirouettes with increasing confidence in and out of lace, satin and silk.

The beauty hidden by Cinderella's rags is revealed, not through an undressing – to expose a radiant nakedness – but by a *transformation of the rags themselves* into *froufrous*, cascading fabrics, shimmering colours, plunging lines. It is worth recalling here the words with which the fashion designer introduces Hepburn as she makes her first appearance as a fashion model in *Funny Face*: 'A gamin, a waif, a lowly caterpillar . . . when we open the cocoon it is not a butterfly that comes out, no . . . it is a bird of paradise!' A truly magical moment: a bird born from a cocoon. The comparison of the woman with a bird of paradise is ornithologically inaccurate – it is the male of the species, not the female, which displays a brilliantly coloured plumage – but it nevertheless makes the point that beauty is a *display*. It may further bring to mind J. C. Flügel's notion of the 'Great Masculine Renunciation': the moment in history when the human male abandoned sartorial flamboyance in favour of austerity.[2]

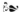

The surrendering by aristocratic men of their prerogative to exhibitionism has been explained as a response to the political, social and economic transformations which took place in eighteenth-century Western society. For example, Flügel speaks of the demand for a greater uniformity of dress as an expression of the belief of the French Revolution in the common humanity of all men. Women, who had traditionally

played a lesser part in civic society, consequently remained for the greater part untouched by these influences. Quentin Bell argues that, with the rise of a large industrious middle-class, the association of wealth with leisure and the sartorial sumptuousness that this leisure encouraged, became meaningless to the working man – but not to his non-working wife, whose task it became to show off the wealth of her husband through her vestimentary display. Kaja Silverman remarks that there is a point at which Bell's 'plausible' explanation of the economic and social determinants of the changes in male dress lapses into something approximating a 'fleeting avowal of male castration'. She quotes him: 'It was as though the men were sacrificing their hair, and indeed all their finery, for the benefit of women.'[3] The discursive shift from cause to affect acknowledges a sense of loss and the consequent envy of the woman's exhibitionistic licence. Flügel writes: '. . . it is of course true that such a change can only have been brought about by the operation of very powerful psychical inhibitions.'[4] The man's desire for exhibitionism, once satisfied by the ostentatious display of fineries, has undergone certain vicissitudes; for example, in some individuals, it may be transformed into a desire to achieve conspicuous professional success; it may be reversed into the opposite desire to look at; or it may be projected onto the woman – a projection which always involves a degree of identification.

But first, what is it that the man had to give up when he surrendered sartorial ostentatiousness? Flügel invokes the scene of the child prancing about naked, without any sense of shame, its pleasure sustained and heightened by the adoring gaze of the parents or adults standing by. He suggests that the pleasure afforded by sartorial display derives initially from such narcissistic investment in one's own body, which is later metonymically displaced onto the clothes and other decorations that the body wears. For Freud, the pleasure of self-display is a vicissitude of the scopophilic drive. Exhibitionism originates in the auto-erotic activity of looking at a part of one's own body – an activity initially coincident with pleasurable bodily sensations – which will later evolve into looking at someone else's body by a process of comparison. The scopophilic drive will then once again be turned around upon part of one's own body, but this time with a new passive aim, that of being *looked at*. Finally, a new subject is introduced, to

whom one displays oneself in order to be looked at. Between the finding of, and the subsequent turning away from, the extraneous object, the subject acquires an image of its body in identification with that of another – a formative transaction which Lacan encapsulates in the utterance, 'I am looked at, that is to say, I am a picture.'[5] It is this picture which the subject proudly displays. And the pleasure afforded by self-display arises from the subject's identification with the gaze of the other: the subject sees itself, as a picture, from the vantage point of the other; the pleasure is fundamentally scopophilic. At a later stage of the child's development, exhibitionism will most likely involve the display of the genitals, which have become libidinally invested. Freud insists on the concurrency of the primary active aim of the scopophilic drive with its secondary passive direction: '. . . anyone who is an exhibitionist in his unconscious is at the same time a *voyeur*.'[6]

Invoking Lacan's account of the mirror phase, Kaja Silverman stresses the importance of the function that is performed by the look of the other in the articulation of a corporeal image, to assert that: 'the male subject is as dependent upon the gaze of the Other [i.e. the other invested with an imaginary plenitude] as is the female subject, and as solicitous of it – in other words . . . he is as fundamentally exhibitionistic.'[7] Here Silverman argues that voyeurism is only a secondary formation, or 'alternative avenue of libidinal gratification', which implies a primacy of exhibitionism over the pleasure in looking. However, I wish to retain the model proposed by Freud in his account of the vicissitude of the scopophilic drive: first, there has to be not just looking, but a certain pleasure in looking, to motivate the formation of a unified corporeal image (which, as Lacan has shown us, is always an ideal image). Second, Freud's account of the developmental history of the drives emphasizes the permanence of the intermediate phases in later life; the aim of the drive is never fixed, but always oscillates between activity and passivity. It seems to me that Freud's notion of the fundamental duality of the drive already provides a strong enough argument for the coexistence of passive exhibitionistic and active scopophilic tendencies in men as well as in women, without having to posit a primacy of exhibitionism. Evidently, this structural ambivalence of the drive will manifest itself differentially according to the individual, and the period in which the individual lives.

The 'Great Male Renunciation' would testify to a moment in history when an extensive redefinition of social formations inflected the expression of this psychic ambivalence more in the direction of active scopophilia for the man. One should note here that there is a perpetual replay of the historical 'renunciation' at the level of the individual, when the small boy, in becoming aware of social codes, gradually rejects the garish – *tape-à-l'œil* – clothing he once delighted in.

According to Silverman, man's abandonment of sartorial ostentation is effected through the 'disavowal of his specularity', of his being as a picture; a disavowal which we could formulate as: 'I know very well that I am looked at, that I am a picture, but nevertheless, I am not a picture because I am doing the looking.' The male subject can disavow, but cannot obliterate, his specularity, which is the condition of his existing in the visible. The picture he displays does not lure the gaze in order to ensnare it; it rather elicits, beside and above a pleasure in looking, a process of deciphering of the social codes it carries; man's specularity is put at the service of the Law, while woman's appearance functions to sustain the man's pleasure in looking.[8] (This is not to suggest that the woman's appearance can ever be apprehended outside of social encodification; neither is it to say that it never falls foul of the Law.)

Audrey Hepburn appears on stage, 'transformed'. All activity ceases as the assembled cleaners, designers, dressers, editor and photographer gaze in wonder as Hepburn advances regally down the catwalk towards them. All smile a smile of contented recognition. The scene is literally a staging of ostentatious display: the ornate curtain is raised slowly to reveal Hepburn, shrouded in cascading draperies, framed like a picture by the proscenium arch. In that instant of enraptured stillness it is possible to imagine that Hepburn's audience – the male designer and the photographer, the low-paid female cleaners, the magazine editor (who would 'not be caught dead' in any of the showy garments her models wear) and of course the cinema audience – recognize, in that excess of visibility, no one other than themselves. More specifically, they participate – no matter that it is vicariously – in the possibility of acceding to the status of 'being as a picture'. Why else would they look so contented? Why else would the two young female receptionists in *Pretty Woman* beam with such

approving admiration as Julia Roberts strolls across the hotel lobby, clad in a long red evening-dress? Ideal cinematic moments, when the onlooker gazes at the Other, without envy, in joyful *mis*-recognition.

It is worth recalling here that while the sartorial panache of the woman attests to her being in the visible, it also performs the function of rendering invisible the parts of the body over which it displays itself. Unlike the man who peered at Lady Godiva's nakedness as she rode through the city streets in broad daylight, he who gazes at the clothed woman is not in danger of punishment. The vestimentary display sustains the look, and gives itself over to scrutiny, ideally without eliciting either threat or guilt. While acknowledging the ever-present fetishistic dimension of the man's imaginary investment in female dress (in the dialectic of display and concealment, the dress can always stand in for that which is missing), I now wish to consider a perhaps less familiar aspect of the relation.

> ʈ *There is no finer, richer, more beautiful fabric than the skin of a pretty woman*
>
> ANATOLE FRANCE[9]

Arguing in favour of sartorial extravagance, Kaja Silverman insists on the central function performed by clothing in the articulation of body and psyche. Clothing, she writes, is a 'necessary condition of subjectivity'. She quotes Freud's definition of the ego as 'a mental projection of the surface of the body' and invokes Jean Laplanche's own inference of the need for an 'envelope' or 'sack' to contain and define body and ego. She concludes: 'In effect, clothing is that envelope.'[10] If we turn to Laplanche's text we find that the 'sack' in question is specifically defined as 'a sack of *skin*'. He writes: 'We are thus led to admit the existence of an identification that is both extremely early and probably also extremely sketchy in its initial phase, an identification with a form conceived of as a limit or a sack: a sack of skin.'[11] I wish to foreground here the reference to the skin which remains tacit in Silverman's argument, and clearly establishes the role played by the cutaneous surface of the body in the constitution of the ego. As Silverman suggests, clothing articulates the 'body-ego', to

which I want to add: on the model of the skin. When Flügel mentions the skin, he merely concerns himself with its sensory functions. For him, the auto-erotic pleasures arising from the contact of the skin with certain fabrics, or the comforting feeling afforded by tight garments, are inferior to the sensations arising from the play of air and wind upon the surface of the skin, or the free-play of the muscles. Therefore, sartorial display would have very little to do with these sensory experiences of the skin. Flügel writes: '. . . on the whole, therefore, muscle-erotism, like skin-erotism, loses rather than gains by the wearing of clothes. It is therefore to displacements of the Narcissistic rather than of the auto-erotic elements that clothing must look for psychological support of a directly pleasure-giving kind.'[12] Flügel fails here to look beyond the sensory experiences afforded by the body-surface, at the imaginary representation of that surface – the relationship between skin and clothes is conceived of as simply tactile. Yet, a few pages earlier, Flügel makes a comment that is suggestive of a symbolization of skin contacts. Following a citation from Thomas Carlyle's posthumous homage to his wife – 'She wrapped me round like a cloak to keep all the hard and cold world off me' – he comments: 'Deep down in the heart of mankind is the longing for a mother who will protect us, cherish us, and warm us with her love – a longing which seems to take us back to the very earliest stages of our being.' Flügel then mentions the 'phantasies of a return to the warm, enveloping, and protecting home, where we spent the first nine months of our existence.'[13] Thus Flügel indirectly evokes the development of early sensory experiences of containment and protection into representations of an envelope of love and caring; representations in which love, the woman/mother's body and the garment become confounded.

In order to understand the relation of the garment to the maternal envelope I first need to assess the subjective status of the skin. My further aim will be to redefine the male fascination with the female dress, at work in the cinematic tales of transformation mentioned above, as being, at least in part, a fascination for the sartorial *skin*.

In his 1923 essay entitled the 'Ego and the Id', Freud stated that, 'The ego is first and foremost a bodily ego; it is not merely a surface entity, but is itself the projection of a surface.' In 1927 he added the following footnote: 'i.e. the ego is ultimately

derived from bodily sensations, chiefly from those springing from the surface of the body. It may thus be regarded as a mental projection of the surface of the body, besides as we have seen above, representing the superficies of the mental apparatus.'[14] Taking his cue from Freud, Didier Anzieu wishes to re-evaluate current theories of the formation of the ego by foregrounding the role played by the skin, and suggesting that the ego is primarily structured as a 'Skin Ego'.

Anzieu's notion of a 'Skin Ego' presupposes a shift of emphasis from psychical contents to psychical container, and the reassessment of the reality experienced by the baby at the oral phase. Anzieu writes: 'By Skin Ego, I mean a mental image of which the Ego of the child makes use during the early phases of its development to represent itself as an Ego containing psychical contents, on the basis of its experience of the surface of the body.'[15] The infant acquires the perception of a bodily surface through the contact with the skin of the mother (or a substitute) when it is being fed and cared for. It is the experience of being held in the mother's arms and pressed against her body, of being picked up, manipulated, washed and caressed which Anzieu foregrounds as being as important as, and correlative to, the experience of sucking and the subsequent pleasure of repletion of which Freud has spoken.

The contact between the lips and the nipple, the passage of the milk from the buccal cavity through the pharynx, the inner sensation of fullness, the epidermal contacts – all of these lead the infant to gradually acquire a sense of a surface which has both an inner and an outer face, and a sense of volume. The sensation of surface and volume affords the infant the experience of a 'container' and the perception of orifices – passages from the inside to the outside and vice-versa – through which the food is ingested and expelled. The further interplay of touches and sounds between mother and child creates a secure tactile and acoustic envelope, a receptacle in which the infant may store its sensations, images, affects. At that stage the nascent Skin Ego is imaginarily represented as an outer shell that envelops the whole of the psychical apparatus, in the same way as the skin covers the entire body, with the Id as an inner kernel. The formation of a Skin Ego necessarily involves the constitution of an 'interface', with the mother on one side and the infant on the other – an imaginary *common skin* which, ideally, ensures direct communication, empathy

and, in Anzieu's expression, 'adhesive identification' between mother and child. This interface keeps the two partners in symbiotic dependency, and it is only gradually that each will (re)acquire a sense of a separate skin, a separate ego. (We may recall here the example of the skin of the milk which Kristeva uses in *Powers of Horror*. She argues that the revulsion experienced as the lips touch that skin is the expression of the rejection of parental love, and more fundamentally, of the expulsion of the body of the archaic mother. Anzieu's insights allow us to further define this archaic body as the primitive interface between mother and infant: the rejection of the skin of the milk would effectively be the rejection of the imaginary common skin, and therefore of the subject itself.)

The surrendering of the common skin, of which the withdrawal of the breast is an instance, is painful; it is at this early stage of ego-structuring that Anzieu locates the origins of the fantasies of the flayed skin, the stolen skin, or the bruised or murderous skin – of which the Classical myth of Marsyas would be a literary instance. In Anzieu's description, the 'successful' surrendering of a common skin, and the resulting acquisition of a Skin Ego, is conditional upon a dual process of interiorization: the interiorization of the common skin, which becomes a psychical container, and that of the mothering environment, which becomes the child's 'inner world of thoughts, images and emotions'.[16]

The Skin Ego is, therefore, a part of the mother that has been internalized and which serves as a support to the psychical and physical development of the child. Anzieu notes that, 'What is evident here is not the phantasised incorporation of the nourishing breast, but the primary identification with a supporting object which the child hugs and which supports it.'[17] The idea of an internal support evokes Lacan's notion of the 'orthopaedic' form that is acquired in identification at the later mirror stage – the form which holds the sensory fragments into the totality of a body-image. Anzieu describes the skin as 'a surface containing pockets and cavities where the sense organs, apart from those of touch (which are contained in the epidermis itself), are located.'[18] The Skin Ego displays a parallel structure as a psychical surface which unites the various sensations into a 'common sense' – an original tactile background against which sensory events stand out. The development of a 'common sense'

anticipates the jubilant sense of recognition felt in the mirror stage.

The mental representation of a Skin Ego is sustained by the multiple functions of the skin: as a container that holds all the good things accumulated through feeding and care; as a surface that marks the limit between exterior and interior; as a protection against the aggressions and avidities of the other; as a primary site and means of exchange with the other – the infant initially experiences the mother's touch as a sensory stimulus, then as a communication. The mental representation thus elaborated serves the dual function of establishing boundaries, and filtering exchanges; a function which responds to the need for what Anzieu calls a 'narcissistic envelope', which ideally provides the psychical apparatus with 'a sure and continuous sense of a basic well-being'[19] (a state of being for which the French language has an apposite expression: *être bien dans sa peau*). However, common vicissitudes of this function will inevitably produce a defective psychical surface – perforated like a sieve, fragmented, and either so rigid that it does not register or respond to stimulation, or so insubstantial that it is unable to resist aggression. This psychical surface may also be marked by shameful and indelible inscriptions that have issued from the Super-Ego, and thus become an envelope of suffering; various strategies may be developed by the Skin Ego to palliate the resulting psychical anxiety. In one such instance, characteristic of 'narcissistic personalities', the structure of a fragile Skin Ego is reinforced through two mental operations, which Anzieu describes as follows:

> The first [operation] consists in abolishing the space between the two faces of the Skin Ego, between external stimuli and internal excitation, between the image [the subject] gives of himself and that which is reflected back to him; his surface becomes solidified by becoming a centre, indeed a double centre, of interest: both for himself and for others, and it tends to envelop the whole of the psyche. Thus extended and solidified, the envelope gives him security, but it lacks flexibility, and the slightest narcissistic wound makes a tear in it. The second operation aims at doubling the outside of the Skin Ego thus cemented with a symbolic maternal skin, analogous to the aegis of Zeus, or

those stunning showy rags in which young female models, often anorexic, drape themselves, the splendour of which re-narcissizes them temporarily in the face of the constant threat the physical container may disintegrate.[20]

The defensive mechanism described here reactivates the fantasy of an unbroken, all-enveloping psychical skin that originates in the early phases of ego structuring, when mother and child share an imaginary common skin. The subject's attempt to secure for itself an impregnable Skin Ego gives rise to the narcissistic fantasy of a second skin – the skin the mother has given up to the child in order to guarantee its protection and strength. Here we may again recall Thomas Carlyle's fantasy of being cloaked in the skin of his loving wife. It is interesting to note, too, that the airbrushed brilliance which Jean-Paul Goude bestows upon the Black woman's skin is, in a sense, a maternal inheritance. Goude's White mother once belonged to a troup of Black dancers; he thus finds the terms to express his fascination with the common skin in his mother's admiration of the Black body.

Anzieu writes: 'This double covering ([the subject's] own joined with that of the mother) is brilliant, ideal; it provides the narcissistic personality with an illusion of invulnerability and immortality.'[21] The cost, however, is the ever-present threat of having one's own skin torn off by the mother, who may desire to repossess the subject's Skin Ego, and thus reestablish the fantasy of a common skin.

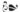

As I have already noted, Flügel argues that the pleasure afforded by sartorial exhibitionism derives from a narcissistic investment in one's own body that has been metonymically displaced onto clothing. We may now further suggest that the body in question has to be thought of as a body-*surface*, an envelope of skin (indeed, Flügel himself suggests that sartorial display will yield most satisfaction when it affords the wearer a sense of unity, that is, when clothes become a second skin). Anzieu likens the narcissistic second skin to the 'stunning showy rags' in which the young female model drapes herself. We are back with the image of Audrey Hepburn, as she steps onto the catwalk draped to the hilt. The narcissistic fantasy of an inviolable second skin can only be sustained if it is

recognized as such by the other; and, in order to be recognized, it must first be acknowledged. The subject may display its second skin through the metonymic mediation of clothing, or adornments that lure the eye. I purposefully spoke of an *inviolable* second skin: a surface that cannot be penetrated by any means, including sexual means. This protective function of the narcissistic envelope would therefore partake of the prohibition on touching which Anzieu posits as a precursor to the prohibition on incest.

Anzieu notes that the first interdiction that the infant encounters is related to tactile contacts. The prohibition on touching is aimed, on the one hand, at protecting the child against its own aggressivity and that of others; on the other hand, it is intended to protect the child from sexuality – its own and that of others. In both cases it is the excess of excitation, 'instinctual violence', which is kept in check by the parental prohibition. Anzieu distinguishes two phases of the prohibition on touching, corresponding to two structures of tactile experiences: a primary prohibition on the embracing, conjoining and confusing of bodies (weaning would be an instance), which imposes a separate existence on the small human being; and a secondary prohibition which concerns touching with the hand and the drive to master – one no longer points at or touches, one names – and which encourages the renunciation of echotactile communication as the primary mode of communication with others. Touching is subsequently limited to certain adaptive necessities, and the pleasures that it produces are lasting only if they are subordinated to the reality principle. The prohibition on touching, insofar as it involves an act of seduction and aggressivity, provides the grounding for the later prohibition on incest and parricide. In Anzieu's words, 'the Oedipal prohibition is constructed by metonymic derivation upon the prohibition on touching.'[22]

Undoubtedly, clothing provides a protective layer which hinders, however temporarily, skin contacts. However, when clothing takes on the status of a narcissistic second skin and becomes ostentatious display, the gaze is lured with the promise of something that is deferred by the act of contemplation. The prohibition on touching is now effected through the 'sublimation' of touching into looking. 'Seeing', Freud remarks, is 'ultimately derived from touching.'[23] The resplen-

dent sartorial skin, worn and displayed by the young model, functions to secure for her – and for the man who can admire her without fearing castration – an imaginary all-enveloping invulnerability.

The woman confidently displays her sartorial skin. The man, who has disavowed his own vestimentary exhibition- ism, looks on with a twinge of envy. Didier Anzieu has shown us that the narcissistic second skin is the skin of the mother, and cannot be dissociated from the archaic common skin which the child and the mother once shared. The notion of a *common* skin implies that the question of ownership is never decided. In putting the maternal skin on, over its own, the subject invokes the imaginary plenitude that preceded differ- entiation. This fantasy of the double-walled skin contains another: that of the stolen skin. The mother's gift of her own skin is a fantasy of reparation, in which the mother returns to the subject the skin she had stolen from it in early separations. It is in the narcissistic nature of the fantasy that the gift is conceived as one of *boundless* love.

The reparatory fantasy has a retaliatory correlative in which the subject steals the maternal skin. For Eugénie Lemoine- Luccioni, who also draws the analogy between dress and 'the second skin', 'the garment is always stolen'.[24] In displaying her sartorial covering, therefore, the woman parades that which she has acquired from the mother by either gift or theft. By the same token, she displays to the man the skin which he perceives as having been stolen from him by the mother. Furthermore, as woman, and therefore as always potentially representing the mother to the man, the sartorially extrava- gant woman not only displays the maternal skin, but embo- dies it. The fascination which female dress holds for the man may draw some of its strength from his desire to repossess the once commonly held maternal skin – a desire overdetermined by the 'historical renunciation', but not initially derived from it. Henceforth, while he may not re-enact the wearing of the maternal skin, the man may nevertheless derive a vicarious comfort in his proximity to, and identification with, the woman who possesses it.

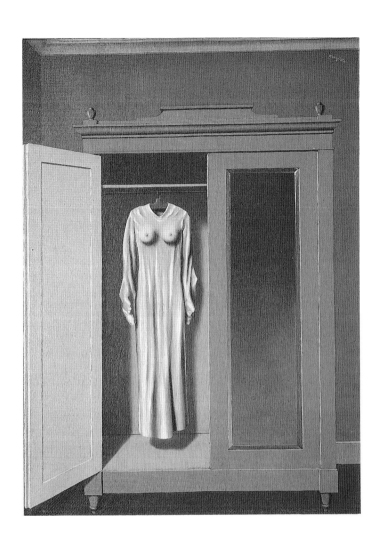

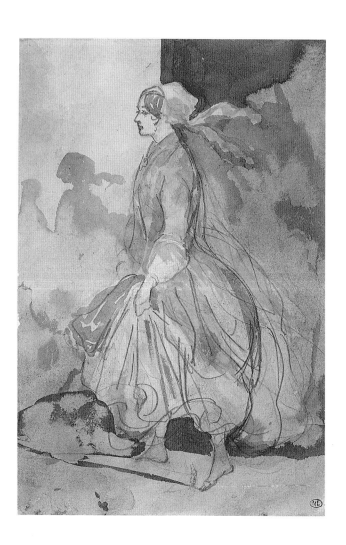

8 Love at last sight

The deafening street around me roared.
Tall, slender, in deep mourning, majestic grief,
A woman passed, with a magnificent hand
Lifting, swinging flounces and hem;

Agile and noble, with her statue's leg.
Me, I drank, tense as a madman
From her eye, livid sky where the hurricane rises,
The sweetness which fascinates and the pleasure which kills.

A lightning flash . . . then night! — Fugitive beauty
Whose gaze has caused me to be suddenly reborn
Shall I see you again only in eternity?

Elsewhere, far from here! too late! never, perhaps!
For I know not where you fly, you know not where I go,
O you whom I would have loved, O you who knew it.
CHARLES BAUDELAIRE[1]

An aimless and distracted glance, captured for the briefest
instant by a female figure; the hand clutching the black fabric,
the ankle beneath the lace; the look which fleetingly meets his
– 'a lightning flash', *coup-de-foudre*, '. . . then night'. The 'agile'
stride of the passer-by carries her away from the poet. He is
immobilized – almost as if in a state of neonatal motor
incapacity, infantilized by social conventions – and helplessly
witnesses her disappearance. The scenario Baudelaire evokes
is very unlike the glossy chance encounters that are familiar to
us from television advertisements for perfume, where the
man, bouquet in hand, actively and impulsively follows the
female scent, as far as the fulfilment of his wish, as the
unknown woman coquettishly turns to offer him the spectacle
of her radiant image. The Baudelairean passer-by does not
stop. Her gaze is furtive, her presence ephemeral. She is not a
fully-formed image so much as a single impression issued
from among the myriad impressions of the urban street.

I am reminded here of Breton's first encounter with Nadja –
'Suddenly, perhaps still ten feet away, coming in the opposite
direction, I saw a young, poorly dressed woman . . .'[2] Breton,

contemptuous of convention (if, indeed, convention applied when a middle-class man of Breton's days confronted a shabbily dressed woman), unhesitantly approaches the young woman. Further encounters follow – rendezvous in street cafés and bars – yet still Breton's Nadja eludes him. When asked 'Who are you?' she replies 'the wandering soul'. Throughout their haphazard autumnal meanderings along the streets of Paris, Nadja remains essentially a passer-by. Her fleeting presence is never fixed in space, and her whimsical speech evades interpretation. Similarly, Nadja's appearance escapes description – Breton allows us to 'know' only the eyes, *yeux de fougère*, underlined in thick black, 'so black for a blonde', says Breton, the 'lovely teeth' he kisses, the ill-manicured hands. Furtive apparitions eluding description, the litany of physical attributes, and which are formed of mere impressions – visual traces impressed upon the psyche, in a flash. Nadja says to Breton: 'If you wished, for you I would be nothing, or just a trace.'[3]

In her essay on the 'invisible *flâneuse*', Janet Wolff writes: 'The modern consciousness consists in the parade of impressions, the particular beauty appropriate to the modern age.'[4] In 'The Painter of Modern Life', Baudelaire had praised the water-colourist Constantin Guys for his depictions of urban public life, which for him succeeded in capturing this transitory quality of modernity. Photography had been invented at the time Baudelaire was writing, but, for mainly technical reasons, it had not as yet 'taken to the street'.[5] Photography was to become the medium of modernity *par excellence*. It responded to a wish to record the changing appearances of things in a world rapidly metamorphosing, and it also answered to an elusive desire arising from, to misappropriate Baudelaire's words, '. . . a fear of not going fast enough, of letting the phantom escape before the synthesis has been extracted and pinned down.'[6] More than a century later, Garry Winogrand's street photography can be seen as continuous to Constantin Guys's project, as defined by Baudelaire. In the early 1970s, Winogrand took a series of photographs of unknown women, passers-by who on occasions looked back at the camera, seemingly with amused embarrassment, mute discomfort or

exhibitionistic affront. These were published in 1975 under the title *Women are Beautiful*. A collection of parting glances, they constitute a visual record of so many instances of 'love at last sight'. However, to record that instant is to alter it irrevocably. Held back in a lingering farewell, the fugitive female figure has been stopped in her stride. The photograph here is at once a record of impotency – the 'never' of the poet – and a testimony to the impulse, not so much to detain the object as to sustain the moment of its finding, which is also that of its loss. This is suggested by the fact that the women in Winogrand's photographs are rarely seen in isolation; the space they inhabit is not the idealized space of the portrait, inviting intimate contemplation. They are actors in a *mise-en-scène* of public life that is set mainly in the crowded urban street – the space of transience and chance encounters. The women in Winogrand's book are, to borrow Baudelaire's words, 'floating existences', borne along by the movement of the street, at times detained in hurried conversation, or pausing on their way to somewhere else. The woman in Breton's book appears in no photograph, possibly because no photograph of her was taken. (There could have been a portrait of her by Max Ernst if the artist had turned a deaf ear to the predictions of his clairvoyant.) All we see in invocation of Nadja are the photographed sites of her long urban wanderings with Breton, and her drawings, the pencil traces of her fantasies. Unlike Winogrand, Breton seems to have chosen not to detain his passer-by in an image.

Baudelaire, Breton, Winogrand; evocations of a commonplace experience of urban seduction – the unexpected surge of emotion at the sight of a stranger passing in the street – reveal an object which eludes contemplation, a fleeting image which traverses the man's field of vision without being pinned down. In her reference to Baudelaire's sonnet 'A une passante', which she approaches by way of Walter Benjamin's comments on the poem, Griselda Pollock overlooks this central motif of powerlessness, just as she ignores Benjamin's insightful notion of 'love at last sight'. She writes: 'The gaze of the *flâneur* articulates and produces a masculine sexuality which in the modern sexual economy enjoys the freedom to look, appraise and possess, in deed or in fantasy.'[7] Pollock's reading allows her to retain a clear and simple picture of a controlling male gaze and a subjected female body, of a male

sexuality which freely exhausts itself in fulfilment – actual or fantasmatic. Certainly, the fantasmatic impulse to master is inevitably at play in scopophilia, whether the subject be female or male. Furthermore, it is surely true that the act of looking itself, and what it comes to mean, is inflected by the particular socio-historical context in which it takes place – the right to stroll unaccompanied along the streets in nineteenth-century Paris and to allow one's gaze to brush by strange *redingotes* and skirts belonged only to men; similar behaviour would have been considered as reprehensible in women. In 'The Painter of Modern Life' Baudelaire does indeed conceive of the 'perfect *flâneur*' as an ideally free male subject; one who enjoys the 'fugitive pleasure of circumstance', who 'sees the world', is 'the centre of the world and yet remains hidden from the world.'[8] Baudelaire's praise of *flânerie*, however, should be considered squarely in the context of a notion of 'modernity' conceived as 'the ephemeral, the fugitive, the contingent'[9] – that is, the context of a present which is always already disappearing into the past. The urban street then becomes the privileged figure of modernity, and the moving crowd its very embodiment, precisely to the extent that it is the site of a perpetual transience, a transience which cannot be mastered.

Pollock's transformation of the poet's helpless 'never' into an instance of 'mastery' derives from her too hasty assimilation of the elusive experience of the urban street, evoked in Baudelaire's poem, to the leisurely spectatorship implied in those more sedentary aspects of public life – the theatre, the café, the casino – which were also depicted in 'The Painter of Modern Life'. Here, for example, Baudelaire is describing one of Constantin Guys's watercolours: 'Bathed in the diffused brightness of an auditorium, are young women of the most fashionable society, receiving and reflecting the light with their eyes, their jewelry and their snowy, white shoulders, as glorious as portraits framed in their boxes.'[10] The women are no longer 'fugitive beauties', but are indeed still images upon which a contemplative gaze may linger, perhaps in a fantasy of mastery. Note here the *mise-en-abîme* of looks and images, in which the painter's gaze upon the young women 'framed in their boxes' is contained within the writer's gaze upon the painting. Let us imagine a scenario in which the attention of a man walking down the street is inadvertently caught by the

figure of a woman moving in and out of the bright rectangle of a window. The subject now looking at the woman from the public space of the street is looking into a forbidden, private space – becoming, however unwittingly and momentarily, a voyeur. Although the figure of the woman keeps disappearing from his sight as she moves about the room, she is nevertheless contained, boxed both in the rectangle of light, and between the walls behind the window. This spatial fixity makes her, like the young women in the auditorium, already more knowable, in principle more attainable, her disappearance less final.

The passer-by, on the other hand, comes into her ephemeral existence precisely in the public space of transition between, let us say, the office and the room behind the window, between that room and the theatre. Here she eludes fixity and containment, evading the gaze her passing figure has momentarily animated. Baudelaire's lines in 'A une passante', then, do not express mastery over the object of desire, nor fulfilment; they rather represent the flaring up of desire at the moment in which the object is lost. This is why Walter Benjamin inverts the common expression 'love at first sight' to suggest that, 'The delight of the city dweller is not so much love at first sight as love at last sight.'[11] The twinge of emotion, what Benjamin more emphatically calls 'shock', felt at the sudden and fleeting apparition is thus already an acknowledgment of the impossibility of the fulfilment of desire. As Benjamin observes: 'The *never* marks the high point of the encounter, when the poet's passion seems to be frustrated but in reality bursts out of him like a flame. He burns in this flame, but no Phoenix arises from it.'[12] Desire is kindled precisely at the moment the object is lost, lost in the crowd that bears her away.

≥ *What we call libidinal investment is what makes an object become desirable, that is to say, how it becomes confused with this more or less structured image which, in diverse ways, we carry with us . . .*
JACQUES LACAN[13]

In *L'Amour Fou*, Breton writes about the *trouvaille*, a term which stands both for the object found and for its finding. The emotion aroused by the *trouvaille* – 'the poignant feeling of the

thing revealed, the integral certainty produced by the emergence of a solution, which, by its very nature, could not come to us along ordinary logical paths'[14] – is one of the conditions of beauty which Breton names 'convulsive'. The chance encounter with Nadja in the bustle of Paris evokes the *trouvaille*. 'The objects . . . had just been barely distinguishable from each other in the first hour of our stroll. They flowed by, without accident . . .'[15] Nadja emerges out of the stream of indifferent and undifferent passers-by – 'holding her head high, unlike everyone else on the sidewalk' – just as another of Breton's *trouvaille* in *L'Amour Fou*, a wooden spoon with a little shoe forming part of its handle, takes on a poignant visibility against a background clutter of indistinguishable things. 'This object', writes Breton, 'in its matter, in its form, I more or less predicted . . .'[16] As he looks at the wooden spoon that he has placed on a piece of furniture, he remembers the 'cendrier-Cendrillon' which he had asked Giacometti to sculpt for him. It was to be a little slipper made out of grey glass, which Breton intended to use as an ash-tray. Giacometti forgot to make it, and Breton recalls feeling 'the *lack* of this slipper' which impelled him into a long daydream. The object he had so desired he rediscovers in the shape of the wooden spoon, in which he sees first the slipper that Cinderella lost in her flight from the ball, then the motion of the pumpkin-carriage (by analogy with the imagined movement of the shoe), and finally the utensil that Cinderella must have used in the kitchen. Hence Breton's *flânerie* amongst the stalls of the flea-market has again led him to the signifier of an absent woman, or more correctly, of the *loss* of a woman – Cinderella, another fugitive pedestrian. Breton has here retraced his steps back to the glass slipper, anchoring the found object to memories which borrow from both the personal and the cultural; the mythical shoe of a legendary woman comes to figure in the desiring life of the subject.

Writing about photography – more correctly, about the only photograph which assuredly existed for him, that of his now-deceased mother as a little girl in the Jardin d'Hiver – Roland Barthes draws a distinction between that which in an image awakens an intellectual interest, the *studium*, and that which moves the viewer in a way that is incommunicable, the *punctum*. The *studium* is characterized by reason, by the subject's commonsense interpretative hold on the image. The

punctum, on the other hand, is that which the subject does not seek, but which, in Barthes's words, 'rises from the scene, shoots out of it like an arrow, and pierces me.'[17] An unexpected and ephemeral event, like a chance-encounter, 'A photograph's *punctum* is that accident which pricks me (but also bruises me, is poignant to me').[18] The *punctum* disturbs the knowledge we have of the object as it traverses 'the seamless surface of the *studium*; it is manifested in the 'unexpected flash' which evokes the dazzlement that Baudelaire describes as the tall and slender figure of a woman sweeps across his field of vision: 'What makes his body twitch spasmodically is not the excitement of a man in whom an image has taken possession of every fiber of his being; it partakes more of the shock with which an imperious desire suddenly overcomes a lonely man.'[19]

In his essay of 1986 entitled 'Diderot, Barthes, *Vertigo*', Victor Burgin theorizes about the *punctum* by way of the psychoanalytic concept of the 'ideational representative'. The ideational representative is an idea, or set of ideas, to which the drive has attached itself in the course of the subject's history, and which has thereby come to represent the drive in the psyche. The drive is only ever known through its representatives; in Freud's words: 'An instinct [*Trieb*] can never become an object of consciousness – only the idea that represents the instinct can. Even in the unconscious, moreover, an instinct cannot be represented otherwise than by an idea. If the instinct did not attach itself to an idea or manifest itself as an affective state, we could know nothing about it.'[20] It may be useful here to look back, again, at the early history of the subject's fantasy life, at the prototypical instance of loss which, for the first time, awakens desire and motivates fantasy. The absence of the nipple, in denying the satisfaction of a need, provokes the hallucinatory re-enactment of the pleasurable experience of feeding. This first hallucinatory representation of satisfaction – mnemic traces of the perceptual experience – is the ideational representative of the component drive which will thereafter be evoked every time that hunger is felt. The internalization of parental and social interdictions by the older child will cause him/her to give up the pleasure afforded in suckling; from then on, the ideational representatives of the oral drive are denied access to the consciousness, and thus form a first unconscious nucleus

which will act as a pole of attraction for any elements to be repressed. This primary binding of the component drive to a representative, or set of representatives, is permanent but not singular. Hence the primary ideational representative will become overlaid with other representations, or delegates of the representatives, of the drive.

In the case of one of Serge Leclaire's patients, known to us as 'Philippe', the image of cupped hands, and the verbal formula *J'ai soif*, appear as representatives of the oral drive.[21] The gesture and the utterance do not figure in the manifest content of Philippe's dream – a town square, a barefooted woman called Liliane, a brightly coloured forest, something said about sand, a unicorn – but are arrived at in the associative context of its analysis. This analysis succeeds in bringing to consciousness three childhood memories. In the first of these, a three-year-old Philippe, on a summer day, bends over a fountain that is surmounted by a statue of a unicorn, trying to drink the spouting water as it collects in the hollow of his cupped hands. The second memory contains the same gesture, but this time it figures in an attempt on the part of the five-year-old Philippe to imitate an older friend, who could produce the sound of a siren by bringing the palms of his hands together in the shape of a conch, and blowing through the gap formed by his joined thumbs. The third memory is of a hot summer day on the beach when Philippe, again aged three, kept repeating to the woman caring for him, 'J'ai soif'; she, in teasing and tender retaliation, gave him the nickname 'Philippe-j'ai-soif', which became a sign of complicity between them. The first mnemic scenario suggests the binding of the oral drive to the gesture of the cupped hands at the moment when satisfaction is attained through mastery. Mastery, or the lack of it, is what is at stake in the second memory. Laplanche and Leclaire suggest how the fixation of the drive onto particular representatives is to some degree further inflected and reinforced by social meaning; for instance, the motor representation of the cupped hands 'evokes in everyone, long before Philippe had "rediscovered" it, that of the supplicant awaiting alms; the gesture of invocation, the "sumbolon" at last realized in this mime. It is also, more concretely but no less deeply, the complementary form – inverted in its concavity waiting to be filled – of the felicitous and full convexity of the breast'.[22] The image of the 'cupped

hands', then, figures at once in the familiar context of everyday *gestuelle* – where it will always, for Philippe, 'drag along with it a small measure of the basic avidity . . . of this oral libido'[23] – and as an indelible inscription, in the unconscious, where it bears the full measure of the drive. This common gesture thus remains, for Philippe, most irreducibly his own.

The third memory reveals a subsequent binding of the oral drive, no longer to an image but to a verbal formulation – the mastery of motor capacities involved in collecting the spouting water in his small cupped hands is translated here into the mastery of verbal signifiers at the moment of the acquisition of language. The utterance *J'ai soif* comes to represent the oral drive as it is now directed to Lili, the woman on the beach, in the form of a demand. Hence the binding of the drive to the verbal representation brings into play, beyond the organic need, the demand Philippe addresses to a woman whose name contains within it the word '*lit*', and which further evokes the childish appellation for milk, '*lolo*' (which passes into adult life as the vulgar designation for the breast); a woman who, in acknowledging his demand, has recognized his desire, and has become complicit with it. The utterance *J'ai soif* and, even more succinctly, the phonic fragment '*zhe*' – present not only in *J'ai soif*, but also in the childish *moi-je*, and in *plage* [24] is thereafter, for Philippe, inseparable from a purely personal meaning.

Burgin brings this discussion to Barthes' notion of the *punctum*, suggesting that there is something of the ideational representative in the imagistic detail which, like the enactive gesture of the cupped hands and the phonic detail '*zhe*', moves in a way reason cannot account for. For Barthes, the detail that pierces him in a particular photographic portrait by James Van der Zee is the large belt worn by one of the women – 'Oh nurturing negress' – [25] and perhaps more forcefully, the strap of her black shoes; later Barthes says that it is the slender ribbon of braided gold around her neck. Indeed, it was the same necklace which he had seen worn by a certain maiden aunt, who had spent most of her life caring for her mother; after her death, the necklace was kept in the family jewel-box. Following the path laid out by Barthes, from one object encircling a part of the body to another, from the unknown woman in the photograph to his deceased relative, Burgin

suggests the possibility of a more archaic origin by way of the fictive scenario of the small child playing with the ring on its mother's finger . . .

> . . . in a playful demonstration the mother takes off the ring and slips it onto one of the child's fingers; then she takes it back. Other circumstances being favourable, the mnemic-trace of this event could become structurally reinforced and re-cathected by the previously established trace of the mouth circling the nipple, and the nipple's subsequent withdrawal. Later in the history of the subject, knowledge of the significance of the giving of the ring in marriage could, by 'deferred action', further reinforce and intensify the cathexis of the image of the 'encircling of a body-part' – producing the sort of affective and semantic consequences Barthes decribes.[26]

Here, the subject's oral drive is seen as alienated in a series of signifiers or 'representatives'. The necklace is such a signifier – the condensation in one fine braid of gold of the blissful circling of the nipple and the denial of oral, sexual, pleasure – signifier of the 'barren' breast of the now-deceased maiden aunt who wore the necklace, and whose sexuality, like the necklace itself, had remained 'shut up in a box'. An object encircling part of the body, a gesture, a phonic fragment. For Proust such a chain of associations began with a *taste*, that of the madeleine dipped in tea: 'And soon, mechanically, weary after a dull day with the prospect of a depressing morrow, I raised to my lips a spoonful of the tea in which I had soaked a morsel of the cake. No sooner had the warm liquid, and the crumbs with it, touched my palate than a shudder ran through my whole body. An exquisite pleasure had invaded my senses, but individual, detached, with no suggestion of its origin.'[27] The memory Proust will finally elicit – 'this old, dead moment which the magnetism of an identical moment has travelled so far to importune'[28] – is that of the morsel of madeleine his grandmother used to give him after having dipped it in her tea. And yet, as the memory 'grows solid', Proust is aware that he does not yet know why this memory made him so happy. Beyond the recollection of the gift of the madeleine soaked in tea, lie other memories to which he had no access, archaic traces which carry with them the full force of the libido, and which came to figure, for a fleeting and unique

moment, in the guise of this sweet and moist taste. Proust notes that the sight of the madeleine – 'so richly sensual under its severe, religious folds' – did not evoke anything to his mind before he tasted it. This madeleine was just like all the 'little scallop shells of pastry' he often saw on the trays in the pastry cook's windows; it was only when he lifted the small moist morsel to his lips and put it in his mouth – and no doubt because of everything else which constituted the setting for this experience of oral gratification – that the shock of recognition was felt. It is not my purpose to try to disengage the ideational representative – that primitive psychical inscription of the drive – from this literary account. Rather, more modestly, I wish to suggest the possibility of its figuring in other scenes – scenes perhaps of nurturing and gratification – of which we can have no sure knowledge.

Returning to the poem with which I began, Baudelaire's 'A une passante', we may infer from the above scenarios that there is some intimation of the libidinal force attached to the 'ideational representative' in the otherwise unaccountable intensity of affect aroused by the passing figure of a woman. Here the attribution of beauty – because it owes very little, if anything, to the contemplative attitude necessary to the evaluation of correct proportions or the fastidious description of attributes, and everything to an importune emotion, the source of which remains indefinite – readily suggests the coincidence of an external reality with an unconscious representation. Hence, in Burgin's fictive reconstruction, it is the configuration of an object encircling a body-part which becomes cathected with some of the energy that is bound to the ideational representative, by virtue of its capacity to evoke this original fixation. Similarly, we may assume that there is something in that fleeting image of the passer-by which has come to coincide with the highly invested representative of the drive, something as punctual as a detail – a gloved hand on the dark fabric of a dress – or as evanescent as a movement, or perhaps a gait:

> Suddenly, at that moment, something struck him and, for the moment, he was unable to make out where this kind of shock came from. But he soon recognized the origin. Below, in the street, turning her back to him, with a resilient gait, there walked a woman; a young lady, judging from her

appearance and her clothing. With her left hand she lightly lifted the hem of her skirt, so that it reached only as far as her ankles, and he had the instant impression that, in the process of walking, the sole of the one of her fine feet that rested behind, remained vertical for a brief instant, the point lightly grazing the ground; at least, this is the way it appeared to him, for seeing her from such a height and at such a distance, he could not assure himself of the fact in any certain manner.

Suddenly, Norbert Hanold found himself in the street without quite knowing how he got there[29]

ॐ *She had long hair and bad skin . . . Little half moons clustered underneath her cheekbones, like faint hoofmarks. There and on her forehead. I bought the stuff she told me, but glad none of it worked. Take my little hoof marks away? Leave me with no tracks at all. In this world the best thing, the only thing, is to find the trail and stick to it*

TONI MORRISON[30]

In *Camera Lucida*, Barthes remarks that 'Yet once there is a *punctum*, a blind field is created (is devined).'[31] This 'blind field' is that other unseeable dimension of the image: the connotative elaboration. Hence, this idea of a 'blind field' evokes at once both the possibility of there being something which remains hidden from sight, something *repressed*, and the possibility of a narrative unfolding of that highly cathected detail, the *punctum*. In the story Morrison tells, the track of 'hoof-marks' on a girl's face leads the character Joe to the hideaway of his destitute mother. In Barthes's case, the imagistic fragment of the slender ribbon of braided gold around the neck opens onto a memory which succinctly articulates the themes of death and sexuality as they are played out within the familial space. The taste of the morsel of cake, soaked in tea, similarly leads to a childhood memory which, as Proust himself remarks, is but an intimation of something else, another psychical inscription which, if we had access to it, might bring us closer to the more primitive configuration of the representative of the drive. In an inverse chronology, the phonic fragment 'zhe' and the image of cupped hands, are the representative elements arrived at once

they are disengaged from their more elaborate psychical manifestations – the unconscious fantasies which underlay Philippe's childhood memories and later dream productions. Indeed, the ideational representative is inseparable from the fantasy in which it manifests itself. As we have already remarked, the primary re-cathexis of hallucinatory traces of satisfaction is the first binding of the drive to a representative. Secondary bindings of the drive involve punctual revivifications of that original representation, as it is now elaborated into the more complex composition of a fantasy.

Fantasy, Laplanche and Pontalis insist, cannot be reduced to an intentional aim of the desiring subject towards a particular fantasmatic object. 'Fantasy is not the object of desire, but its setting. In fantasy, the subject does not pursue the object or its sign: he appears caught up himself in the sequence of images.' [32] In order to understand this assertion, we should first remember that the prototype of the fantasy is the first hallucinatory re-enactment, in the absence of the object, of the experience of satisfaction. This hallucinatory revivification entails a metonymic slide from the object of the need (the milk) to the object of desire (the breast), and a transition from the functional aim of ingestion to the sexual aim of incorporation. However, it would be wrong to assume a relation of desire to an object on the model of the relation of the physiological need to its object. Satisfaction is not a unitary experience; nor is its hallucinatory re-presentation. When we speak of the fantasmatic breast as the primary object of desire, we do not mean the simple imagining of the anatomical entity, but a constellation of mnemic traces of olfactory, tactile, visual, auditory and kinaesthetic sensations which constitute the perceptual experience of feeding. Primary hallucination consists of these various psychical inscriptions of perceptions (of which the visual impression of the maternal breast may be one). Laplanche writes: 'The signs accompanying satisfaction (the breast accompanying the offering of nursing milk) will henceforth take on the value of a fixed arrangement, and it is that arrangement, a *fantasy* as yet limited to its barely elaborated elements, that will be repeated on the occasion of a subsequent appearance of need.' It is not a singular object which is represented in fantasy, but a configuration of psychical representations. Again, Laplanche: 'with the appearance of an internal excitation, the fantasmatic arrangement – of

several representative elements linked together in a short scene, an extremely rudimentary scene, ultimately composed of partial objects and not whole objects, for example, a breast, a mouth, a movement of a mouth seizing a breast – will be revivified . . .'[33] Hence, this rudimentary scene is the simplest configuration of object, aim and source, now detached from the feeding function, as it can be expressed in the simplest proposition suggested here by Laplanche: 'It's coming in by the mouth'. This laconic narrativization of a scene brings to light a peculiar character of the fantasy structure, a 'grammar' that allows the subject to occupy different positions within the fantasmatic syntax: hence 'it' can refer equally to the object incorporated by the subject, and to the subject of incorporation. Freud's analysis of a more elaborated fantasy, exemplifies this transformational grammar of fantasy: from the enunciation 'a child is being beaten', Freud infers further unconscious fantasies which he formulates as transformations of the original enunciation, as the subject changes positions, from object of the beating to onlooker.[34]

From the above account, we now understand fantasy to be an elaboration of the primary hallucination, which itself is an elementary arrangement of the mnemic traces of satisfaction. Although we speak of fantasy as an arrangement of psychic elements, is not to be thought of as a static configuration: fantasy has a stable structure comprising, at its most elementary, a subject, an object and a predicate; however, the elements and the relations between them undergo transformations in order to accommodate the exigencies of desire and the correlative censorship. This dynamic configuration of elements is best characterized, in Laplanche and Pontalis's words, as a *mise-en-scène* of desire.[35] It is in this process of staging – the setting out of psychic elements – and not the invocation of a particular object, that the pleasure of fantasy lies. This is made particularly manifest in day-dreams where the satisfactory resolution of the fantasy never exhausts the underlying wish. Day-dreams are characteristically repetitive: the staging of desire is re-enacted every time the ending comes in view. Elizabeth Cowie gives the example of fictional stories which interminably postpone the often predictable ending through delays, obstacles and diversions, or altogether refuse a narrative closure. She writes: 'The pleasure is in how to bring about the consummation, is in the happening and the con-

tinuing to happen; in how it will come about, and *not* in the moment of *having happened*, when it will fall back into loss, the past.'[36] Philippe's dream ends at the very moment his wish is about to be satisfied, 'the *moment of drinking* in which desire culminates and fades away.'[37] Of the butcher's wife who has a dream about an unfulfilled wish to give a dinner party, and who moreover asks her husband *not* to give her the caviar she craves, Freud asks: 'But why was it that she stood in need of an unfulfilled wish?'[38] The dream, he replies, expresses the wish not to feed her skinny friend lest she grows plumper, and therefore more attractive to the butcher (who likes full-figured women, such as his own wife).

Lacan proposes a different interpretation of the same case-study. As Catherine Clément puts it, 'Lacan is emphatic where Freud is discreetly reserved, on the question of the good sexual relationship between the butcher and his wife.'[39] The butcher's wife is very much in love with her husband, who satisfies her every sexual need – she is presumably a 'satisfied woman'. And yet there is her wish for caviar which she knows her husband would readily give her if she did not ask him precisely not to. Here is Lacan on the subject:

> But there you are, she doesn't want to be satisfied only at the level of her real needs. She wants other, gratuitous needs, and to be sure that they are gratuitous they must not be satisfied. This is why to the question 'What does the witty butcher's wife want?', we can reply, 'Caviar'. But this reply is hopeless, because she also does not want it.[40]

Hence the butcher's wife is attempting to articulate her desire in a space in which no room has been left for frustration: between her and the randy husband who gives her 'too much' satisfaction. As Clément suggests, the butcher's wife is siding with the child whose every need is anticipated and who consequently never feels hunger or the pleasure of assuaging that hunger. Stuffed with the 'choking porridge of love', the child will cease to eat.[41] In wishing that her desire for caviar remain unfulfilled – that is, not reduced to a need – the butcher's wife asserts herself as desiring in her relationship to her husband. The caviar, insofar as she makes sure it is denied to her, can therefore be sustained as signifier of the object of desire.

Such, in brief, are the workings of desire which animate

fantasy. We can now recognize that the woman in the street is to Baudelaire, Winogrand and the others as the caviar is to the butcher's wife. Unattainable, she is the signifier of the object of desire; she figures the lack which awakens and sustains desire. As Cowie reminds us, 'fantasy as a *mise-en-scène* of desire is more a setting out of lack, of what is absent, than a presentation of a having, a being present.'[42] Hence, we can now better understand Benjamin's notion of 'love at last sight' in terms of this seemingly strange wish of the butcher's wife to have an unfulfilled desire; that is, in terms of the desire to sustain oneself as desiring through the loss of the object. What is at issue in these scenarios of urban seduction is not so much the displacement of desire as it exhausts itself from one object to the next, from one woman to the next, but rather the surge of desire in the movement of loss – its entrapment in the vanishing figure of a woman.

The vanishing figure of a woman cannot fail to further evoke the scene of the young child, helplessly watching its mother walk away, its desire and demand made more pressing with each of her strides. Thus, Winogrand – like the child who plays with the cotton-reel, making it disappear and re-appear over the edge of its cot, actively re-enacting the disappearance of its mother as a way to come to terms with the trauma – in photographing his passers-by, retains the object in symbolic form while simultaneously recording the instant of its real loss. Here the viewer sustains himself as desiring in what is effectively a double inscription of lack: the scene of an encounter which never took place, recorded on paper; the imagistic presence of an absence, a moment forever passed and lost. When Nadja is interned in the asylum of Vaucluse, Breton chooses not to visit her. He instead writes a book in which he restores to his passer-by the mobility, fluidity and whimsicality which the institution denies her. The spatial fixity imposed on her, her identification as 'mad', he finds intolerable – just as her occasional lapses into the commonplace, the ordinary, used to distress him because they would leave him without desire.

By definition, the passing object of love at last sight will not bear scrutiny. Nevertheless, the beauty of the passer-by is open to no doubt. We might guess that her overwhelming beauty is indisputable and irrefutable to the precise extent that it is not the subject of examination or reflection. 'Love at last

sight' admits of no second thought. It is clear, however, that there is more to the explanation. It is this: the passer-by is beautiful because she is lost. Breton recognized this in Nadja, but misrecognized the situation in supposing that the 'lost' Nadja might somehow be saved. What is lost is not simply the passer-by herself, not just any passing object (for love at last sight will come again), it is the 'lost object' itself, the *fantôme* of which Baudelaire speaks. We can now understand the particular beauty of the *trouvaille*, of which Breton says that 'it is enough to undo the beauty of everything beside it'.[43] We can understand it in terms of Freud's own interpretation of the *trouvaille*. The finding of the object, he writes, '. . . is in fact a re-finding of it.'[44]

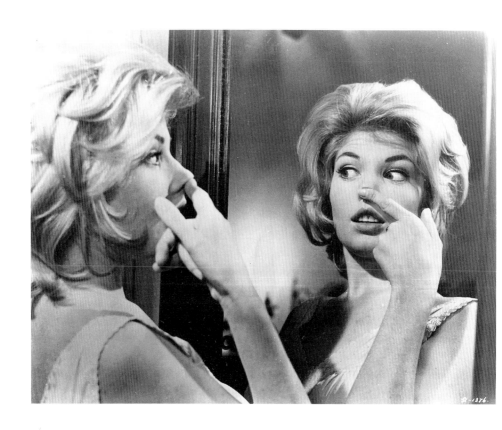

9 Mirror, mirror . . .

❧ . . . the woman imagining herself being seen, the hard edge of
the coat against the noisy city
LESLIE DICK[1]

In London's Soho, the major film distribution companies are
gathered in one street. A man is walking down this street, past
the posters on display in the windows of Fox. One of his
favourite actresses looks out from a poster. He stops to look
back, and to look at the other images of her in the stills pinned
alongside the poster. The images please him. No particular
thought in mind, in a state of pedestrian distraction, he
resumes his passage down Wardour Street, which is con-
gested with late afternoon traffic. Suddenly, a woman steps
out of a doorway and hurries down the street ahead of him – a
slender figure in a dark suit, the jacket nipped in at the waist
and a short, tight, skirt which at each step restrains her stride
with a tug at her thighs and buttocks. She carries a briefcase,
and moves with an efficient tic-tack of high-heeled shoes. She
stops and unlocks her car – a small car with no room for the
encumbrance of a family – throwing her briefcase on the
passenger seat as she slides behind the wheel. He has still not
seen her face. His last sight of her is a leg clad in black nylon.
Then the leg is swallowed by the car, and the car is swallowed
by the traffic. He speaks of the shock of this apparition, the
importune tug at the heart, the experience of beauty in this
fugacious female figure. All that he saw was a faceless
silhouette – but the shape was momentarily invested with all
the associations of the lingering image from the window of
Fox.

In my anecdote, the man's fascination with the passing figure of a woman, his 'love at last sight', seems to be prompted by the publicity images disseminated throughout our everyday environment – impossibly glossy un-realities, traps set for our desire. In the quotations which frame the anecdote, the woman sees herself as an image – literally *picturing* herself, in the starkly graphic terms of fashion photography. It is such unattainable, or unsustainable, images which some feminist writers have attempted, and still attempt, to 'demystify'; or, more voluntaristically, altogether *repress*, in favour of 'positive' representations of women. In the process, animated by the desire to find the sole culprit of our existential unsatisfaction, the problematic of the fascination with the image has often been reduced to a simple opposition between an oppressive agency, 'man', the 'male look', or 'male fantasies' – always active – and an oppressed, implicitly passive, 'woman'.

In the earlier chapters, I too turned my attention on the 'male' gaze, but in the hope of showing the complexity of the psychical processes at work in the man's repeated attempts to negotiate his relation to sexual difference through images – a complexity of structure that the singular and strident term 'oppression' collapses into a simple, inexplicable, fact. The fact remains, however, that – as a woman – it is my own unhappy relation to representations of female beauty which impelled me to write about the subject in the first place. My discussion so far may have suggested that there is more to the 'male look', in its attribution of beauty to a woman, than many women have been prepared to consider. But have I, if I leave my argument here, come to any very different conclusion from those who have been content to speak simply of the 'oppressive male gaze'? After all, it is of little interest to the oppressed, and certainly no consolation, to have the complexity of their oppression pointed out to them.

I believe, however, that there is yet something left to say. I may not be happy with the woman's position in relation to images of female beauty, but I am no less unhappy with the

idea that her role in this play of illusions is simply one of passivity. In conclusion, therefore, and necessarily provisionally (a more complete consideration of the question would require another book), I wish to look at the relation of the woman to the image of female beauty; not in terms of her 'captivity', but rather, more suggestively, in terms of her *captivation*.

ಀ *In this exercise room, a hall of mirrors where all is reflection, I unhappily try to model my movements on those of the blond, ponytailed instructor. Few and far between are those blissful moments when, in the play of mirroring, I coincide with the supple and agile body beyond the glass*

F. P.

In the nineteenth century, an Italian countess commissioned a large number of photographs to be taken of herself. Many of the images which she directed the photographer to make were, by the standards of the day, immodest. Writing about the Countess de Castiglione's 'obsessive self-representations', Abigail Solomon-Godeau asks a fundamental question: is the Countess 'the architect of her own representations'?[3] Solomon-Godeau's answer is unequivocal: '[the Countess's] individual act of expression is underwritten by conventions that make her less an author than a scribe.'[4] According to Solomon-Godeau, when de Castiglione lifted her skirt to reveal her bare calves to the camera, she was, unwittingly or not, merely quoting from the representational codes of her time – a time when bourgeois men frequented the ballet solely to see the legs of the ballerinas, the time of the advent of the mass-production of pornographic photographs of women. The photographs which the Countess commissioned of herself, therefore, are seen as 'significant testimonials of the power of patriarchy to register its desire within the designated space of the feminine.'[5] It would be difficult to disagree with the basic premise of the argument, which is that the Countess was – as we all still are – well and truly locked into a patriarchal order. Lamentable, but surely unavoidable. Solomon-Godeau, however, finds de Castiglione guilty of 'colluding in her own objectification',[6] a judgement which intimates that the Countess could somehow have *escaped* representational conventions, to become the sole and solitary subject – *sujet à part*

entière – of her own image. But this option is not open to any of us, whether in the nineteenth century or today. Nor is acknowledging this to relinquish all autonomy. Here, it is important to refuse the choice between two forms of reductionism: on the one hand, the delusory voluntarism of total liberty; on the other hand, the petrifying hopelessness of total determinism.

It is first worth noting that, of the several hundred photographs the Countess commissioned, only a few show her lifting her skirts. On Solomon-Godeau's own evidence, the majority of the images show her in 'extravagant court dress, in masquerade, in narrative tableaux enacting such roles as drunken soubrette, Breton peasant or cloistered nun'. There were 'close-ups of her feet in the sandals she wore for the costume of the Queen of Etruria', photographs of her 'feigning sleep and awakening, terror and rage', or again, weeping 'within the rectangle of an empty picture frame propped on a table'. There were images of her personal effects: 'photographs of herself shown *en abyme*, along with shawls, keepsakes, and dried flowers, and, half-buried in their midst, one of her lapdogs together with his leashes, collars, and dog clothes.'[7] All of these photographs, Solomon-Godeau notes, were kept by the Countess for her own enjoyment, and never shown, except perhaps to a lover. And yet not a word about the *desire* that moved the Countess to construct so many, and often such elaborate, representations of herself. Not a word about the aetiology of the Countess's 'narcissism', which the author names only to condemn as 'extravagant' and 'grotesque'. However, it is only by allowing this word 'narcissism' the full sense that it takes in the psychoanalytic context – from which, presumably, Solomon-Godeau has extracted it – that we may see the woman in the dock as none other than ourselves.

But there is above all, in the subject itself, the passion to be object, to become object – enigmatic desire whose consequences we have hardly evaluated, in all the domains, political, esthetic, sexual – lost as we are in the illusion of the subject, of its will and of its representation
JEAN BAUDRILLARD[8]

Solomon-Godeau writes: 'the Countess's obsessive self-representations are less an index of her narcissism – although they are that too – than a demonstration of a radical alienation that collapses the distinction between subjecthood and objecthood'[9]; and, again: 'the extravagant narcissism of the Countess's self-appraisal is startling, but less so than the objectification to which it attests.'[10] What Solomon-Godeau has noticed here is important, but I believe there is more to be made of her observation. I am not 'startled' if I remember that narcissism is *precisely* that process – in that initial misrecognition and alienation which Lacan has called the 'mirror stage' – in which the subject takes its own body as object.[11] As further indication of the Countess's 'startling' self-objectification, Solomon-Godeau cites Castiglioni's use of the third person singular to refer to herself, when, at the age of sixty, she writes in praise of the beauty she once was. However, it is the very condition of subjectivity that, having first learned to represent our being in language through our proper name, we pass to the use of the impoverished 'shifter' *I* – while recognizing that this 'I' is also a 'you' and a 'she' or 'he'. Too much 'I' and the consequence may be paranoia, in the form of a megalomaniac withdrawal from society. Too much 'you' and paranoia may ensue in the forms which afflicted the women of Lacan's earlier publications – 'Aimée' and the Papin sisters – who had failed to achieve what Clément has called the 'correct distance' from the 'other'.[12]

Solomon-Godeau's 'I' is, in fact, one that is at odds with the subject of the more recent critical insights, such as those derived from psychoanalysis, to which her terminology alludes. It is explicitly at odds with that critical theory which has sought, as Robert Young has put it: 'to redefine the self through the model of the different grammatical positions which it is obliged to take up in language, which disallow the centrality of the "I" assumed by humanism.' As Young comments: 'It is precisely this inscription of alterity within the self that can allow for a new relation to ethics: the self has to

come to terms with the fact that it is also a second and third person.'[13] From this point of view, then, there is nothing startling or objectionable in the Countess's ability to see herself as other – far from it, it would be 'grotesquely' narcissistic if she perceived herself any other way. Considering the vantage point from which the Countess writes – that of old age – the use of the third person singular to speak of her past self also indicates the radical alienation one may feel as one ages, looking back upon a beauty which can only be youthful. The Countess's shift from 'I' to 'she' suggests to me the disjunction between the corporeal subject – the being who ages and dies – and the immortal disembodied ideal self which never ceases to seduce. This shift may therefore be seen, again, to restate the very terms in which our subjectivity is formed. As Lacan put it: 'The human being only ever sees his form materialised, whole, the mirage of himself, outside of himself.'[14] In Rimbaud's expression: 'I is another'. Nothing, then, prevents us from seeing the Countess's self-portraits as her own idiomatic inscription of this fundamental insight into the inescapable condition of identity. She repeatedly performs her being as object, her 'I' as 'other': in the studio of Louis Pierson; in the privacy of her own rooms as she reviews Pierson's work; in addressing her haunting ideal – in the same terms that she would her several hundred photographic portraits – as a *'meravigliosa opera'*; and, last but not least, in masquerading in a multitude of identities. To my mind, therefore, this is no simple self-aggrandizement, but rather the intuition that a sense of beauty in oneself can only ever be alien to oneself, can only be in an image: a 'beautiful work' formed in the gaze of another, and in the guise of another. She does no more nor less than articulate the primordial cry that Rousseau imagined was uttered by Pygmalion: 'That my Galatea lives, and that I not be her. Ah! that I always be another, so as to always wish to be her.'[15]

No, I do not see the Countess's narcissism as 'grotesque'. I accept that it was 'infantile', in that it was comparatively unsocialized and unrepressed. I would suppose that it was her wealth, and her social status, which allowed her ordinary narcissism this literally extraordinary and sustained expression. (With a confidence most probably born of the certainty of her position in society, she returned to the studios of Louis Pierson at the age of sixty, to bare her legs to the

camera one last time.) I am not seeking to deny socio-historical explanations of her behaviour, such as those Solomon-Godeau convincingly provides. Even at the psychical level which is my concern, the 'obsessive self-representation' of the Countess is doubtless overdetermined. She may, for example, have enjoyed a thrill of transgression in acting out and recording herself in a reality 'below her station'. However, her images speak most emphatically, for me, of the pleasure of self-display. Her work reveals the pleasure of identifying with the gaze of another, a pleasure that is therefore fundamentally scopophilic: the subject exhibiting herself – here in front of the photographer – derives her pleasure from seeing herself through the eyes of the other who watches. In this context, we may recall the widely reproduced photograph in which La Castiglione dramatically isolates her eye, her gaze fixed upon the viewer, within the black oval of an empty frame. There could be no more explicit representation of her sense of her own activity, of her sense that pictures look at *us*. A similar, and similarly explicit, intuition inhabits another photograph, in which she poses herself looking at herself in a small hand-mirror – but which she holds in such a way that her gaze is deflected outward, at the viewer. In the background of this image she has propped another photograph of herself. In such marvellous *mise-en-scènes* of the symbiosis of exhibitionism and voyeurism, the Countess shows herself as both subject and object of the look. Looked at by the camera, she frames her gaze in the passe-partout, and in the narrow oval of the mirror, as in a keyhole. Solomon-Godeau asks, 'with whose eyes does the Countess gaze at images of her face? her legs? her body?' It is a rhetorical question, as the case she has made against the Countess has been at pains to leave no room for doubt that it is with the look of the other, and that this other is male. For my part, in her defence, I would rather insist that it is with *her own eyes* that La Castiglione gazes upon these images of herself, but in the full understanding that her looking at herself can only ever be from the vantage point of another. In response to the question 'whose desire?', with which Solomon-Godeau closes her essay, I find myself thinking of Roland Barthes, at dinner with a friend and an unknown young man whom the friend has also invited. Barthes writes: 'the trio of Desire fatally forms itself, B.G. having, by his choice, designated *who I must* desire'.[16] This

minimal scene might serve as an illustration of Lacan's adage, 'desire is the desire of the other.'[17] Unavoidably, any relation to the other will be inhabited by the question of his or her desire: 'What do you want from me?', or, 'How can I be your desire?' This question, as I have already discussed, has its earliest, non-linguistic, formulation in the trauma of primal seduction. The ever-approximate answers to the question of the other's desire provide the material for the elaboration of an ego-ideal, towards which the subject ever strives in order to maintain the imaginary narcissistic perfection of early child-hood. They are only ever *approximate* answers because, to the question of the desire of the other, there is no definitive answer. The other does not know the answer, in that it is not the conscious subject of its own desire, but is rather carried forth by something it cannot master.

'My' desire is inseparable from the desire of the other. An unequivocally 'female' imaginary, free of all taint of 'male' constructions, is therefore impossible (except, of course, as an imaginary object). There is no doubt that the actual pro-duction and dissemination of representations of an ideal femininity has been, and still is, (albeit to a lesser degree), the prerogative of men. There is no doubt that the bulk of those representations – some of which I have discussed in this thesis – speak clear and loud of the man's imaginary relation to sexual difference. But, nevertheless, it should be remembered that the psyche of a male subject is not formed in isolation, but in relation to other psyches. To simply speak of the subordi-nation of woman's desire to men's fantasies is to apply a sociological model to the workings of the unconscious, one which overlooks its structural autonomy and negates the way in which fantasies circulate between subjects – the fantasy production of one inflecting that of the other. Laplanche, for example, is ever at pains to stress the importance of the role played by the mother's sexuality as it expresses itself in her relationship to her infant, as it erupts in the space of the non-sexual to affect the nascent psyche. I say 'erupts' because, in speaking of fantasies impinging upon each other, I intend the image of a repeated clash of demands, which the punctual satisfaction of needs leave unfulfilled, and not the common-place ideal, or ideology, of mutual complementarity. The male subject's relation to sexual difference, to the desire of the sexual other, finds expression in representations of an ideal

femininity, the particular physiognomy of which changes historically. Confronted with this 'sur-real' surfeit of representations, the woman is lured back into the imaginary space of primary narcissism, in which she gazes at her ideal other, captivated by an image which eludes her. In Paola Melchiori's words, 'she feels at home in her illusion.'[18]

When we consider the structure of the woman's captivation with the image of female beauty, it becomes apparent that it is inhabited by, in Malcolm Bowie's expression, 'a perverse will to remain deluded'.[19] The image seduces by offering a coherence and a unity that is foreign to the existential body. The fascination with this disembodied ideality is contingent upon the disavowal of one's own corporeality in the real – a disavowal which supports the anticipation of an ever-deferred more 'perfect' body. It is essentially *in anticipation* that we insistently strive towards a corporeal ideality, in the face of the slow but certain degradation of what Laura Mulvey has termed the 'entropic body'. There is something in the nature of 'beauty', then, which can only be unattainable; not just out of reach, but *recognizable* as lost. This is the 'something' which Virginia Woolf's woman in Mrs Milan's workroom quite correctly considers 'the core . . . the soul of herself'. It is the sum of the losses which make up our subjectivity, and Woolf renders the pain of this loss quite tangible:

> . . . when Miss Milan put the glass in her hand, and she looked at herself with the dress on, finished, an extraordinary bliss shot through her heart. Suffused with light, she sprang into existence. Rid of cares and wrinkles, what she had dreamed of herself was there – a beautiful woman. Just for a second (she had not dared look longer, Miss Milan wanted to know about the length of the skirt), there looked at her, framed in the scrolloping mahogany, a grey-white, mysteriously smiling, charming girl, the core of herself, the soul of herself.
>
> . . . And now the whole thing had vanished . . . here she was in a corner of Mrs Dalloway's drawing-room, suffering tortures, woken wide awake to reality. . . . She faced herself straight in the glass; she pecked at her left shoulder; she issued out into the room, as if spears were thrown at her yellow dress from all sides. But instead of looking fierce and tragic, as Rose Shaw would have done – Rose would have

looked like Boadicea – she looked foolish and self-conscious, and simpered like a schoolgirl and slouched across the room, positively slinking, as if she were a beaten mongrel, and looked at a picture, an engraving. As if one went to a party to look at a picture![20]

She went to the party *as* a picture, an 'object of the look' certainly, but at the same time her own picture – the one at the core of herself, a charming girl. A moment of joyous misrecognition. How else to explain my own shock at the sight of a young woman who danced by me, no doubt awkwardly, like the rest of we beginners, and yet so 'beautiful'. How to explain that the certainty of her beauty was so fragile as to be shattered by the sound of her voice, even though there was nothing harsh or unmusical in it? The awkward dancer, for an instant, became image; an ethereal configuration which could support nothing so human as her voiced concern – one I certainly shared – for the uncomfortably rising temperature of the room. In addressing me she had broken the spell of reflectivity, she had become the ambivalently loved/hated specular rival whom I must denigrate in order to preserve – '*tais-toi et sois belle*'. The Countess gazes at the retouched photographs of herself: 'That's me, over there!' 'She is me.' The real shatters the image. The corporeal voice with its corporeal concerns. The corporeal materiality of 'the female subject of a "certain age"', for whom, 'identification enters on a period of vacuum and dearth'.[21]

If we accept that desire is inseparable from the desire of the other, we may entertain the possibility that man-made images of female beauty are, at least in part, a product of the man's attempt to meet the desire of the woman – to accede to being *her* desire, by presenting her with an ideal image of herself. The attempt is doomed to failure. Of her desire he knows nothing more – no more than she knows herself – than its force, a force equalled by that of his own. In this scenario, the image he offers the woman would be a compromise-formation, constructed in a dual striving: both to be her exclusive desire, and to negotiate the pitfalls of castration. I have, so far in this chapter, emphasized only the extent to which the female and the male subject share a common psychical history. It is of course crucial also to take account of their *differential* relation to the Oedipus complex, and to castration. I

shall not embark here on this notoriously complex and contested field, of which there are already many accounts. I merely wish, in conclusion, to return by a different path to my earlier comments in respect of Didier Anzieu's notion of the 'Skin-Ego'. I privilege this topic above the others I have raised, and might have raised, because of the ubiquitous emphasis on clothing, make-up, jewellery and other forms of surface adornment which characterizes (modern Western) practices of, and discourses on, female beauty. With reference to Anzieu's work, I have already suggested that the functionally 'excessive' concern with one's appearance can be partly theorized in terms of the investment in the fantasy of a common skin: the archaic sensory interface between infant and mother. Here is an instance of a fantasy common to both men and women, but which necessarily finds different symbolic expressions. For the man, the fascination with female dress is always tinged with envy, as the fantasy of such an intimate embrace of the maternal body cannot, *as a rule*, be symbolized by him in such ostentatious and public fashion. The woman, on the other hand, is able to act out the fantasy of the primordially glorious skin in the actual production, on her own body – through make-up, dress and other ornaments – of a magically elaborated auxiliary corporeal surface: the skin the mother has 'given up' to the child in order to guarantee it protection and strength. It is important to remember that the fantasy of a common skin, originating in the early phases of ego structuring, issues from the contact with the skin of the mother (or her substitute). From this we may infer that the origin of the activity of adorning oneself – an activity involving touch – would be primarily tactile in nature. The sense afforded by the second skin of fabric and paint that the woman constructs is fundamentally one of an all-enveloping invulnerability, an imaginary impenetrability. This narcissistic envelope, although visually splendid to the beholder, thus remains, at the essential level, a protective surface. This is not, however, to *confine* the woman to the realm of the tactile, or at least to the realm of *proximity*: to deny her that dimension of the scopic which every infant enters with its inevitable shift from contact perception to distance perception, from oral incorporation to the visual internalization of the scene of sensual gratification. It is true that the later prohibition on touching is never as rigorously enforced in the case of the female child as

it is for the boy. Her masturbatory activities (again, at least in the West) are not likely to provoke any threat as terrifying as that of castration. For this same reason, neither does her physical closeness to the maternal body become 'sublimated' into looking to quite the degree that it does for the male child. The pleasure in looking is no less a female than it is a male preserve, but it is diversely inflected by sexually differentiated relations to the maternal body. For the woman, the visual can never be totally separated from the tactile. It is to this fundamental fact that the woman's enjoyment in adorning/ displaying herself attests. For her, dressing may be a privileged ritual: a re-enactment of that primordial interweaving of look and touch which is the fabric of the maternal space.

Now, the maternal space to which I refer provides no cause for exaltation. Melanie Klein has shown it to be composed of as much pain as pleasure. She describes a primordial arena, of chaotic perceptual fragmentation, in which tenderness and aggressivity alternate in relation to a maternal 'body' which is as yet no more than a complex of benevolent and threatening body-parts. In his turn, Didier Anzieu has revealed the all-giving mother to be equally the murderous thief of the glorious common skin, the golden fleece which can as easily become a miserable sieve through which the strained ego is dissipated and lost to itself. Again, Julia Kristeva has finely traced the first intuition of a subjective boundary to the convulsive vomiting of the archaic mother. What these various accounts insist on is the ambivalence at the core of ego-structuring, the inseparability of tenderness and aggressivity that is consequent upon the persecutory fears which inhabit the infant's vital need for satisfaction. Thus, for Lacan, the formation of the ego can only be conceived in relation to an original 'intra-organic and relational discordance'. The primary narcissism of the mirror stage is a recognition that the premature body of the infant is *limited*; hence the frustrated aggressivity, 'in relation to the still profound lack of coordination of his own motility'. The *Gestalt* of the infant's own body represents an ideal unity, 'a salutory *imago*', yet which at the same time is, 'invested with all the original distress resulting from the child's intra-organic and relational discordance during the first six months when he bears the signs . . . of a physiological natal prematuration.'[22] Thus the ego is torn between the need for gratification and a jealousy that can find expression only in an *intra-subjective*

aggressivity; this primordial narcissistic ego is at once the object of love, because 'ideal', and of hatred, because it is *unattainably* ideal. Catherine Clément, so accurately, speaks of 'amorous hatred'.[23] She is speaking of 'Aimée', in effect Lacan's first patient, whose string of attachments to disparate idealized women – including a fallen aristocrat and her own sister – culminated in her attempted murder of a famous actress. The reasonable explanation Aimée offered for her 'deranged' attack was that she sought to put an end to the actress's persecution of her. But this was only her most recent, albeit now criminal, defence against a series of imaginary assailants. Lacan suggests: 'Each of these female persecutors was in fact merely a new image of the sister whom our patient had taken as her ideal. In other words, they were mere prisoners of Aimée's narcissism'.[24] Aimée, then, identified herself with a succession of variously ideal mirror-images, each of them socially and professionally more successful than she. In attempting to stab the famous actress, Aimée was attacking her own ideal ego, giving expression to her amorous self-hatred. Lacan concludes that Aimée had remained locked in the narcissism of her ideal-ego, never properly establishing the boundaries between herself and others. It was only when Aimée realized that, in striking the actress, she had in fact struck at herself, that her paranoid delirium came to an end. Lacan adds: 'Now we can understand what the glass obstacle was that prevented her from *knowing* that she loved her persecutors, although she cried that she did: they were merely images.'[25]

The case of Aimée is now an historic example of the founding ambivalence of all subjectivity; which is to say it is typical, rather than unique. It shows us that alienated mis-recognition is the very condition of subjectivity. What I am, or may become, is formed only in response to imaginary ideals, and specular rivals. My aggressivity is the inescapable under-tow of my idealism and my idealization. The case of Aimée, and the many other similar cases it may serve to represent, suggests that the question of the woman's relation to images of ideal femininity cannot be properly addressed without taking into account the full implications of her narcissism. We might then well ask, with not the least hope of a straight answer, who or what was the *real* target of the celebrated axe Mary Richardson aimed at Velázquez's 'Venus':[26] Was it the skin of paint, or was it the painted skin?

Narcissus died of love, trapped in the body of his specular rival. Aimée struck out in hatred of her ideal and survived, in a way. The rest of us, less celebrated, live our lives in the shadowy intimation of a perfection yet to come, reached for in the everyday objects of mis-recognition which elude our ever-infantile grasp – again and again.

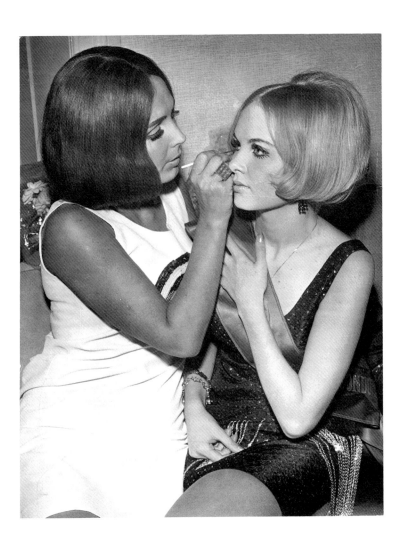

Phone rings. Jo's on her way. Glad she's coming, though I met her only once before at the museum. Winter, ground covered in ice, everything about to crack, fragile, intense – her performance, my ordeal with the director, our conversation over breakfast. Wonder if she still remembers, if she's changed. Lovely DANCER'S BODY, in baggy pants, huge leather jacket, lace-up boots, all carefully battered like her FACE, small features more defined with some success, EMBLAZONED: lives alone, a loft downtown of course, no nonsense baby, if you want to be an artist YOU MUST PAY. I am in debt, no doubt about it, overdressed and uncommitted, wishing I could seek asylum in her duffle bag. Stunned by THE RIGHTNESS OF THAT IMAGE first, then intrigued by every detail, but especially by the BOOTS. They had a PRESENCE MUCH LIKE HERS, older but not dated and attractive without trying too hard. They haunted me. I HAD TO HAVE THEM, kept on looking for months after, finally FOUND SOME that were similar, not soulfully worn out but stylishly distressed at least. In these I could do anything, WORE THEM ALL THE TIME, have them on now in fact. Will she be wearing hers? The door. I let her in, look down – the boots are different, lighter, higher heels and polished. Then look up – astonishing, a dress, small flowers, forties, second-hand, cut on the bias, screaming what the hell, feels good to be a woman sometimes, give me credit, I'll pay later. And the jacket, padded shoulders, Persian Lamb, not black but very much like mine, the one that I was wearing when we met. She senses this and says that's why she bought it, tried to look smart, stylish even, just to please me. Can't help smiling. 'See these boots,' I ask, 'HAVE I SUCCEEDED?' 'Well, ALMOST', she laughs.

Mary Kelly, *Interim*, Part I: Corpus, 1985 – detail, 'Supplication' (capital letters signify red highlights in the original text).

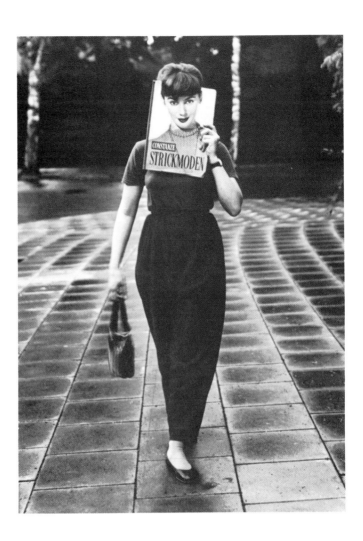

Images

cover Loomis Dean, 'Shirley Eaton in *Goldfinger*', 1964.

p. 10 Cecil Beaton, 'Evening Gown', late 1950s.

p. 20 Dana Andrews and Gene Tierney in *Laura*, 1944.

p. 33 Anon., fashion photograph for Lanvin.

p. 34 Johann Theodor de Bry, 'Gold rains down, while Pallas is born in Rhodes and Sol lies with Venus', in M. Maier's *Atlanta Fugiens*, Frankfurt, 1617/18.

p. 55 Hermine Moos, *The Doll*, 1919 (made for Oskar Kokoschka).

p. 56 Chuck Close, *Laura I*, 1984.

p. 73 Jean-Paul Goude, 'Preparatory work for *Improvements on a Masterpiece, New York, 1975*'.

p. 75 Anon. (School of Fontainebleau), *Gabrielle d'Estrées and the Duchesse de Villars*), c. 1594.

p. 76 Federico Patellani, Beauty contest – measurement of the contestants, San Remo, 1949.

p. 96 Giacomo Barozzi da Vignola, 'Allegorical representation of the technique of perspectival distancing and the correctly proportioned reproduction of objects', in *Due regole della prospettiva practica*, ed. E. Danti, Rome, 1611.

p. 97 Anon., Busby Berkeley showing a formation sequence to some of the chorus from *Gold Diggers in Paris*, c. 1936.

p. 98 Fernand Léger, *Mona Lisa with Keys*, 1930.

p. 121 Don Ornitz, 'Carole Ohmart as a Sphinx', c. 1940s.

p. 122 Man Ray, *Black and White*, 1926.

p. 144 Anon., 'Indecision', 1955.

p. 159 René Magritte, *Homage to Mack Sennett*, 1934.

p. 160 Constantin Guys, *Woman on Foot*, c. 1850.

p. 179 Garry Winogrand, *London*, c. 1965.

p. 180 Monica Vitti in *l'Avventura*, 1960.

p. 195 S.AA. Mortensen, untitled.

p. 199 Uli Grohs, *Constanze*, 1980.

p. 202 Anon., 'Best ankles competition', 1936.

p. 226 Anon., 'A deportment class', 1950.

back cover Audrey Hepburn and Fred Astaire in *Funny Face*, 1957.

References

Introduction: more than a woman

1 Marcel Proust, *Remembrance of Things Past – Swann's Way* (London, 1973), p. 59.
2 Honoré de Balzac, *Sarrasine*, in Roland Barthes, *S/Z* (London, 1975), p. 238.
3 Honoré de Balzac, *Gillette, or the Unknown Masterpiece* (London, 1988).
4 Plato, 'Hippias Major', in *The Works of Plato* (London, 1870), p. 224.
5 Tolmach Lakoff and Rachel L. Scherr, *Face Value – The Politics of Beauty* (Boston, London, 1984), p. 284. On a less triumphalist note, Nancy Freedman writes, 'as women gain access to the institutions that control society, they gain the means to shift beauty off the back of femininity and onto the gender-neutral position where it belongs': *Beauty Bound – Why Women Strive for Physical Perfection* (London, 1988), p. 240. See also, Wendy Chapkis, *Beauty Secrets – Women and the Politics of Appearance* (Boston, 1986).
6 Villiers de l'Isle-Adam, *Tomorrow's Eve* (Chicago, London, 1982), p. 41.
7 Carl Spitteler, *Imago* (Paris, 1984), p. 43. (Translated by the author.) With such accounts of the splitting of the object, Spitteler's story reads like a psychoanalytic case-history *avant la lettre*. Indeed, Freud admired Spitteler's novel to the extent of giving the same title – *Imago* – to the first journal of psychoanalysis (founded in 1912).
8 See, for example, P. Perrot, *Le Travail des apparences ou les transformations du corps féminin, XVIIIe-XIXe siècle* (Paris, 1984); also G. Leroy and M. Vivian, *Histoire de la beauté féminine à travers les ages* (Paris, 1989); or, V. Steele, *Fashion and Eroticism – Ideals of Feminine Beauty from the Victorian Age to the Jazz Age* (New York, Oxford, 1985).
9 See, for example, Arthur Marwick, *Beauty in History – Society, Politics and Personal Appearance c. 1500 to the present* (London, New York, 1988), for which Angela Carter suggests this fitting subtitle: 'Women I have fancied throughout the ages with additional notes on some of the men I might have fancied if I were a woman' (*London Review of Books*, 16 February 1989). For a history of who Sir Kenneth Clark fancies, with the added touch of a connoisseur of art, see his *Feminine Beauty* (New York, 1980).
10 Sigmund Freud, *Three Essays on the Theory of Sexuality* in *The Standard Edition of the Complete Psychological Works of Sigmund Freud*, trans. & ed. J. Strachey et al., 24 vols. (London, 1953–74), reprinted 1981, VII, p. 156 n.2; hereafter cited as *S.E.*
11 S. Freud, 'Civilisation and its Discontents' in *S.E.*, XXI, p. 83.
12 S. Freud, 'Civilisation and its Discontents' in *S.E.*, XXI, p. 99.
13 S. Freud, 'Civilisation and its Discontents' in *S.E.*, XXI, p. 83.
14 For example, Jean Laplanche and Serge Leclaire speak of the unconscious as resulting from 'the capture of drive energy in the web of the signifier', 'The Unconscious: A Psychoanalytic Study', *Yale French Studies*, 48 (1975), p. 169.
15 See Ferdinand de Saussure, *Course in General Linguistics* (New York, Toronto, London, 1966), pp. 88–9.

16 S. Freud, 'Civilisation and its Discontents' in *S.E.*, xxi, p. 83.
17 S. Freud, 'Civilisation and its Discontents' in *S.E.*, xxi, p. 83.
18 J. Laplanche and J. B. Pontalis, 'Fantasy and the Origins of Sexuality', in *Formations of Fantasy*, eds V. Burgin, J. Donald and C. Kaplan (London, 1986), p. 14.
19 S. Freud, 'Remembering, Repeating, and Working-Through (Further Recommendations on the Technique of Psycho-Analysis II)' in *S.E.*, xii, p. 147.
20 In a worn, but true, Lacanian formula, 'desire is the desire of the other'. The mirror reflects a mirror, and the regression of mutual reflections is infinite.

1 *The portrait of Laura*

1 J. G. Farrell, *The Singapore Grip* (London, 1984), p. 118.
2 Roland Barthes, *S/Z* (London, 1975), p. 33.
3 Stendhal, *Vie de Henry Brulard* (Paris, 1973), p. 306. 'Mlle Létourneau était une beauté dans le genre lourd (comme les figures de Tiarini, *Mort de Cléopâtre* ou *d'Antoine*, au musée du Louvre).' (Translated by the author.)
4 Denis Diderot, *Sur l'art et les artistes* (Paris, 1967), p. 37. '– Tenez, sans m'alambiquer tant l'esprit, quand je veux faire une statue de belle femme, j'en fais déshabiller un grand nombre; toutes m'offrent de belles parties et des parties difformes; je prends de chacune ce qu'elles ont de beau. – Et à quoi le reconnais-tu? – Mais à la conformité avec l'antique, que j'ai beaucoup étudié. – Et si l'antique n'était pas, comment t'y prendrais-tu? Tu ne me réponds pas . . .' (translated by the author).
5 R. Barthes, *S/Z*, p. 33.
6 Honoré de Balzac, *Sarrasine*, in R. Barthes, *S/Z*, p. 238.
7 R. Barthes, *S/Z*, p. 115.
8 Sacha Guitry (origin of citation lost). '. . . Est-il rien de plus ravissant que l'entrée d'une femme, d'une jolie femme dans un salon? On était là, trois hommes, on causait librement, sans contrainte, on était entouré d'objets d'art, de tableaux, et l'atmosphère était cordiale. Elle est entrée. La conversation s'est brisée en tombant, la peinture s'est effacée, les objets d'art sont rentrés dans l'ombre . . .' (translated by the author).
9 Giovanni Pietro Bellori, 'The Idea of the Painter, Sculptor and Architect, Superior to Nature by Selection from Natural Beauties' (*c.* 1672), in E. Panofsky, *Idea – A Concept in Art Theory* (New York, London, 1968), p. 161.
10 Plato, 'Statesman', in *Plato* (Chicago, London, Toronto, 1952), p. 594.
11 Aristotle, *Metaphysics*, Book 12 (Ann Arbor, 1975), p. 276.
12 See St Augustine, *De Musica*, Book vi, in *Philosophies of Art and Beauty*, eds A. Hofstadter and R. Kuhns (Chicago, London, 1976).
13 Marsilio Ficino, 'How Hate and Love are Born, or that Beauty is Incorporeal', Ch. v, 'Commentary on Plato's Symposium', in *Philosophies of Art and Beauty*, p. 224.
14 Immanuel Kant, 'The Critique of Aesthetic Judgement', *The Critique of Judgement*, in *Kant* (Chicago, London, Toronto, 1952), p. 486.
15 Benedetto Croce, 'Aesthetics', in *Philosophies of Art and Beauty*, p. 569.
16 Giovanni Petrarch, lxxvii and lxxviii, *Il Canzoniere* (*c.* 1540), (Rizzoli, Milan, 1954), p. 113. Translated by Mary Rogers in 'Sonnets on Female Portraits from Renaissance North Italy', *Word and Image*, ii/4 (October-December 1986), p. 300. Martini's portrait, if it ever existed, is now lost.
17 M. Rogers, 'Sonnets on Female Portraits from Renaissance North Italy', p. 292.
18 Pietro Bembo, 'Sonnet xlvii' (*c.* 1501) in *Le Rime di Pietro Bembo* (1552),

p. 7, 'Ch'al men, quand'io ti cerco, non t'asscondi' (translated by the author).

19 Antonio Brocardo, (c. 1530), 'On a Marble Bust of his Lady', in M. Rogers, 'Sonnets on Female Portraits from Renaissance North Italy', p. 302.

20 Kenneth Clark, *Feminine Beauty* (New York, 1980).

21 Mario Pozzi, 'Il ritratto della donna nella poesia d'inizio Cinquecento e la pittura di Giorgione', *Lettere Italiane*, xxxi/1 (January–March, 1979).

22 See, for instance, Boccaccio's 'Teseida' (1339–40), xii, 53–63, in *Opere in Versi* (Milan, 1965), pp. 412–15.

23 M. Pozzi, 'Il ritratto della donna nella poesia d'inizio Cinquecento e la pittura di Giorgione', p. 8. 'Solo incombe l'immanitá corposa e quasi brutale dell' elenco' (translated by the author).

24 Lucy Gent draws a useful distinction between the Renaissance concern for verisimilitude – the bare imitation of nature – and the attention to lifelikeness which, achieved through artistic skills, led to 'extreme consciousness of the art'. Lucy Gent, *Picture and Poetry, 1560–1620* (Leamington Spa, 1981), p. 54.

25 We may note that it is across this same period that there occurs the elaboration of the doctrine of 'ut pictura poesis', in which the protocols of narrative painting are to be derived from literary models. We may see, therefore, that both poetry and painting sought in the other the means to correct its own insufficiency: in the one case an insufficiency of image, in the other an insufficiency of narrative.

26 M. Pozzi, 'Il ritratto della donna nella poesia d'inizio Cinquecento e la pittura di Giorgione', p. 21.

27 Although it is interesting to note that motivations of a tactile nature became more popular in the fifteenth century.

28 François Lecercle, *La Chimère de Zeuxis* (Tübingen, 1987), p. 65, 'Le "cheveau d'or", loin de combler, par son pouvoir de suggestion, un certain "manque-à-voir" de l'écriture, produirait plutôt un effet contraire: non pas accroître l'effet de réel mais, insidieusement le défaire . . .' (translated by the author). A full consideration of the use of metaphors in Renaissance poetry should acknowledge a further level of meaning beyond the most immediate evocations I have spoken of so far. In his account of the historical evolution of the metaphor, Terence Hawkes stresses the importance of a *contextual* understanding of the role of metaphor. For the Renaissance, he argues, the choice of metaphors was dictated by *appropriateness* rather than accuracy; that is, a particular metaphor would be selected for its power to evoke a socially sanctioned meaning rather than for its capacity to translate accurately a perceptual experience. Hawkes quotes a passage from a poem by Campion in which the woman's face is referred to as a 'Garden of Eden': to fail to look beyond the immediate paradisiac botanical evocation would be to ignore that other level of meaning which speaks, in this instance very loudly, of innocence and virginity. Precious stones and metals, milk, snow and flowers – the substances of the poetic body – are all products of nature, albeit a highly mediated nature, but it is above all (and this is Hawkes's point) a nature controlled by meaning: 'In short, metaphor . . . represents an act of ordering imposed on Nature.' Terence Hawkes, *Metaphor* (London, 1972).

29 Pontus de Tyard, 'Erreurs Amoureuses', ii/44 (1549), in F. Lecercle, *La Chimère de Zeuxis*, p. 114. 'Cet or filé, ce marbre, cest yvoire' (translated by the author).

30 Pierre de Ronsard, *Les amours*, xxiii (1552–3), in H. Weber, *La Création poétique au XVIe siècle en France* (Paris, 1955), p. 266, 'Ce beau coral, ce marbre qui souspire' (translated by the author).

31 Oliver de Magny, 'Sonnet XLVII', in *Les Cents deux sonnets des amours de 1553* (Geneva, 1970), p. 73; also in F. Lecercle, *La Chimère de Zeuxis*, p. 107, 'Du plus fin or qui fut onques bruny/Ces longs cheveux furent ainsi dorez/De la blancheur des beaux lys colorez/Ce teint vermeil fut proprement muny' (translated by the author).

32 Agnolo Firenzuola, 'Celso, Dialogo delle bellezze delle donne' (*c.* 1541), in *Opere*, ed., A. Seroni (Florence, 1958), pp. 519–96. Translated as *On the Beauty of Women*, eds K. Eisenbicher and J. Murray (Philadelphia, 1992).

33 O. de Magny, 'Sonnet XLVII', in *Les Cents deux sonnets des amours de 1553*, p. 73; also in F. Lecercle, *La Chimère de Zeuxis*, p. 107, 'Et ce cueur d'où? d'un riche diamant/Qui m'esblouyt, & fait en un moment/De moy, dolent, mile metamorphoses' (translated by the author).

34 F. Lecercle, *La Chimère de Zeuxis*, p. 108, 'Et les "milles métamorphoses" finales de l'amant transfiguré évoquent . . . le *pouvoir* qu'à l'amant-poète de changer à sa guise le corps de la dame en tous les trésors de l'Orient' (translated by the author).

35 Honoré de Balzac, *Gillette, or the Unknown Masterpiece* (London, 1988).

36 Vera Caspary, *Laura* (London, 1987). Otto Preminger, director, *Laura* (USA 1944).

37 V. Caspary, *Laura*, p. 72.

38 H. de Balzac, *Gillette, or the Unknown Masterpiece*, p. 18.

2 *The imaginary companion*

1 Lester del Rey, 'Helen O'Loy' in *Robots Robots Robots* (Boston, 1978), p. 216.

2 Enno Patalas, '*Metropolis*, Scene 103', *Camera Obscura*, XV (1986).

3 See Roger Dadoun, '*Metropolis*, Mother-City – "Mittler" – Hitler', *Camera Obscura* XV (1986).

4 Roger Dadoun, '*Metropolis*, Mother-City – "Mittler" – Hitler', p. 144.

5 Max Milner, *La Fantasmagorie* (Paris, 1982), p. 47, 'L'acteur féminin et maternel y fait totalement défaut. Cet . . . effacement de la mère va caractériser tout l'univers fantasmatique de Nathanael, celui auquel ni Clara, ni Lothaire n'auront accés et où la seule femme possible sera Olympia' (translated by the author).

6 Villiers de l'Isle-Adam, *Tomorrow's Eve* (Chicago, London, 1982), p. 73.

7 Peter Wollen, 'Cinema/Americanism/The Robot', *New Formations*, VIII (Summer, 1989), p. 17.

8 Villiers de l'Isle-Adam, *Tomorrow's Eve*, p. 65.

9 E. T. A. Hoffmann, *The Sandman* in *The Best Tales of Hoffmann* (Dover, New York, 1967), p. 188.

10 E. T. A. Hoffmann, *The Sandman*, p. 190.

11 E. T. A. Hoffmann, *The Sandman*, p. 207.

12 Villiers de l'Isle-Adam, *Tomorrow's Eve*, p. 73.

13 E. T. A. Hoffmann, *The Sandman*, p. 189.

14 Andreas Huyssen, 'The Vamp and the Machine', in *After the Great Divide* (London, 1986), p. 70. Huyssen gives a very succint historical overview of the development of the automaton as manufactured object and literary subject matter.

15 Patricia Mellecamp, 'Oedipus and the Robot in Metropolis', *Enclitic*, V (Spring, 1981).

16 R. Dadoun, '*Metropolis*, Mother-City – "Mitler" – Hitler', p. 145. Dadoun offers a thorough analysis of the latent structure – the 'unconscious' of the film – made manifest in the Nazi imagination.

17 See Georg Groddeck, *The Book of the Id* (New York, 1950).

18 Correlative to the idea of the threatening woman-machine is the prior

notion of the de-gendered 'human body' as a machine the mechanism of which never breaks down – an idealized body that never ails nor dies: 'The human body is a self-winding clockwork: living image of perpetual motion', *Man a Machine* (1748); republished by The Open Court Publishing Company (La Salle, 1961), p. 21.

19 P. Wollen, 'Cinema/Americanism/The Robot', P. 17.

20 The equation of the purported unabating libidinal energy of the woman with mechanical motion is found in the rather derisory expression 'she fucks like a sewing machine'. The threat posed to the man by the woman's actual capacity for a more rapid renewal of sexual arousal, and therefore her capacity for multiple orgasms, is turned into a joke. Having been a woman himself, Teiresias confirms that 'if the parts of love-pleasure be counted as ten, thrice three go to women, one only to men'. Robert Graves, *The Greek Myths* (London, 1979), II, p. 11.

21 Sigmund Freud, 'The Question of Lay Analysis' (1926) in *S.E.*, xx, p. 195. Freud remarks how the notion of an impersonal force that impels our actions is to be found in everyday language, in such common expressions as 'It shot through me', 'there was something in me at that moment which was stronger than me' (*c'etait plus fort que moi*).

22 Siegfried Kracauer, *From Caligari to Hitler – A Psychological History of the German Film* (Princeton, 1974), p. 164. Kracauer examines the structure of the film *Metropolis* in the retrospective light of the German totalitarianism of the Thirties. The Tiller Girls was an English dance troupe in the 1920s and 1930s.

23 S. Kracauer, quoted in K. Theweleit, *Male Fantasies* (London, 1987), p. 433. See also S. Kracauer, 'The Mass Ornament', *New German Critique'*, v (Spring, 1975).

24 Elizabeth Grosz, 'Julia Kristeva: Abjection, Motherhood and Love' in *Sexual Subversions – Three French Feminists* (Sydney, London, Boston, 1989), p. 79.

25 Villiers de l'Isle-Adam, *Tomorrow's Eve*, pp. 129–30.

26 Villiers de l'Isle-Adam, *Tomorrow's Eve*, p. 58.

27 Honoré de Balzac, *Gillette, or the Unknown Masterpiece*, p. 30.

28 Plotinus quoted in M. Barasch, *Theories'of Art* (New York, 1985), p. 37. See M. A. Williams, 'Divine Image – Prison of Flesh: Perceptions of the Body in Ancient Gnosticism', *Zone*, 3 (1989).

29 Julia Kristeva, *Revolution in Poetic Language* (New York, 1984), p. 25.

30 D. Lacotte, 'A la recherche du geste parfait', *Le Monde*, 20 January 1980. At the time this article appeared, Dr Ariel was engaged in pioneering research, in the United States, in 'biomechanics'. He was himself an athlete, holding the record, in Israel, for throwing the discus.

31 Paul Virilio, 'Un corps energétique' in *Quel corps* (Montreuil, 1986), p. 58. Virilio refers here to the Futurist 'Dandy Guerrier': 'Le seul sujet capable, survivant et savourant dans le combat, la puissance du rêve métallique du corps humain'; 'The only able subject, surviving and enjoying in combat, the power of the metallic dream of the human body' (translated by the author).

32 J.-K. Huysmans, *Against Nature* (London, 1984), p. 37.

33 J.-K. Huysmans, *Against Nature*, pp. 37–8.

34 J. B. Pouy, 'Belle comme un Camion', *Autrement*, 91 (June, 1987).

35 Isaac Asimov, 'Satisfaction Guaranteed' in *The Rest of the Robots* (St Albans, 1975), p. 111.

36 A. Huyssen, 'The Vamp and the Machine', p. 71.

37 Oskar Kokoschka, Letter to Hermine Moos, Berlin, 10 December 1918, in *Vienne 1880–1938 – l'Apocalypse Joyeuse*, ed. J. Clair (Paris, 1986), pp. 491–4, 'N'est-ce pas, chère mademoiselle Moos, vous ne permettrez

pas qu'on me torture pendant de longues années de ma vie en autorisant cet objet malicieux et réel – ouate, tissu, fil, chiffon ou quels que soient les noms que l'on donnent à ces choses effroyables – à s'imposer dans toute sa platitude terrestre alors que je m'imagine embrasser du regard une créature qui est ambiguë, morte et esprit vivant!' (translated by the author).

38 What followed this title was an article about the development of artificial limbs.

39 Immanuel Kant, 'Analytic of the Sublime', in *The Critique of Judgement*, Book II (Oxford 1961), p. 167.

40 R. M. Benson, D. B. Pryor, ' "When Friends Fall Out": Developmental Interference with the Function of Some Imaginary Companions', *Journal of the Psychoanalytic Association*, XXI/3 (1973), p. 469.

41 Villiers de l'Isle-Adam, *Tomorrow's Eve*, p. 9.

42 Villiers de l'Isle-Adam, *Tomorrow's Eve*, p. 131.

43 Villiers de l'Isle-Adam, *Tomorrow's Eve*, p. 38.

44 E. T. A. Hoffmann, *The Sandman*, p. 206.

45 Villiers de l'Isle-Adam, *Tomorrow's Eve*, p. 199.

46 S. Freud, 'On Narcissism: An Introduction' in *S.E.*, XIV, p. 94.

47 Villiers de l'Isle-Adam, *Tomorrow's Eve*, p. 68.

48 Guy Rosolato, 'Le Narcissisme', *Nouvelle Revue de Psychanalyse*, XIII (Spring, 1976), p. 23, 'D'une manière générale la projection du moi idéal donne l'occasion au Moi d'observer sa propre image idéale dans l'illusion même d'une constatation "objective" qui a pour effet d'emporter la croyance' (translated by the author).

49 See G. Rosolato, 'Le Narcissisme'.

50 Jacques Lacan, 'The Mirror Stage as Formative of the Function of the I. . .', in *Ecrits – A Selection* (New York, 1977).

51 See Jean Laplanche and Jean-Bertrand Pontalis, *The Language of Psycho-Analysis* (London, 1973), p. 202.

52 Villiers de l'Isle-Adam, *Tomorrow's Eve*, p. 133.

53 Daniel Lagache, in J. Laplanche and J. B. Pontalis, *The Language of Psycho-Analysis*, p. 145.

54 Villiers de l'Isle-Adam, *Tomorrow's Eve*, p. 199.

55 Raymond Bellour, 'Ideal Hadaly', *Camera Obscura*, XV (1986), pp. 128.

56 Villiers de l'Isle-Adam, *Tomorrow's Eve*, p. 199. It would be more correct to speak here of Hadaly/Sowana since it is the disembodied soul of Sowana who speaks through Hadaly.

57 Villiers de l'Isle-Adam, *Tomorrow's Eve*, p. 200.

58 G. Rosolato, 'Le Narcissisme', p. 16, 'L'idéal en jeux dans l'extase est de pouvoir tenir la gageure d'atteindre la jouissance dans le retrait le plus radical à l'égard de l'objet et du monde. Même dans la plus grande proximité avec eux, un suspens, une aspiration hors du temps, par la contemplation ou la méditation, tend à dissoudre l'objet. Les comparaisons freudiennes sont connues: la satiété du nourisson et son sommeil consécutif, le retour au ventre maternel' (translated by the author).

59 Villiers de l'Isle-Adam, *Tomorrow's Eve*, p. 204.

60 Villiers de l'Isle-Adam, *Tomorrow's Eve*, p. 199.

61 S. Freud, 'Civilization and its Discontents' in *S.E.*, XXI, p. 65.

62 Marsilio Ficino, 'How Divine Beauty inspires Love', Ch. II, *Commentary on Plato's Symposium*, in *Philosophies of Art and Beauty*, eds, A. Hofstadter, R. Kuhns (Chicago, London, 1976), p. 209.

63 O. Kokoschka, Letter to Hermine Moos, Berlin, 10 December 1918, *Vienne 1880–1938 – l'Apocalypse Joyeuse*, pp. 491–4, '. . . Il faut que les mains et les pieds soient encore davantage articulés. Prenez par exemple, votre main pour modèle. Ou pensez à celle d'une Russe

soignée qui monte aussi à cheval. Et le pied, par exemple, qui pourrait être comme celui d'une danseuse: Karsavina par exemple. Il faut aussi que vous teniez compte de ce que les mains et les pieds restent attirants même nus et ne donnent pas l'impression de masses inertes, mais d'avoir du nerf. La taille à peu prés telle qu'on puisse leur mettre une élégante chaussure de dame . . . Pour ce qui est de la tête, son expression est trés, trés originale et devra être tout au plus renforcée encore, mais faites disparaître toutes les traces de sa confection et du travail effectué! La bouche s'ouvrira t-elle? Et y a-t-il des dents et une langue à l'intérieur? J'en serais heureux! . . . Pour les paupières, les pupilles, le globe oculaire, les coins de l'oeil, l'épaisseur, imitez le plus possible les vôtre. La cornée pourrait être recouverte de vernis à ongles. Ce serait joli si l'on pouvait aussi baisser les paupières sur les yeux. Tout l'ensemble, autant de nerf que dans la grande ébauche à l'huile avec le plus de détails possibles! L'oreille un peu plus articulée . . . Les seins, s'il vous plait, je les aimerais plus détaillés! Pas de mamelons saillants, mais plutôt irréguliers et ne les faites ressortir qu'au moyen d'une certaine rugosité. Le modèle parfait est donné par ceux d'Hélène Fourment dans le petit bouquin sur Rubens où elle tient l'un des garçonnets contre elle . . . La peau enfin, qu'elle soit au toucher comme celle d'une pêche et ne vous permettez pas de coutures là où vous pensez que ça me fera mal et me rappelera que ce fétiche est un misérable poupon de chiffon . . .' (translated by the author).

64 O. Kokoschka, Letter to Hermine Moos, Weisser Hirsch, 6 April 1919, *Vienne 1880–1938 – l'Apocalypse Joyeuse*, pp. 494–5, 'Chère Mademoiselle Moos, Qu'allons-nous faire maintenant? Je suis sincèrement épouvanté par votre poupée qui, bien que j'ai été prêt à réduire quelque peu mes fantasmes au profit de la réalité, contredit en trop de choses ce que j'attendais d'elle et espérais de vous . . . j'avais demandé une présentation si discrète que je pouvais m'attendre qu'elle m'apporte une certaine illusion qui m'a été cruellement arrachée, et je ne sais ce qui va se passer maintenant . . .' (translated by the author).

65 E. T. A. Hoffmann, *The Sandman*, p. 207.

66 O. Kokoschka, Letter to Hermine Moos, Weisser Hirsch, 6 April 1919, *Vienne 1880–1938 – l'Apocalypse Joyeuse*, pp. 494–5, 'Toute cette histoire s'écroule comme un paquet de chiffons' (translated by the author).

3 *Shattered beauty*

1 Patrick Drevet, *Huit petites études sur le désir de voir* (Paris, 1991), p. 68, 'Mon regard se fixe t-il sur un détail? C'est le galbe d'une hanche qui le retient, le croissant d'une épaule, l'arête d'un nez, les courbes alternées d'une jambe' (translated by the author).

2 Annette Michelson, 'On the Eve of the Future: The Reasonable Facsimile and the Philosophical Toy', *October*, 29 (Summer, 1984).

3 Although the term *blason* is sometimes used to refer to any poetic description in praise of an object, I shall speak here specifically of the French form of the *blason anatomique*, eulogy of the body fragment. For a discussion of the powers of the rhetoric of praise, see Nancy J. Vickers, 'This Heraldry in Lucrece's Face' in *The Female Body in Western Culture*, ed., S.R. Suleiman (Cambridge, Mass., 1986); also Patricia Parker, 'Rhetorics of Property: Exploration, Inventory, Blazon' in *Literary Fat Ladies* (London, New York, 1987).

4 Villiers de l'Isle-Adam, quoted in A. Michelson, 'On the Eve of the Future: The Reasonable Facsimile and the Philosophical Toy', p. 6.

5 A. Michelson, 'On the Eve of the Future: The Reasonable Facsimile and the Philosophical Toy', p. 8.

6 The *canone lungo* takes as its object the entirety of the feminine body. See for instance Boccaccio's 'Teseida' (1339–40), XII, 53–63 in *Opere in Versi* (Milan, 1965), pp. 412–15.

7 Pierre de Ronsard, *Les Amours* (1552), sonnet LXXII (Paris, 1963), p. 45, 'Petit nombril, que mon penser adore, / Non pas mon oeil, qui n'eut onques ce bien, / Nombril de qui l'honneur mérite bien, / Qu'une grande ville on luy bastisse encore: / Signe divin, qui divinement ore/ Retiens encore l'Androgyne lien, / Combien & toy, mon mignon, & combien / Tes flancs jumeaulx follastrement j'honore! / Ny ce beau chef, ny ces yeulx, ny ce front, / Ny ce doulx ris, ny ceste main qui fond / Mon cuoeur en source, & de pleurs me fait riche, / Ne me sçauroyent de leur beau contenter, / Sans esperer quelque foys de taster / Ton paradis, où mon plaisir se niche.' (Translated by the author.) Although Ronsard's *blason* sonnet does not exemplify the form of the *blason anatomique*, it nonetheless provides a succint exposition of the dynamics of the *blason*.

8 Note in the background, the bottom left corner of a painting of a reclining figure, of which all we are allowed to see are the legs – slightly spread apart in a configuration which mirrors the position of the thumb and index finger of the Duchesse de Villars.

9 Alison Saunders, *The Sixteenth-century Blason Poétique* (Bern, Las Vegas, 1981), p. 95.

10 Leonardo da Vinci, in *The Notebooks of Leonardo da Vinci*, I, ed., Edward McCurdy (London, 1938), p. 168.

11 Devon L. Hodges, *Renaissance Fictions of Anatomy* (Amherst, 1985), pp. 4–6.

12 Clément Marot, 'Du Beau Tetin', CIV (c. 1535) in *Clément Marot – Oeuvres Poétiques*, ed. Y. Giraud (Paris, 1973), p. 402, 'Tetin refaict, plus blanc qu'ung oeuf, / Tetin de satin blanc tout neuf, / Tetin qui fais honte à la rose, / Tetin plus beau que nulle chose; / Tetin dur, non pas Tetin, voyre, Mais petite boule d'ivoyre, / Au milieu duquel est assise / Une fraize, ou une cerise / Que nul ne veoit, ne touche aussi, / Mais je gaige qu'il est ainsi. / Tetin donc au petit bout rouge, / Tetin qui jamais ne se bouge, / Soit pour venir, soit pour aller, / Soit pour courir, soit pour baller. / Tetin gauche, tetin mignon, / Toujours loing de son compaignon, / Tetin qui porte tesmoignage / Du demourant du personage. / Quand on te voit, il vient à mainctz / Une envie dedans les mains / De te taster de te tenir; / Mais il se faut bien contenir / D'en approcher, bongré ma vie, / Car il viendroit une aultre envie. / O Tetin ne grand ne petit, / Tetin meur, Tetin d'appetit, / Tetin qui nuict et jour criez: / "Mariez moy, tost mariez!" / Tetin qui t'enfles et repoulses / Ton gorgerin de deux bons poulses, / A bon droict heureux on dira / Celluy qui de laict t'emplira, / Faisant d'un Tetin de pucelle / Tetin de femme entiere et belle' (translated by the author; last four lines translated by A. Michelson).

13 Catherine Clément, *The Lives and Legends of Jacques Lacan* (New York, 1983), pp. 93–4.

14 Jacques Lacan, 'Aggressivity in Psychoanalysis' in *Ecrits – A Selection* (New York, 1977), p. 11.

15 J. Lacan, 'Aggressivity in Psychoanalysis', p. 19.

16 R. D. Hinshelwood, *A Dictionary of Kleinian Thought* (London, 1989), p. 374.

17 Melanie Klein, 'Some Theoretical Conclusions Regarding the Emotional Life of the Infant', in *Developments in Psycho-analysis* (London, 1952).

18 M. Klein, 'A Contribution to the Psychogenesis of Manic-depressive states', in *The Selected Melanie Klein*, ed. J. Mitchell (London, 1986), p. 116.

19 I am here adopting Melanie Klein's orthography of the term.

20 M. Klein, 'Notes on Some Schizoid Mechanisms' in *The Selected Melanie Klein*, p. 182.

21 M. Klein, 'Notes on Some Schizoid Mechanisms', p. 183.

22 M. Klein, 'Some Theoretical Conclusions Regarding the Emotional Life of the Infant', p. 200.

23 See, for example, Mario Pozzi, 'Il ritratto della donna nella poesia d'inizio cinquecento e la pittura di Giorgione', *Lettere Italiane*, XXXI/1 (January–March, 1979), and François Lecercle, *La Chimère de Zeuxis* (Tübingen, 1987). In Roland Barthes' words, '. . . once reassembled, in order to *utter* itself, the total body must revert to the dust of words, to the listing of details, to a monotonous inventory of parts, to crumbling: language undoes the body. . . .', *S/Z* (London, 1975), p. 113.

24 It is worth noting that in their published form – that is collected in a compendium – each of the *blasons anatomiques* becomes but a sentence, a section in a long enumeration of the parts of the feminine body.

25 D. B. Wilson, *Descriptive Poetry in France from Blason to Baroque* (New York, 1967), p. 8.

26 The repetition throughout the poem of the name of the body-part under scrutiny was a common feature of all *blasons anatomiques*. In François Sagon's *Blason du pied* each of the forty-four lines of the poem begins with the invocation of the *pied*.

27 Maurice Scève, 'Blason du sourcil' (1536) in *Oeuvres Poétiques Complètes*, ed. B. Guégan (Geneva, 1967), p. 282, '. . . O sourcil brun soubz tres noires tenebres / j'ensepvely en desirs trop funebres / Ma liberte et ma dolente vie / Qui doucement par toy me fut ravie' (translated by the author).

28 C. Marot, quoted in A. Michelson, 'On the Eve of the Future: The Reasonable Facsimile and the Philosophical Toy', p. 10.

29 M. Klein, 'Notes on Some Schizoid Mechanisms', p. 183.

30 C. Marot, 'Du Layd Tetin', CV (*c.* 1535) in *Clément Marot – Oeuvres Poétiques*, p. 403, '. . . Tetin grillé, Tetin pendant, / Tetin flestry, Tetin rendant / Villaine bourbe en lieu de laict, / Le diable te feit bien si laid. / Tetin pour trippe reputé, / Tetin ce cuydé-je, emprunté, / Ou desrobé, en quelque sorte, / De quelque vieille chevre morte' (translated by the author).

31 M. Klein, 'Some Theoretical Conclusions Regarding The Emotional Life of the Infant', p. 234.

32 C. Marot, 'Du Layd Tetin', in *Clément Marot – Oeuvres Poétiques*, p. 403, 'Quand on te voit, il vient à mainctz / Une envie dedans les mains, / De te prendre avec les gans doubles / Pour en donner cinq ou six couples / De souffletz sur le nez de celle / Qui te cache soubz son esselle' (translated by the author).

33 A. Michelson, 'On the Eve of the Future: The Reasonable Facsimile and the Philosophical Toy', p. 8.

34 For an early – strictly, pre-psychoanalytic – formulation of the immateriality of the fetish, see Binet's discussion of the *idée fixe* as fetish in *Etude de psychologie expérimentale: le fétichisme dans l'amour* (Paris, 1888).

35 Nancy J. Vickers, 'Diana described: Scattered Woman and Scattered Rhymes', *Critical Inquiry*, VIII (Winter, 1981).

36 Another precursor to the form of the *blason anatomique* is Francesco Petrarch's sonnet in praise of the hand of Laura. Of the influence of Petrarchan writings upon later poetic descriptions of beautiful women, Elizabeth Cropper asks 'how the conventional description of the beautiful woman became so closely associated with a lyric poet who never painted her complete portrait' ('On Beautiful Women,

Parmigianino, Petrarchismo, and the Vernacular Style', *The Art Bulletin*, LVIII, 1976, p. 386.)

37 N. J. Vickers, 'Diana Described: Scattered Woman and Scattered Rhymes', p. 273.

38 S. Freud, 'Beyond the Pleasure Principle' in *SE*, XVIII, pp. 7–43.

4 The girl of the Golden Mean

1 Hans Bellmer, in Gilbert Lascault, *Figurées, défigurées – Petit vocabulaire de la féminité représentée* (Paris, 1977), p. 80. 'Comme le jardinier oblige le buis à vivre sous forme de boule, de cône, de cube, l'homme impose à l'image de la femme ses élémentaires certitudes, les habitudes géométriques et algébriques de sa pensée' (translated by the author).

2 'How to Become a Model', *Honey*, January 1986, p. 28.

3 Lewis Tuchlin, *The Photography of Women – The Nude as Art* (New York, London, 1965), p. 37.

4 John Cody, *Atlas of Foreshortening – The Human Figure in Deep Perspective* (New York, 1984), p. xi.

5 Danièle Laufer, 'Chirurgien esthètique: Narcisse et Pygmalion', *Autrement*, 91 (June, 1987), p. 145, 'Critères objectifs de la beauté . . . symétrie par rapport à une verticale . . . Netteté des surfaces, Proportionalité des volumes et des droites par l'application de la règle d'or' (translated by the author).

6 Francis Bacon, *Novum Organum*, quoted in Michel Foucault, *The Order of Things – An Archeology of the Human Sciences* (New York, 1973), p. 52.

7 By experimenting with varying lengths of a resonant string, Pythagoras arrived at an arithmetic formulation of the whole harmonic system according to the ratios of the first four integers. For an account of the experiment, see Rudolf Wittkower, 'The Changing Concept of Proportion', in *Idea and Image* (London, 1978), p. 110.

8 Plutarch, *De Musica*, XXXVII, quoted in Jean Lacoste, *L'Idée de Beau* (Paris, 1986), p. 15. (Translated by the author.)

9 'Proportion', in *Encyclopædia Universalis*, XIII (Paris, 1979), p. 650. 'La Nature paraissait répondre à la pensée mathématique, la beauté à toutes deux . . .' (translated by the author).

10 Desmond Lee, Introduction to Plato's *Timaeus and Critias* (London, 1983), p. 8.

11 Plato writes '. . . he left the circle of the Same whole and undivided, but slit the inner circle six times to make seven unequal circles, whose intervals were double or triple, three of each; and he made these circles revolve in contrary senses relative to each other, three of them at a similar speed, and four at speeds different from each other and from that of the first three but related proportionately.' *Timaeus*, in *Timaeus and Critias*, p. 48.

12 See Jean Lacoste, *L'Idée de beau* (Paris, 1986), p. 15; also R. Wittkower, 'The Changing Concept of Proportion', p. 116.

13 The five solids are the cube, tetrahedron, octahedron, icosahedron, dodecahedron; these constitute respectively earth, fire, air, water and 'the whole heaven', or cosmos.

14 Plato, *Timaeus*, p. 44.

15 Vitruvius, quoted in Harold Osborne, *The Oxford Companion to Art* (Oxford, 1970), p. 933.

16 R. Wittkower, 'The Changing Concept of Proportion', p. 117.

17 Erwin Panofsky, 'History of the Theory of Human Proportions' in *Meaning in the Visual Arts* (London, 1970), p. 113.

18 Umberto Eco, *Art and Beauty in the Middle Ages* (New Haven, London, 1986), p. 41.

19 Naturalistic representations of the human body did exist during the Middle Ages. Life-size polychrome statues of the dying Christ were central to Christian ceremonies. The body of Christ was rendered in its finest details, down to the hair in his armpits and on his stomach above his loincloth. However, the body depicted here is that of Christ, not quite human to begin with, in extreme agony. It was not the spectacle of the flesh, but of the pain inscribed in the flesh, which was intended to move the beholder to faith. Another polychrome sculpture of the fifteenth century represents 'a Gothic beauty, completely naked, in the pose of Venus Pudica . . . back to back with a youth . . . who wears only a small loin cloth knotted at the hip. Back to back with both of them, a hag [sic.] . . . withered, veinous, her breasts empty sacks, her mouth caved in over her gap-toothed jaws . . .' (Marina Warner, *Monuments and Maidens*, London, 1985, p. 297). Here the detailed nakedness of the female body, young and old, provides a graphic narrative of the decay of the flesh, a warning against, and a condemnation of, the pleasure of the flesh.

20 R. Wittkower, 'The Changing Concept of Proportion', p. 117.

21 E. Panofsky, 'History of the Theory of Human Proportions', p. 123.

22 Leonardo da Vinci, *The Notebooks of Leonardo da Vinci*, ed. Irma A. Richter (Oxford, New York, 1980), p. 151.

23 Leonardo da Vinci, *The Notebooks of Leonardo da Vinci*, p. 163.

24 Sir Joshua Reynolds, quoted in H. Osborne, *The Oxford Companion to Art*, p. 936.

25 Roger de Piles, *The Principles of Painting*, quoted in Osborne, *The Oxford Companion to Art*, p. 931.

26 A. A. Cooper, 3rd Earl of Shaftesbury, *The Moralists*, Part III, Section II (dialogue between Theocles and Philocles), in eds A. Hofstadter and R. Kuhns, *Philosophies of Art and Beauty* (Chicago, London, 1976), p. 250.

27 René Descartes, quoted in J. Lacoste, *L'Idée de beau*, p. 12, 'Un accord et un tempérament si juste de toutes les parties ensembles qu'il n'y en doit avoir aucune qui l'emporte sur les autres' (translated by the author).

28 Denis Diderot, 'Beau', in *Encyclopédie ou dictionnaire raisonné des sciences, des arts et des métiers, par une Société de Gens de Lettres* (Paris, 1751–65), p. 621, 'Je n'entends pas autre chose sinon que j'aperçois entre les parties dont ils sont composés, de l'ordre, de l'arrangement, de la symmétrie, des rapports (car tous ces mots ne désignent que différentes manières d'envisager les rapports mêmes)' (translated by the author).

29 D. Diderot, 'Beau', in *Encyclopédie*, p. 622, 'Le rapport en général est une opération de l'entendement . . . il n'en a pas moins son fondement dans les choses' (translated by the author).

30 William Hogarth, *The Analysis of Beauty*, quoted in James T. Boulton, Introduction to Edmund Burke's *A Philosophical Enquiry into the Origin of our Ideas of the Sublime and the Beautiful* (Oxford, 1987), p. xxiii. '. . . fit proportion' writes Hogarth . . . 'is one part of beauty to the mind, tho' not always to the eye.' William Hogarth, *The Analysis of Beauty* (1753; Scholar Press facsimile, 1974), p. 69.

31 André Masson, 'En péril', *L'Ane*, XXIII (October–December 1985), p. 46, 'L'expression tend à remplacer la beauté, chez les romantiques certes, mais dés le seizième siècle: du Greco, on dit qu'il est expressif, on ne dit pas qu'il est beau' (translated by the author).

32 R. Wittkower, 'The Changing Concept of Proportion', p. 121.

33 Donald Reynolds (about Eugène Delacroix's *The Death of Sardanapalus*), *The Nineteenth Century* (Cambridge, 1985), p. 19.

34 A. Masson, 'En péril', p. 46 (my emphasis), 'Pour moi l'art grec reste le pivot pour toute discussion sur la beauté. . . . Il y a quelque chose de

magique dans la beauté, c'est pourquoi les foules défilent encore devant la Vénus de Milo, où elle reste *entière*, où elle n'est pas *atteinte*' (translated by the author).

35 *The Oxford English Dictionary*, I (Oxford, 1986).

36 Jean-Michel Rabaté, *La Beauté Amère – Fragments d'esthétiques* (Seyssel, 1986), pp. 26–7, '. . . deux sortes de photographies. La première représente une chambre baignée de lumière, la seconde le visage et la poitrine de Jane Russell. La salle centrale de la tour de Maubergeon de Poitiers, construite selon le "nombre d'or", lui donne des proportions telle qu'un homme puisse s'y tenir vers midi sans jeter d'ombre au sol' (translated by the author).

37 Shaftesbury, *The Moralists*, Part III, Section II, in *Philosophies of Art and Beauty*, p. 247.

38 Nicolas Poussin, 'Lettre à Paul Fréart de Chantelou, 20 mars 1642', in G. Lascault, *Figurées, défigurées – Petit vocabulaire de la féminité représentée*, p. 21, 'Les belles filles que vous avez vues à Nîmes ne vous auront, je m'assure, pas moins délecté l'esprit par la vue que les belles colonnes de la Maison Carrée, vu que celles ici ne sont que de vieilles copies de celles-là' (translated by the author).

39 Reproduced in Colin St John Wilson, 'Adrian Stokes on Architecture', *PN Review*, XV (1980), p. 47.

40 N. Poussin, 'Lettre à Paul Fréart de Chantelou, 20 mars 1642', in G. Lascault, *Figurées, défigurées – Petit vocabulaire de la féminité représentée*, p. 21, 'C'est, ce me semble, un grand contentement lorsque, parmi nos travaux, il y a quelque entremêt qui en adoucit la peine. Je ne me sens jamais tant excité à prendre de la peine et de travailler comme quand j'ai vu quelque bel objet' (translated by the author).

41 Friedrich Wilhelm Joseph von Schelling, *System of Transcendental Idealism*, in *Philosophies of Art and Beauty*, p. 348.

42 Jean Laplanche and Jean-Bertrand Pontalis, *The Language of Psycho-Analysis* (London, 1973), p. 431.

43 Jean Laplanche, *Problématiques III: La Sublimation* (Paris, 1980).

44 S. Freud, '"Civilized" Sexual Morality and Modern Nervous Illness', in *S.E.*, IX, p. 189.

45 S. Freud, '"Civilized" Sexual Morality and Modern Nervous Illness' in *S.E.*, IX, pp. 188–9.

46 S. Freud, 'The Ego and the Id' in *S.E.*, XIX, p. 30.

47 J. Laplanche and J.-B. Pontalis, *The Language of Psycho-Analysis*, p. 433.

48 S. Freud, 'Leonardo da Vinci and a Memory of his Childhood', in *S.E.*, XI.

49 Victor Burgin, 'Man, Desire, Image', *Desire*, ICA documents (London, 1984), p. 34.

50 I wish to stress at this point that I am not speaking only of the practical application of theories of proportion, or the 'refined' aesthetic judgement of the connoisseur. The same 'operations' govern the most commonplace of polite everyday expressions of appreciation of the female form.

51 Hans Thorner, 'Either/Or: A Contribution to the Problem of Symbolization and Sublimation', *The International Journal of Psycho-Analysis*, LXII/4 (1981), p. 461.

52 H. Thorner, 'Either/Or: A Contribution to the Problem of Symbolization and Sublimation', p. 460.

53 H. Thorner, 'Either/Or: A Contribution to the Problem of Symbolization and Sublimation', p. 460.

54 Friedrich Nietzsche, *The Birth of Tragedy* (New York, 1967), p. 50.

55 J. Laplanche, *Problématiques III: La Sublimation*, p. 114, 'Et bien, si l'on parle de primat génital comme façon de coordoner les pulsions

partielles dans cette espèce d'unité qu'est la relation sexuelle adulte, ne pourrait-on dire aussi de l'activité sublimée qu'elle est une sorte de substitut du primat génital, une façon, elle aussi, de coordoner les activités prégénitales sous une sorte de primat, celui d'une oeuvre, d'un travail, d'un résultat à accomplir; mais une synthèse qui, à la différence de la synthèse génitale se produirait peut-être sous le signe du refoulement ou du déni, précisément sous le signe du déni du génital?' (translated by the author).

56 J. Laplanche and J.-B. Pontalis, *The Language of Psycho-Analysis*, p. 433.

57 It is only when the aggressive tendency of mastery is turned round onto the self and the extraneous object is given up, that the instinctual activity becomes sexual: 'sensations of pain, like other unpleasurable sensations, trench upon sexual excitation and produce a pleasurable condition, for the sake of which the subject will even willingly experience the unpleasure of pain.' In a first stage the subject inflicts pain upon itself, in a second stage, masochism proper, there is a reversal of activity into passivity as the subject has pain inflicted upon itself. The pleasure afforded to the passive subject in masochism follows along the path of the original drive to master: '. . . the passive ego [places] itself back in phantasy in its first role, which has now in fact been taken over by the extraneous subject.' In another turning round of the masochistic drive into sadism, the pains are now being inflicted on another person, however, 'they are enjoyed masochistically by the subject through the identification of himself with the suffering object' (all citations from S. Freud, 'Instincts and their Vicissitudes' in *S.E.*, xiv, pp. 128–9).

58 S. Freud, 'Character and Anal Erotism' in *S.E.*, ix, p. 172. In *Civilization and its Discontents* Freud writes: 'Beauty, cleanliness and order obviously occupy a special position among the requirements of civilization' (*S.E.*, xxi, p. 93).

59 See Didier Anzieu, *The Skin Ego – A Psychoanalytic Approach to the Self* (New Haven, London, 1989).

60 J. M. Rabaté, *La Beauté Amère*, pp. 26–7, 'Le nombre d'or a certes dissipé les ombres, et mis en scène la disparition anonyme du sujet . . . il ne perpétue que la neutralité froide de la mort des noms et des sujets. Une telle neutralité peut me permettre d'accéder à une forme de beauté: sublimée, harmonieuse, transcendante, monadique, hors accidents, reservée, crypte cryptée d'un code à jamais perdu . . . A l'inverse de ce modèle d'une beauté formelle qui ne donne rien à voir, un célèbre poster représentant Jane Russell, l'air boudeur, le sourcil noir obliquant vers les méches de la tempe, puis l'épaule droite, nue et offerte au regard jusqu'à la naissance du sein, sur fond de paille dans la touffeur imaginaire d'une grange' (translated by the author).

5 *Woman as hieroglyph*

1 Hans Bellmer, *Petite anatomie de l'inconscient physique ou l'anatomie de l'image* (Paris, 1957), unpaginated, '. . . la passion la plus humainement sensible et la plus belle, celle d'abolir le mur qui sépare la femme de son image' (translated by the author).

2 A. Moret, *Rois et dieux d'Egypte* (Paris, 1911), p. 279, 'Sa beauté reste cachée, nul n'a pu soulever son voile' (translated by the author).

3 Heinrich Heine, quoted in S. Freud, 'Femininity', in *S.E.*, xxii, p. 113.

4 Mary Ann Doane, 'Film and the Masquerade – Theorizing the Female Spectator', *Screen*, xxiii/3–4 (September–October 1982), p. 75.

5 M. A. Doane, 'Film and the Masquerade – Theorizing the Female Spectator', p. 78.

6 Monroe C. Beardsley, on Plato's doctrine of recollection, *Aesthetics from Classical Greece to the Present* (Alabama, 1982), p. 40.
7 Plotinus, *The Enneads*, Book i, Sixth Tractate, 'Beauty' (Cambridge, Mass., 1988), p. 65.
8 Plotinus, *The Enneads*, Book v, Eighth Tractate, 'On the Intellectual Beauty', p. 490.
9 Marsilio Ficino, quoted in Rudolf Wittkower, *Allegory and the Migration of Symbols* (Boulder, Colorado, 1977), p. 116.
10 Alberti, *Ten Books on Architecture*, Book viii, Ch. iv, ed J. Rykwert (London, 1955), p. 170.
11 From the fifteenth to the eighteenth century, the hieroglyphics became the support upon which numerous scholars erected their individual, more or less eccentric, semantic constructions – such as Athanase Kircher, who, in the seventeenth century, elaborated his own metaphysical system by identifying each hieroglyph with a demonological or philosophical manifestation. Another manifestation of the same phenomenon was the proliferation of hieroglyphic systems which bore no stylistic relation whatsoever to the ancient Egyptian scriptures. As Rudolf Wittkower remarks: 'Egypt's influence makes itself felt at the level of the conceptual side of artistic creation and not on the style of this long period', R. Wittkower, *Allegory and the Migration of Symbols*, p. 117.
12 Mark Cousins and Athar Hussain, *Michel Foucault* (London, 1984), p. 32.
13 Plato, *Phaedrus*, 'The Privileged Role of Beauty', in *Philosophies of Art and Beauty*, eds A. Hofstadter and R. Kuhns, p. 61.
14 René Spitz, *The First Year of Life – A Psychoanalytic Study of Normal and Deviant Development of Object Relations* (New York, 1965), p. 65. It is assumed that the neonate gazing at the mother's face does not yet have a sense of distance as we understand the term; this it will gradually acquire as its motor capacities develop. Nevertheless, the infant experientially distinguishes between touch and sight as it is repeatedly subjected to the displeasure which accompanies the withdrawal or loss of the nipple.
15 Jacques Lacan, 'What is a Picture?', in *The Four Fundamental Concepts of Psycho-Analysis* (London, 1977), p. 115.
16 See Jean Laplanche, *Problématiques III: La Sublimation* (Paris, 1980), pp. 102–3.
17 J. Laplanche, 'The Ego and the Vital Order', in *Life and Death in Psychoanalysis* (Baltimore, London, 1976), p. 60.
18 J. Lacan, 'The Mirror Stage as Formative of the Function of the I as Revealed in Psychoanalytic Experience', in *Ecrits – A Selection* (New York, 1977), p. 2.
19 I am not implying here a causal relation between the loss of the breast and that of the ideal ego, but a temporal one. Although the loss of the breast in real terms, through weaning, occurs over a period of time which may very well extend beyond the mirror phase, the first fantasmatic inkling of the disjunction between need and satisfaction, resulting from the repeated withdrawal and non-availability of the nipple, pre-dates the loss of the ideal ego.
20 Catherine Clément, *The Lives and Legends of Jacques Lacan* (New York, 1983), p. 76.
21 Jacqueline Rose, 'Sexuality in the Field of Vision', in *Sexuality in the Field of Vision* (London, 1986), p. 227.
22 Garry Winogrand, *Women are Beautiful* (New York, 1975), unpaginated.
23 E. T. A. Hoffmann, *The Sandman*, in *The Best Tales of Hoffmann*, p. 202.
24 Victor Burgin, 'Photographers in Music Video' in *What a Wonderful*

World – *Music Videos and Architecture*, Groninge Museum (Groninge, 1990).

25 Laura Mulvey, 'Visual Pleasure and Narrative Cinema' in *Visual and Other Pleasures* (Bloomington, Indianapolis, 1989), p. 19.

26 Raymond Chandler, *Trouble is my Business* (New York, 1972), p. 16.

27 British edition of *Elle*, 1 November 1985.

28 Wilhelm Jensen, *Gradiva*, in Sigmund Freud, *Délire et Rêve dans la 'Gradiva' de Jensen* (Paris, 1971), pp. 21–2.

29 Jean-Paul Sartre, *The Psychology of Imagination* (London, 1978), p. 225.

30 J-P. Sartre, *The Psychology of Imagination*, p. 225.

31 Paul-Laurent Assoun, 'Entre horreur et narcissisme – Où donc chercher la beauté?', *L'Ane*, xxiii (October–December 1985), p. 50. 'L'obscure vocation de la beauté de faire accroire, image à l'appui, que le réel est sans faille' (translated by the author).

32 See Sarah Kofman, *The Enigma of Woman – Woman in Freud's Writings* (Ithaca, London, 1985).

33 P-L. Assoun, 'Entre horreur et narcissisme – Où donc chercher la beauté?', p. 50.

34 J-P. Sartre, *The Psychology of Imagination*, p. 225.

35 Sacher-Masoch, 'Venus in Fur' in Gilles Deleuze, *Sacher-Masoch – An Interpretation* (London, 1971), p. 202.

36 Sacher-Masoch, 'Venus in Fur', p. 202.

37 Jean-Bertrand Pontalis, *Frontiers in Psychoanalysis – Between the Dream and Psychic Pain* (London, 1981), p. 47.

38 Denis Diderot, quoted in Paul Hoffmann, 'La Beauté de la femme selon Diderot', *Dix Huitième Siècle*, ix (1977), p. 275, 'Un visage de jeune fille . . . innocent, naïf, sans expression encore' (translated by the author).

39 P. Hoffmann, 'La Beauté de la femme selon Diderot', p. 279, 'Quand nous parlons du sens que la beauté révèle et établit, dans les choses et les êtres, nous entendons ces significations que l'homme se donne à lui même, en réponse à son interrogation, pour appaiser en lui une inquiétude. Les choses et les êtres autour de lui, une intelligence discursive ne les lui fera jamais connaître parfaitement, impuissante à en recréer la présence vivante. La beauté est le language redécouvert du monde, ''une langue de nature'', au delà des mots' (translated by the author).

40 Friedrich Nietzsche, *The Birth of Tragedy* (New York, 1967), pp. 139–40.

41 Les Frères Goncourts, *Journal*, i, quoted in Mario Praz, *The Romantic Agony* (London, 1970), p. 293. 'Femme au délicat profil, au joli petit nez droit, à la bouche d'une découpure si spirituelle, à la coiffure de bacchante donnant aujourd'hui à sa physionomie une grâce mutine et affolée, femme aux yeux étrangers qui semblent rire, quand sa parole est sérieuse. Toutes les femmes sont des égnimes, mais celle-ci est la plus indéchiffrable de toutes. Elle ressemble à son regard qui n'est jamais en place, et dans lequel passent, brouillés en une seconde, les regards divers de la femme. Tout est incompréhensible chez cette créature qui peut-être ne se comprend guère elle-même; l'observation ne peut y prendre pied et y glisse comme sur le terrain du caprice. Son âme, son humeur, le battement de son coeur a quelque chose de précipité et de fuyant, comme le pouls de la Folie. On croirait voir en elle une Violante, une de ces courtisanes du XVIème siècle, un de ces êtres instinctifs et déréglés qui portent comme un masque d'enchantement, le sourire de nuit de la Joconde.'

42 Walter Pater, 'Leonardo da Vinci – Homo minister et interpres naturæ' in *Strangeness and Beauty – An Anthology of Aesthetic Criticism, 1840–1910*, ii (London, 1983), p. 23.

43 W. Pater, 'Leonardo da Vinci – Homo minister et interpres naturæ', pp. 23–4.

44 J. M. Barrie, *Mary-Rose* (New York, 1924).

45 André Breton, *Nadja* (New York, London, 1960), p. 90.

46 J. Laplanche, *Problématiques III – La Sublimation* (Paris, 1980), p. 106, 'Une cachotterie, un secret, un aparté, un quant-à-soi, bref justement quelque chose qui, de façon réaliste, matérielle, est supposé être caché derrière les apparences' (translated by the author).

47 S. Freud, *The Interpretation of Dreams*, in *S.E.*, v, p. 585.

48 J. Laplanche, *New Foundations for Psychoanalysis* (Oxford, 1989), p. 130.

49 J. Laplanche, *New Foundations for Psychoanalysis*, p. 45.

50 J. Lacan, 'The Subject and the Other: Alienation' in *The Four Fundamental Concepts in Psychoanalysis* (London, 1977), p. 214.

51 C. Clément, *Lives and Legends of Jacques Lacan*, p. 133.

52 Marcel Proust, *Remembrance of Things Past – The Captive* (London, 1972), pp. 248–9.

53 See C. Clément, *Lives and Legends of Jacques Lacan*, pp. 76–7.

54 Plotinus quoting Plato, *The Enneads* v, Eighth Tractate, 'On the Intellectual Beauty', p. 489.

55 'Les hommes contre-attaquent', *Elle* (French edition), 1986, p. 36 (translated by the author).

56 Charles Baudelaire, 'La Beauté', *Les Fleurs du mal*, XVIII, in *Oeuvres complètes de Charles Baudelaire* (Neuilly sur Seine, 1974), p. 135, 'Je trône dans l'azur comme un sphynx incompris' (translated by the author). See *The Flowers of Evil* (California, 1954), p. 59.

6 *Dark continent*

1 Hélène Cixous, 'Sorties: Out and Out: Attacks/Ways Out/Forrays', in H. Cixous and C. Clément, *The Newly Born Woman* (Minneapolis, 1986), pp. 63, 67.

2 Victor Burgin, 'Paranoiac Space', *New Formations*, XII (Winter, 1990), p. 69.

3 Alexander Walker, *An Analysis and Classification of Beauty in Woman* (New York, 1840), p. 82.

4 Richard Payne Knight, quoted in A. Walker, *An Analysis and Classification of Beauty in Woman*, p. 82.

5 Tzvetan Todorov reads the encyclopaedist Georges Louis L. Buffon's *De l'Homme* (1749), citing the litany of oppositions in which black is associated with ugliness and white with beauty. See Tzvetan Todorov, *Nous et les autres – La réflexion française sur la diversité humaine* (Paris, 1989).

6 We may recall here that the biblical myth of the origin of blackness is centred upon the dialectic of seeing and not seeing. Ham, having looked upon the naked body of his father Noah and failed to cover it as propriety required, was punished for his indiscretion. God willed that Ham's son and his descendants would be born black, and thus would be banished from his sight. Blackness, equated here with invisibility, is made to bear the burden of the son's guilty desire for the paternal phallus. See Joel Kovel, *White Racism: A Psychohistory* (New York, 1970), pp. 51 ff.

7 Joseph Arthur, comte de Gobineau, quoted in C. L. Miller, *Blank Darkness – Africanist Discourse in French* (Chicago, London, 1985), p. 122.

8 Gustave Eichtal, Ismayl Urbain, quoted in, C. L. Miller, *Blank Darkness – Africanist Discourse in French*, p. 122: 'Le Noir me parait être la race femme dans la famille humaine, comme le blanc est la race mâle. De même que la femme, le noir est privé des facultés politiques et

scientifiques; il n'a jamais créé un grand état, il n'est point astronome, mathématicien, naturaliste; il n'a rien fait en mécanique industrielle. Mais, par contre, il possède au plus haut degré les qualités du coeur, les affections et les sentiments domestiques; il est l'homme d'intérieur. Comme la femme, il aime aussi avec passion la parure, la danse, le chant; et le peu d'exemples que j'ai vus de sa poésie native sont des idylles charmantes' (translated by the author).

Kobena Mercer writes of the feminization of the black male body in the works of late photographer Robert Mapplethorpe: 'While images of gay S/M rituals represent a sexuality that consists in "doing" something, black men are defined, confined and reduced to their "being" as sexual and nothing more or less than sexual, hence "super-sexual".' K. Mercer, 'Imaging the Black Man's Sex', *Photography/Politics: Two*, eds, Patricia Holland, Jo Spence, Simon Watney (London, 1986), p. 64.

9 Abigail Solomon-Godeau, 'Going Native', *Art in America* (July, 1989), p. 123 (my italics).

10 Mikhail Bakhtin, *Rabelais and His World* (Cambridge, Mass., London, 1968), p. 318.

11 Unattributed quote (1810) in Sander L. Gilman, 'Black Bodies, White Bodies', in *'Race', Writing and Difference*, ed. H. L. Gates Jr. (Chicago, London, 1986), p. 232.

12 It was in 1830 that Philadelphian doctor Samuel George Morton delivered a lecture on the internal capacity of the five skulls of Blumenbach's classification – Caucasian, Mongolian, Malay, American, Ethiopian – in which he concluded that Whites had the biggest brains and Blacks the smallest, thus explaining the differences in the 'capacity for civilization'. Morton's table of measurements was copied by German racial theorist, Carl Gustav Carus, in 1849, and later by the comte de Gobineau in his influential *Essai sur l'inégalité des races humaines*. See Michael Banton, *Racial Theories* (Cambridge, London, New York, 1987).

13 Peter Stallybrass and Allon White, *The Politics and Poetics of Transgression* (New York, 1986), p. 22.

14 Mikhail Bakhtin, *Rabelais and His World*, p. 319.

15 Stallybrass and White, *The Politics and Poetics of Transgression*, p. 23.

16 Elizabeth Grosz, 'Language and the Limits of the Body: Kristeva and Abjection', in *Futur* Fall – Excursions into Postmodernity*, eds E. Grosz, T. Threadgold, D. Kelly et al. (Sydney, 1987), p. 108.

17 E. Grosz, 'Language and the Limits of the Body: Kristeva and Abjection', pp. 111–12.

18 Julia Kristeva, *Powers of Horror* (New York, 1982), pp. 75–6.

19 J. Kristeva, 'Approaching Abjection', *The Oxford Literary Review*, v/1–2 (1982), p. 127.

20 J. Kristeva, 'Approaching Abjection', p. 127.

21 E. Grosz, 'Julia Kristeva: Abjection, Motherhood and Love', in *Sexual Subversions – Three French Feminists*, (Sydney, London, 1989), p. 75.

22 J. Kristeva, 'Approaching Abjection', p. 127.

23 Plotinus, *The Enneads*, v, Eighth Tractate, 'On the Intellectual Beauty' (Cambridge, Mass., 1988), p. 486.

24 J. Kristeva, 'Approaching Abjection', p. 134.

25 Pierre Loti, *Le Roman d'un saphi*, quoted in T. Todorov, *Nous et les autres – La Réflexion française sur la diversité humaine*, p. 354, 'Il lui semblait qu'il allait franchir un seuil fatal, signer avec cette race noire une sorte de pacte funeste'. 'Il avait retrouvé sa dignité d'homme blanc, souillé par le contact avec cette chair noire' (translated by the author).

26 S. L. Gilman, 'Black Bodies, White Bodies', p. 250.

27 Phyllis Rose, *Jazz Cleopatra – Josephine Baker in Her Time* (London, New York, 1989), p. 42.

28 P. Rose, *Jazz Cleopatra – Josephine Baker in Her Time*, p. 42.

29 Picasso, quoted in P. Rose, *Jazz Cleopatra – Josephine Baker in Her Time*, p. 42.

30 Picasso quoted in James Clifford, *The Predicament of Culture – Twentieth-Century Ethnography, Literature, and Art* (Cambridge, Mass., London, 1988), p. 135.

31 Vicar of St Aidan's, quoted in Carolyn Hall, *The Twenties in Vogue* (New York, 1983), p. 80.

32 A reviewer for *Vogue*, quoted in C. Hall, *The Twenties in Vogue*, p. 80.

33 André Levinson, quoted in P. Rose, *Jazz Cleopatra – Josephine Baker in Her Time*, p. 31.

34 Phyllis Rose adheres to a similar discourse when she writes: 'She went down and up; she slid; she turned sideways; she faced the audience; she crossed her eyes; she twirled, putting her finger on her head as though she herself were a top she was spinning; she sang in a man's voice. The next moment she dropped the contortions, the mugging, and reverted to beauty.' P. Rose, *Jazz Cleopatra – Josephine Baker in Her Time*, p. 25.

35 A German critic quoted in John Czaplicka, 'Jungle Music and Song of Machines: Jazz and American Dance in Weimar Culture' in *Envisioning America* (Harvard University, Cambridge, Mass., 1990), p. 98.

36 See Frank Costigliola, *Awkward Dominion: American Political, Economic, and Cultural Relations with Europe* (Ithaca, 1984).

37 Jean-Paul Goude was commissioned by the Socialist government to design the 1989 parade for the Bicentenary of the French Revolution. The result was a splendid display of witty multi-cultural clichés often condensed and displaced into new, unexpected forms. The parade was led by the silent formations of Chinese men and women slowly pushing their bicycles as they rang the bells on the handle-bars – a powerful echo of the repressive force which had silenced so many on Tiananmen Square earlier that summer. Had the bloody repression not occurred, Red Guards would have been marching down the Champs-Elysées in military formations, their orderly ranks suddenly irrupting into break-dancing.

38 Jean-Paul Goude, *Jungle Fever* (New York, 1981).

39 One of my fears, here, is that I may be misperceived by some as a woman pointing the finger at 'bad' men. Here, as elsewhere, I would emphatically distinguish between 'analysis of the author' and 'analysis of the effect'. *Authorial intent is not at issue.* Anyone familiar with the past twenty-five years of theories of representations knows this: the meanings of the codes escape the control of the 'author' who assembles them. What follows, then, is not about the real author, Jean-Paul Goude. It is about the historically and psychically overdetermined *meanings* of the collage of images (advertising, books, and so on), and utterances (interviews, etc.), which are in the public domain and which bear his signature.

40 J.-P. Goude, *Jungle Fever*, p. 31.

41 J.-P. Goude, *Jungle Fever*, p. 102.

42 Homi K. Bhabha, 'The Other Question – the Stereotype and Colonial Discourse', *Screen*, xxiv/6 (November–December, 1983), p. 23.

43 H. K. Bhabha, 'The Other Question – the Stereotype and Colonial Discourse', p. 27.

44 H. K. Bhabha, 'The Other Question – the Stereotype and Colonial Discourse', p. 26.

45 Richard Dyer, 'White', *Screen*, xxix/4 (Autumn, 1988), p. 56.

46 R. Dyer, 'White', p. 57.

47 J.-P. Goude, *Jungle Fever*, p. 31.

48 J.-P. Goude, *Jungle Fever*, p. 104.

49 J.-P. Goude, *Jungle Fever*, p. 41.

50 J.-P. Goude, *Jungle Fever*, p. 103. In an essay about *Jungle Fever*, Ted Colless and Paul Foss relate the ideal of physical perfection in fascist art to Goude's concern with correct proportions – thus choosing to ignore the less sensational fact that representations of the body in fascist art were inherited from ideals which have dominated, and still dominate, Western representations of the body since Classical times. See Ted Colless and Paul Foss, 'Demolition Man', *Art and Text*, x (Winter, 1983).

51 Charles Baudelaire, 'Sed Non Satiata', *Les Fleurs du Mal*, xxviii, in *Oeuvres Complètes de Charles Baudelaire* (Neuilly sur Seine, 1974), p. 148, 'Bizarre déité, brune comme les nuits'; 'tâchez de concevoir un beau banal!' (translated by the author). See *The Flowers of Evil* (California, 1954), p. 91.

52 J. Czaplicka, 'Jungle Music and Song of Machines: Jazz and American Dance in Weimar Culture' in *Envisioning America*, p. 88.

53 J.-P. Goude, *Jungle Fever*, p. 106.

54 J.-P. Goude, *Jungle Fever*, p. 4.

55 Helmut Newton, *Portraits* (New York, 1987), plate 160.

56 See 'Condensation' in Jean Laplanche and Jean-Bertrand Pontalis, *The Language of Psycho-Analysis* (London, 1973), pp. 82–3.

57 J.-P. Goude, *Jungle Fever*, p. 107.

58 J.-P. Goude, *Jungle Fever*, p. 5.

59 J.-P. Goude, *Jungle Fever*, p. 107.

60 J.-P. Goude, *Jungle Fever*, p. 107.

61 J.-P. Goude, *Jungle Fever*, p. 105. The masculinization of Grace Jones is effected here through what Kobena Mercer describes as 'the most commonplace of media sterotypes of the black male; the black male as athlete and sportsman, 'endowed with a "natural" muscular physique with a capacity for strength and machine-like perfection'. K. Mercer, 'Imaging the Black Man's Sex', *Photography/Politics: Two*, p. 65.

62 H. K. Bhabha, 'The Other Question – the Stereotype and Colonial Discourse', p. 34.

63 J.-P. Goude, *Jungle Fever*, p. 40.

64 J.-P. Goude, *Jungle Fever*, p. 106.

65 J.-P. Goude, *Jungle Fever*, p. 106. See Emile Zola, *La Bête humaine* (Paris, 1984), translated as *The Monomaniac* (London, 1901).

66 J. Kristeva, *Etrangers à nous-mêmes* (Paris, 1988), p. 12, 'D'abord sa singularité saisit: ces yeux, ces lèvres, ces pommettes, cette peau pas comme les autres le distinguent et rappellent qu'il y a là *quelqu'un*. La différence de ce visage révèle en paroxyme ce que tout visage devrait dévoiler au regard attentif: l'inexistence de la banalité chez les humains. Pourtant, c'est le banal, précisément, qui constitue une communauté pour nos habitudes quotidiennes. Mais cette saisie, qui nous captive, des traits de l'étranger à la fois appelle et rejette: "Je suis au moins aussi singulier et donc je l'aime", se dit l'observateur; "or je préfère ma propre singularité et donc je le tue", peut-il conclure' (translated by the author).

67 P. Rose, *Jazz Cleopatra – Josephine Baker in Her Time*, p. 7.

7 *Skin deep*

1 Charles Baudelaire, *The Painter of Modern Life and Other Essays* (London, 1964), p. 31.

2 J. C. Flügel, *The Psychology of Clothes* (London, 1950), pp. 110 ff.

3 Quentin Bell, quoted in Kaja Silverman, 'Fragments of a Fashionable Discourse' in *Studies in Entertainment*, ed. T. Modleski (Bloomington and Indianapolis, 1986), p. 140.

4 J. C. Flügel, *The Psychology of Clothes*, p. 110.

5 Jacques Lacan, 'What is a Picture?' in *The Four Fundamental Concepts of Psycho-Analysis* (London, 1977), p. 106.

6 S. Freud, 'Three Essays on the Theory of Sexuality' in *S.E.*, VII, p. 167. See also 'Instincts and their Vicissitudes' in *S.E.*, XIV, pp. 126–33, where Freud discusses the reversal of an instinct into its opposite, taking as his examples two pairs of opposites: sadism-masochism and scopophilia-exhibitionism.

7 K. Silverman, 'Fragments of a Fashionable Discourse', p. 143.

8 I use the term 'appearance' rather than 'specularity' here in order to retain the imaginary dimension of the man's relation to the woman as object rather than subject of the look.

9 Anatole-France, *Histoire, Comique*, II, 'Peau', in *Le Robert – Dictionnaire alphabétique et analogique de la langue française* (Paris, 1966), 'Il n'y a pas de plus fin, de plus riche, de plus beau tissu que la peau d'une jolie femme' (translated by the author).

10 K. Silverman, 'Fragments of a Fashionable Discourse', p. 147.

11 Jean Laplanche, 'The Ego and Narcissism' in *Life and Death in Psychoanalysis* (Baltimore and London, 1976), p. 81.

12 J. C. Flügel, *The Psychology of Clothes*, p. 89.

13 J. C. Flügel, *The Psychology of Clothes*, p. 81.

14 S. Freud, 'The Ego and the Id' in *S.E.*, XIX, p. 26.

15 Didier Anzieu, *The Skin Ego* (London and Newhaven, 1989), p. 40.

16 D. Anzieu, *The Skin Ego*, p. 62.

17 D. Anzieu, *The Skin Ego*, p. 90.

18 D. Anzieu, *The Skin Ego*, p. 102.

19 D. Anzieu, *The Skin Ego*, pp. 39–40.

20 D. Anzieu, *The Skin Ego*, pp. 123–4 (my emphasis).

21 D. Anzieu, *The Skin Ego*, p. 124.

22 D. Anzieu, *The Skin Ego*, p. 145.

23 S. Freud, *Three Essays on the Theory of Sexuality* in *S.E.*, VII, p. 156.

24 Eugénie Lemoine-Luccioni, *La Robe* (Paris, 1983), p. 97. 'Le Vêtement est toujours volé' (translated by the author).

8 *Love at last sight*

1 Charles Baudelaire, 'A une passante' in *Oeuvres Complètes*, x (Paris, 1937), 'La rue assourdissante autour de moi hurlait. / Longue, mince, en grand deuil, douleur majestueuse, / Une femme passa, d'une main fastueuse / Soulevant, balançant le feston et l'ourlet; / Agile et noble, avec sa jambe de statue. / Moi, je buvais, crispé comme un extravagant, / Dans son oeil, ciel livide où germe l'ouragan, / La douceur qui fascine et le plaisir qui tue. / Un éclair . . . puis la nuit!—Fugitive beauté / Dont le regard m'a fait soudainement renaître, / Ne te verrai-je plus que dans l'éternité? / Ailleurs, bien loin d'ici! trop tard! *jamais* peut-être! / Car j'ignore où tu fuis, tu ne sais où je vais, / O toi que j'eusse aimée, ô toi qui le savais.' (translated by the author).

2 André Breton, *Nadja* (New York, London, 1960), p. 64.

3 A. Breton, *Nadja*, p. 114, 'Si vous vouliez, pour vous je ne serais rien, ou qu'une trace' (translation by Richard Howard, adapted by the author).

4 Janet Wolff, 'The Invisible Flâneuse: Women and the Literature of Modernity', *Theory Culture and Society*, II/3 (1985), p. 40.

5 Basically, lenses and emulsions were as yet too 'slow' to capture rapid movement.

6 Charles Baudelaire, 'Mnemonic Art' in *The Painter of Modern Life and Other Essays* (London, 1964), p. 17. Misappropriation, since Baudelaire's words here appear in the context of his discussion on Guy's watercolours. Baudelaire spoke stridently against photography which he conceived of as belonging to 'industry' and not to 'art'. Indeed, for Baudelaire, photography is a tool through which man can certainly record external reality, but not his dreams.

7 Griselda Pollock, 'Modernity and the Space of Femininity' in *Vision and Difference* (London, New York, 1988), p. 79.

8 C. Baudelaire, 'The Artist, Man of the World, Man of the Crowd and Child' in *The Painter of Modern Life and Other Essays*, p. 9.

9 C. Baudelaire, 'Modernity' in *The Painter of Modern Life and Other Essays*, p. 13.

10 C. Baudelaire, *The Painter of Modern Life and Other Essays*, p. 34.

11 W. Benjamin, *Charles Baudelaire, A Lyric Poet in the Era of High Capitalism*, p. 45.

12 W. Benjamin, *Charles Baudelaire, A Lyric Poet in the Era of High Capitalism*, p. 45.

13 Jacques Lacan, 'Ego-ideal and Ideal-ego' in *Freud's Papers on Technique, 1953–54*, ed., J. A. Miller (New York, London, 1988), p. 141.

14 André Breton, *Mad Love* (London, 1987), p. 13.

15 A. Breton, *Mad Love*, p. 24.

16 A. Breton, *Mad Love*, p. 13.

17 Roland Barthes, *Camera Lucida* (New York, 1981), p. 26.

18 R. Barthes, *Camera Lucida*, p. 27.

19 W. Benjamin, *Charles Baudelaire, A Lyric Poet in the Era of High Capitalism*, p. 46.

20 Sigmund Freud, 'The Unconscious' in *S.E.*, xiv, p. 177.

21 Jean Laplanche and Serge Leclaire, 'The Unconscious: A Psychoanalytic Study', *Yale French Studies*, xlviii (1975).

22 J. Laplanche and S. Leclaire, 'The Unconscious: A Psychoanalytic Study', p. 145.

23 J. Laplanche and S. Leclaire, 'The Unconscious: A Psychoanalytic Study', p. 146.

24 It is indeed this phonic fragment which was repressed in the manifest content of Philippe's dream, in which the term *place* appears in place of *plage*.

25 R. Barthes, *Camera Lucida*, pp. 43–4, 'Ô négresse nourricière' (translated by the author).

26 Victor Burgin, 'Diderot, Barthes, Vertigo' in *The End of Art Theory* (London, 1986), pp. 126–7.

27 Marcel Proust, *Remembrance of Things Past – Swann's Way*, Part One (London, 1973), p. 58.

28 Marcel Proust, *Remembrance of Things Past – Swann's Way*, p. 61.

29 Wilhelm Jensen, *Gradiva* in Sigmund Freud, *Délire et rêve dans la "Gradiva" de Jensen* (Paris, 1971), pp. 21–2 (translated by the author).

30 Toni Morrison, *Jazz* (New York, 1992), p. 130.

31 R. Barthes, *Camera Lucida*, p. 57.

32 Jean Laplanche and Jean-Bertrand Pontalis, 'Fantasy and the Origins of Sexuality' in *Formations of Fantasy* (London, 1986), p. 26.

33 J. Laplanche, 'The Ego and the Vital Order' in *Life and Death in Psycho-Analysis* (Baltimore and London, 1976), p. 60.

34 S. Freud, 'A Child is Being Beaten' in *S.E.*, xvii.

35 A useful formulation, which may however mislead us into thinking of desire as pre-existing its fantasmatic *mise-en-scène*; desire is only known through its formulation in fantasy.

36 Elizabeth Cowie, 'Fantasia', *m/f*, 9 (1984), p. 80.
37 J. Laplanche and S. Leclaire, 'The Unconscious: A Psychoanalytic Study', p. 147.
38 S. Freud, *The Interpretation of Dreams* in *S.E.*, IV, p. 148. A friend of Freud's dreams that she wants to give a dinner party, but realizes that the single slice of smoked salmon she has would not be enough to feed her guests. She wants to go shopping, but as it is Sunday all the stores are closed. She tries to call a caterer, but her telephone is out of order. She finally has to give up her wish of having a dinner party. End of dream. In the course of the interpretation, her jealousy towards a woman friend of whom her husband speaks highly becomes manifest. She also tells Freud that she often teases her husband, asking him not to give her the caviar she craves for. Freud's account of his analysis of the dream is found in a discussion of hysterical identification which does not concern me here. For this reason I am not giving a full and fair account of his interpretation.
39 Catherine Clément, *Lives and Legends of Jacques Lacan* (New York, 1983), p. 128.
40 J. Lacan, 'Direction of Treatment and Principles of its Power' in *Ecrits – A Selection* (New York, 1977), p. 261.
41 J. Lacan, 'Direction of Treatment and Principles of its Power', p. 263: 'It is the child one feeds with most love who refuses food and plays with his refusal as with a desire (anorex nervosa).'
42 E. Cowie, 'Fantasia', p. 80.
43 A. Breton, *Mad Love*, p. 13.
44 S. Freud, *Three Essays on the Theory of Sexuality* in *S.E.*, VII, p. 222.

9 *Mirror, mirror* . . .

1 Leslie Dick, 'Envy', in *The Seven Deadly Sins*, ed. A. Fell (London, 1988), p. 171.
2 L. Dick, 'Envy', p. 171.
3 See *L'Album della Contessa di Castiglione* (Milan, 1980).
4 Abigail Solomon-Godeau, 'The Legs of the Countess', *October*, XXXIX (Winter, 1986), p. 67.
5 A. Solomon-Godeau, 'The Legs of the Countess', p. 67.
6 A. Solomon-Godeau, 'The Legs of the Countess', p. 71.
7 A. Solomon-Godeau, 'The Legs of the Countess', pp. 73–4.
8 Jean Baudrillard, *L'autre par lui-même – Habilitation* (Paris, 1987), p. 80, 'Mais il y a surtout, chez le sujet même, la passion d'être objet, de devenir objet – désir énigmatique dont nous n'avons guère évalué les conséquences dans tous les domaines, politique, esthétique, sexuel – perdus que nous sommes dans l'illusion du sujet, de sa volonté et de sa représentation' (translated by the author).
9 A. Solomon-Godeau, 'The Legs of the Countess', p. 76.
10 A. Solomon-Godeau, 'The Legs of the Countess', p. 69.
11 Considering the intensity of infantile narcissism, it seems to me that the question should not be why are women so captivated by their image, but rather why do Western men repress or, more correctly, disavow, their specularity, the inevitability of their being as image for the other. For J. C. Flügel and Quentin Bell this disavowal of specularity, the 'great masculine renunciation', is historically contingent.
12 Catherine Clément, *The Lives and Legends of Jacques Lacan* (New York, 1983). Lacan's account of 'Aimée' may be found in Jacques Lacan, *De la psychose paranoïaque dans ses rapports avec la personalité* (Paris, 1980).
13 Robert Young, *White Mythologies: Writing History and the West* (London, New York, 1990), p. 124.

14 Jacques Lacan, 'Ego-ideal and Ideal ego' in *The Seminar of Jacques Lacan: Freud's Papers on Technique 1953–1954, Book I* (New York, London, 1988), p. 140.

15 Jean-Jacques Rousseau, *Pygmalion*, quoted in Jean Starobinski, *L'Oeil Vivant* (Paris, 1961), p. 179, 'Que ma Galatée vive, et que je ne sois pas elle. Ah! que je sois toujours un autre, pour vouloir toujours être elle' (translated by the author).

16 Roland Barthes, 'Soirées de Paris', in *Incidents* (Paris, 1987), p. 100, 'Le trio du Désir se forme fatalement, B. G. m'ayant, par son choix, désigné *qui je dois* désirer' (translated by the author).

17 Lacan writes: 'Man's desire finds its meaning in the desire of the other, not so much because the other holds the key to the object desired, as because the first object of desire is to be recognized by the other.' Function and Field of Speech in Language' in *Ecrits – A Selection* (New York, 1977), p. 58.

18 Paola Melchiori, quoted in Giuliana Bruno, 'The Image (and the) Movement: An Overview of Italian Feminist Research', *Camera Obscura*, 20–21, p. 32.

19 Malcolm Bowie, *Lacan* (London, 1991), p. 23.

20 Virginia Woolf, 'The New Dress' in *A Haunted House and Other Short Stories* (The Hogarth Press, London, 1943). An encumbering corporeality which Roland Barthes evokes in these lines: 'Futile Soirée. It is both thunderous and not warm: a wind of hostile rain. I do not know how to dress to go out; finally I put on a blue wind-cheater, bought in N.Y., practically brand new (I put back the zip lining); it restricts me, the sleeves are too long, it has no interior pocket, I feel packed tight with objects, at the risk of losing them – as I once lost my cigar case because of the same wind-cheater; already I feel ill at ease in the Soirée . . . As I was a quarter of an hour early, at a loss at the thought of waiting in a hall at a premiere, with my wind-cheater, not knowing what to do, calculating that a simple coffee would not take me a quarter of an hour (and the cafés so desolate), I walked along the boulevard'; see 'Soirées de Paris', in *Incidents*, p. 112 (translated by the author).

21 Norman Bryson, 'Interim and Identification', in Mary Kelly, *Interim* (New York, 1990), p. 27.

22 J. Lacan, 'Aggressivity in Psychoanalysis' in *Ecrits – A Selection* (New York, 1977), p. 19.

23 C. Clément, *The Lives and Legends of Jacques Lacan*, p. 74.

24 J. Lacan, *De la psychose paranoiaque dans ses raports avec la personnalité*, quoted in C. Clément, *The Lives and Legends of Jacques Lacan*, p. 75.

25 J. Lacan, *De la psychose paranoiaque*, quoted in C. Clément, *The Lives and Legends of Jacques Lacan*, p. 75.

26 See 'The Damaged Venus' in Lynda Nead, *The Female Nude – Art, Obscenity and Sexuality* (London, 1992).

A SCUOLA DI «PORTAMENTO». CORSO PER INDOSSATRICI, 1955

Select Bibliography

The purpose of this bibliography is to suggest a kernel of readings around the problematic of beauty, as formulated in the preceding pages. It is far from exhaustive, and aims simply to offer some points of departure. The loose 'categories' listed below are not definitive, and they are more anecdotal than scientific. Nor are they mutually exclusive (no body exists, for example, without racial and sexual difference). Nevertheless, although they occupy a common conceptual and experiential space, the texts cited under the different categories tend towards different *centres* of concern. In addition to scholarly works, I have also included some works of fiction, as well as monographs of visual works, which articulate one or other of the salient topics.

HISTORY AND AESTHETICS

Carter, Angela, 'I Could Have Fancied Her', *London Review of Books*, 16 February 1989
Damisch, Hubert, *Le Jugement de Pâris*, Paris, 1992; 'The Underneaths of Painting', *Word and Image*, 1/2 (1985)
Gagnebin, Muriel, *Fascination de la laideur*, Lausanne, 1978
Kofman, Sarah, *The Childhood of Art – An Interpretation of Freud's Aesthetics*, New York, 1988; *Mélancolie de l'Art*, Paris, 1985
Perrot, Philippe, *Le Travail des apparences, ou, Les Transformations du corps féminin: XVIIIe-XIXe siècle*, Paris, 1984
Rabaté, Jean-Michel, *La Beauté Amère*, Seyssel, 1986
Steele, Valerie, *Fashion and Eroticism – Ideals of Feminine Beauty from the Victorian Age to the Jazz Age*, New York, Oxford, 1985

SEXUAL DIFFERENCE

Bernheimer, Charles and Kahane, Claire, eds, *In Dora's Case: Freud-Hysteria-Feminism*, New York, 1990
Freud, Sigmund, 'Some Psychical Consequences of the Anatomical Distinctions between the Sexes' in *The Standard Edition of the Complete Psychological Works of Sigmund Freud*, xix, London, 1981; 'Female Sexuality' in *S.E.*, xxi; 'Femininity', Lecture xxxiii, *New Introductory Lectures* in *S.E.*, xxii; 'Fragment of an Analysis of a Case of Hysteria' in *S.E.*, vii
Granoff, Wladimir and Perrier, François, *Le Désir et le Féminin*, Paris, 1979; Postface, 1991
Kofman, Sarah, *The Enigma of Woman*, Ithaca, London, 1985
Mitchell, Juliet, and Rose, Jaqueline, *Feminine Sexuality: Jacques Lacan and the Ecole Freudienne*, London, 1982
Young-Bruehl, Elizabeth, *Freud on Women – A Reader*, New York, 1990

RACIAL DIFFERENCE

Bhabha, Homi K., 'Of Mimicry and Man: The Ambivalence of Colonial Discourse', in *October*, xxviii (Spring 1984), and 'The Other Question – The Stereotype and Colonial Discourse', *Screen*, xxiv/6 (Nov–Dec 1983)

Burgin, Victor, 'Paranoiac Space', *New Formations*, XII (Winter, 1990)

Ching-Liang Low, Gail,' White Skins/Black Masks: The Pleasures and Politics of Imperialism', *New Formations*, IX (Winter 1989)

Davenport, Doris, 'The Pathology of Racism: A Conversation with Third World Wimmin', in *This Bridge Called My Back: Writing by Radical Women of Color*, Cherríe Moraga and Gloria Anzaldúa, eds, New York, 1983

Fanon, Frantz, *Black Skin, White Masks*, New York, 1967

Gilman, Sander L., 'Black Bodies, White Bodies: Toward on Iconography of Female Sexuality in Late Nineteenth-century Art, Medicine, and Literature', in *'Race', Writing and Difference*, ed. Henri Louis Gates, Chicago, 1985

Goude, Jean-Paul, *Jungle Fever*, New York, 1981

Rose, Phyllis, *Jazz Cleopatra – Josephine Baker in Her Time*, London, New York, 1989

THE BODY

Anzieu, Didier, *The Skin Ego – A Psychoanalytic Approach to the Self*, New Haven, London, 1989

Bellmer, Hans, *Petite anatomie de l'inconscient physique ou l'anatomie de l'Image*, Paris, 1957

Chapkis, Wendy, *Beauty Secrets – Women and the Politics of Appearance*, Boston, 1986

Creed, Barbara, 'Horror and the Monstrous-Feminine: An Imaginary Abjection' in *Fantasy and the Cinema*, ed. James Donald, London, 1989

Dick, Leslie, 'The Skull of Charlotte Corday' in *Other than Itself – Writing Photography*, eds J. X. Berger and O. Richon, Manchester, 1989

Douglas, Mary, *Purity and Danger – An Analysis of the Concepts of Pollution and Taboo*, London and Boston, 1984

Hawthorne, Nathaniel, 'The Birthmark', in *Hawthorne's Short Stories*, ed. Newton Arvin, New York, 1946

Kelly, Mary, 'Re-Presenting the Body: On *Interim*, Part I', in *Psychoanalysis and Cultural Theory – Thresholds*, ed., James Donald, London, 1991

Kristeva, Julia, *Powers of Horror – An Essay on Abjection*, New York, 1982

Nead, Lynda, 'Framing and Freeing – Utopias of the Female Body', *Radical Philosophy*, LX (Spring 1992)

Stallybrass, Peter and White, Allon, *The Politics & Poetics of Transgression*, Ithaca, New York, 1986

Suleiman, Susan Rubin, ed., *The Female Body in Western Culture*, Cambridge, Mass., London, 1986

Theweleit, Klaus, *Male Fantasies*, 2 vols, Cambridge, 1987 and 1989

LOOKING

Barthes, Roland, *Camera Lucida*, New York, 1981

Burgin, Victor, 'Newton's Gravity' in *The Critical Image*, ed. Carol Squiers, Seattle, 1990

Drevet, Patrick, *Huit petites études sur le désir de voir*, Paris, 1991

Freud, Sigmund, 'Fetishism' in *The Standard Edition of the Complete Psychological Works of Sigmund Freud*, XXI, London, 1981; 'The Psychoanalytic View of Psychogenic Disturbances of Vision', *S.E.*, XI; 'The Uncanny', *S.E.*, XVII

Hoffmann, E. T. A., 'The Sandman', in *The Best Tales of Hoffmann*, ed. E. F. Bleiler, New York, 1967

Milner, Max, *La Fantasmagorie – Essai sur l'optique fantastique*, Paris, 1982

Mulvey, Laura, *Visual and Other Pleasures*, Bloomington, Indianapolis, 1989

Rose, Jacqueline, *Sexuality in the Field of Vision*, London, 1986

Bergstrom, Janet, and Doane, Marie-Ann, eds, 'The Spectatrix', special
 issue of *Camera Obscura*, xx–xxi (May–September, 1989)
Starobinski, Jean, *The Living Eye*, Cambridge, Mass., 1989

NARCISSISM

Assoun, Paul-Laurent, 'Entre horreur et narcissime – Où donc chercher la
 beauté?', *L'Ane* (Oct–Dec, 1985)
Clément, Catherine, 'The Ladies's Way', in *Lives and Legends of Jacques
 Lacan*, New York, 1983
Freud, Sigmund, 'On Narcissism: An Introduction' in *The Standard Edition
 of the Complete Psychological Works of Sigmund Freud*, xiv, London, 1981
Lacan, Jacques, 'Aggressivity in Psychoanalysis' and 'The Mirror Stage as
 Formative of the Function of the I as Revealed in Psychoanalytic
 Experience', in *Ecrits: A Selection*, New York, 1977
Laplanche, Jean, and Pontalis, Jean-Bertrand, 'Narcissism' in *The Language
 of Psycho-Analysis*, New York, London, 1973
Lyons, Elisabeth, 'Unspeakable Images, Unspeakable Bodies', *Camera
 Obscura*, xxiv (September, 1990)
Rose, Barbara, 'Is It Art? Orlan and the Trangressive Act', *Art in America*
 (February, 1993)
Solomon-Godeau, Abigail, 'The Legs of the Countess', *October*, xxxix
 (Winter, 1986)

FANTASY

Cowie, Elizabeth, 'Fantasia', *m/f*, ix (1984)
Freud, Sigmund, 'A Child is Being Beaten' in *The Standard Edition of the
 Complete Psychological Works of Sigmund Freud*, xvii, London, 1981;
 'Creative Writers and Day-Dreaming' in *S.E.*, ix; 'Delusions and Dreams
 in Jensen's "Gradiva"', *S.E.*, ix
Klein, Melanie, 'Some Theoretical Conclusions Regarding the Emotional
 Life of the Infant' in *Developments in Psycho-analysis*, London, 1952
Laplanche, Jean, and Leclaire, Serge, 'The Unconscious: A Psychoanalytic
 Study' in *Yale French Studies*, xlviii, 1975, and 'Fantasy and the Origins of
 Sexuality' in *Formations of Fantasy*, eds V. Burgin, J. Donald and C.
 Kaplan, London, 1986
Laplanche, Jean, and Pontalis, Jean-Bertrand, 'Phantasy' in *The Language of
 Psycho-Analysis*, New York, London, 1973
Rivière, Joan, 'Womanliness as Masquerade' in *Formations of Fantasy*, eds V.
 Burgin, J. Donald and C. Kaplan, London, New York, 1986
Sartre, Jean-Paul, *The Psychology of Imagination*, London, 1978

DESIRE

Balzac, Honoré (de), *Gillette, or the Unknown Masterpiece*, London 1988;
 Sarrasine in Roland Barthes, *S/Z*, London 1975
Barthes, Roland, *A Lover's Discourse*, New York, 1978; 'The Face of Garbo'
 in *Mythologies*, New York, 1972
Breton, André, *Nadja*, New York, London, 1960
Desire, ICA Documents, London, 1984
Huet, Marie-Hélene, 'Living Images: Monstrosity and Representation',
 Representations, 4 (Fall, 1983)
Laplanche, Jean, and Pontalis, Jean-Bertrand, 'Wish (Desire)' in *The
 Language of Psycho-Analysis*, New York, London, 1973
Spitteler, Carl, *Imago*, Paris, 1984
Tournier, Michel, 'Veronica's Shrouds', *The Fetishist*, London, 1984

Villiers de l'Isle-Adam, Philippe-Auguste, comte de, *Tomorrow's Eve*, Chicago, London, 1982

Winogrand, Garry, *Women are Beautiful*, New York, 1975

DRESS

Carter, Angela, 'The Painful Pleasure of the 15-inch Waist', in *New Society* (22 April 1982)

Clérambault, Gaëtan Gatian (de), *Passion érotique des étoffes chez la femme* Paris, 1991

Favrichon, Anna, *Toilettes et Silhouettes Féminines chez Marcel Proust*, Lyon, 1987

Flügel, J. C, *The Psychology of Clothes*, London, 1950

Gaines, Jane and Herzog, Charlotte, eds, *Fabrications – Costume and the Female Body*, New York, London, 1990

Kunzle, David, *Fashion and Fetishism: A Social History of the Corset, Tight-lacing and Other Forms of Body-sculpture in the West*, Totowa, NJ, 1982

Lemoine-Luccioni, Eugenie, *La Robe*, Paris, 1983

Papetti, Yolande et al., eds, *La Passion des etoffes chez un neuro-psychiatre – Gaëtan Gatian de Clerambault*, Paris, 1990

Silverman, Kaja, 'Fragments of a Fashionable Discourse', in *Studies in Entertainment – Critical Approaches to Mass Culture*, ed. Tania Modleski, Bloomington and Indianapolis, 1986

Wollen, Peter, 'Fashion/Orientalism/the Body', *New Formations*, 1 (Spring, 1987)

Woolf, Virginia, 'The New Dress', in *A Haunted House and Other Short Stories*, London, 1943